CHAPTER

I

SHARING SPECIAL MOMENTS

BY JACK WEISER
DIRECTOR OF PHOTOGRAPHY
TIME-LIFE BOOKS INC.

I AM DELIGHTED TO BE A PARTICIPANT IN THIS FIRST PUBLICATION OF THE PHOTOGRAPHS OF THE WINNERS OF the Kodak International Newspaper Snapshot Awards (KINSA), and to be able to view the exhibitions of the original photos at Explorer's Hall of The National Geographic Society and at WALT DISNEY WORLD EPCOT Center. These organizations, along with Time-Life and Kodak, have long shown their commitment to communication and education among the people of the world, a process often accomplished through the use of photography. Their participation in the KINSA contest reaffirms their support for the talented amateur photographers whose pictures bring a view of their lives and homes to a wide audience.

In my current position of Director of Photography at Time-Life Books, I spend my days happily immersed in thousands of photographs, but my interest in photography began in my youth. Like many children in the 1950s, I grew up in a home where the weekly arrival of *Life* magazine brought with it a huge variety of shared visual pleasures: photos of newsmakers, the world of nature, parties, famous personalities, entertainment, fads, world politics, sports—the magic moments of life in our time.

I received the chance to capture the magic moments in my own life when, at Christmas in 1955, I pulled from under the tree Kodak's sleek new Brownie Hawkeye camera.

OPPOSITE: Plunge into a waterfall, from the 1972 KINSA contest.

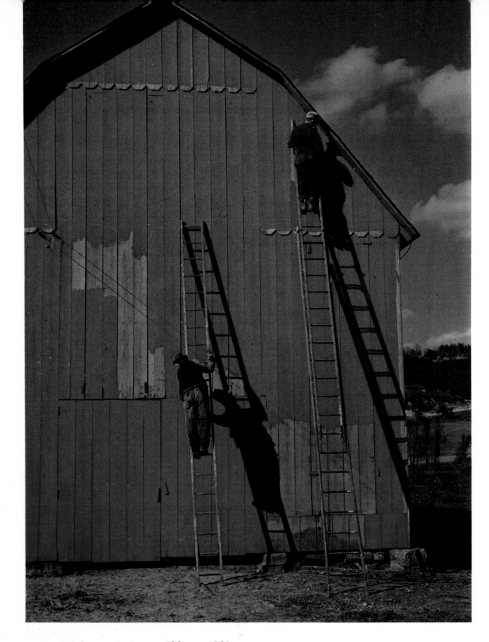

ABOVE: Workers painting a red barn, 1958.

RIGHT: A rural farm amidst wheat fields, 1963.

At first, I thought of the camera as a simple tool that would allow me to record a history of pets, places, and people that I knew. I diligently captioned and dated each photograph and placed it neatly in an album. As I became more proficient in my visual journal, I began to study the snapshots carefully as they came back from the processor—in those days, often a matter of weeks. Was I cropping the image so that one's interest was immediately drawn to the subject? Was my focus sharp? Were people smiling, looking their best, posed properly? Was I standing in the right spot to record the image? As I became increasingly concerned with the "right" look of the photographs, I also became aware that I had lost the spontaneity in the photographs of those special moments in my world.

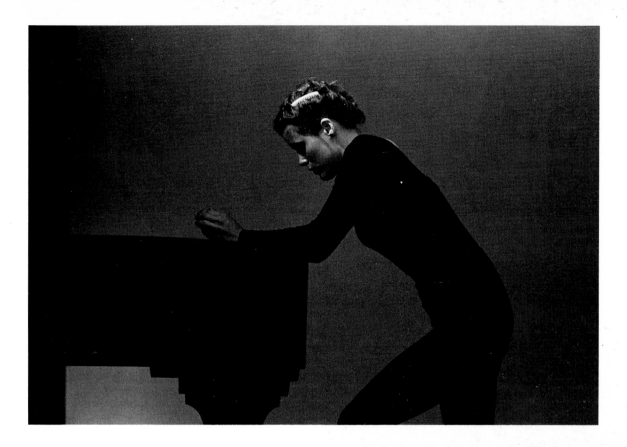

When that "Eureka!" sounded, and I realized I had lost my license for spontaneous creativity, I let go of the studied look and began to capture the natural moments in life. Using *Life* magazine as a guide, I tried to model my "look" on photographs by *Life* staff photographers Alfred Eisenstadt, Eliot Elisofon, Margaret Bourke-White (a former KINSA judge), Mark Kauffman, and others. Although I never progressed beyond amateur status, my photographs took on a fresher look and were more suggestive of the real world around me. Thirty-something years and 49 photo albums later, I am able to share the visual history of my life with family and friends through snapshot memories.

Over the years, thousands of photographers from all over the world have passed through our Photography Department here at Time-Life Books. Many bear famous names; others are struggling young professionals. Still others are amateurs who nurture the dream of appearing in one of our publications. They all bring examples of their work; sometimes I sit down in front of a carefully prepared portfolio, at other times I've had to sift through flimsy cardboard boxes filled to the brim with transparencies. It is when I begin to examine the photos themselves, though, that the true test begins. Much of what the photographers bring is slick, perfectly composed, delighting the design sense of the eye—works of art created by many hours of thoughtful prepara-

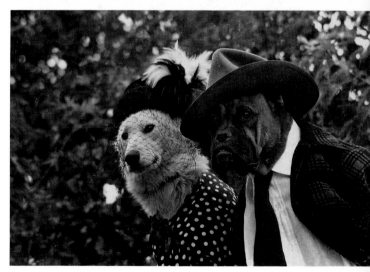

TOP: A sensitive portrait, 1983.

ABOVE: Dressed up dogs, a perennial favorite, 1951.

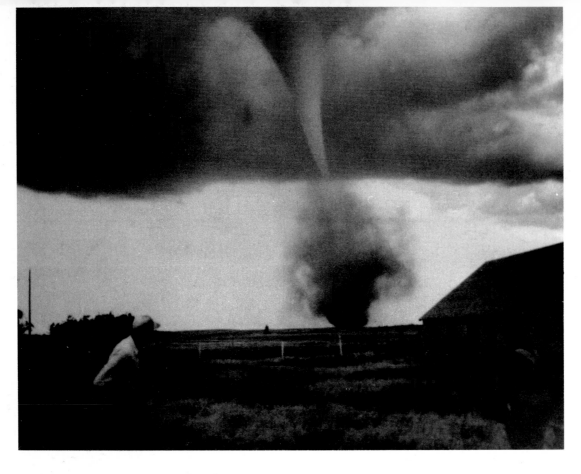

ABOVE: A tornado bears down on a midwestern farm, 1972.

tion in front of and behind the camera. Other work is what some call "amateur," created by men and women caught up in the wonderful world of snapshot photography.

Each viewing is a delight and a challenge for me. Can I offer encouragement? Can I find a place for a promising amateur in one of our books? Should I challenge the photographers to improve upon what they have done?

Some years ago, I was picture editing a book called *Storm* in our Planet Earth series. Over a period of two months, I reviewed more than 30,000 photographs from professional photographers, academics, students, and homemakers. As I selected what I considered to be the best images to illustrate our text, I was drawn to those photographs whose creators had seen a subject, grabbed their cameras and snapped. All of it was spontaneous and captured a moment in time never to be repeated.

The book was published to considerable acclaim. Two of its greatest strengths are marvels of amateur photography, both made by homemakers. The first is a series of twelve photographs of a twister that touched down near Osnabrock, North Dakota, in 1978; it shows a classic pattern of tornado development. The homemaker, who saw the tornado forming from her kitchen window, snatched her camera from the other room and recorded the entire event. Another amateur photograph, so powerful

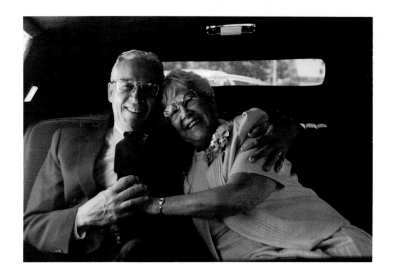

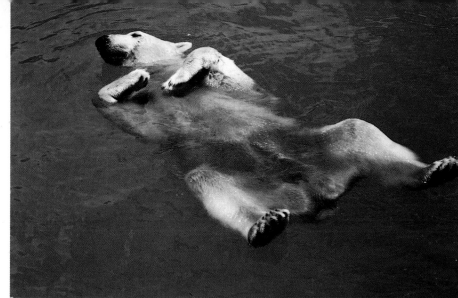

that we chose it for the cover of the book, shows the funnel of a tornado exploding into a thundering, ragged column of debris as it touched the plains of western Kansas in 1979.

Amateur photography? Yes. Great photography? Absolutely.

The photographs that appear in this book were taken for many reasons. Some, like the tornado pictures mentioned earlier, are lucky shots—the photographer was at the right place at the right time. Others are carefully crafted; the photographer selected a subject that was intriguing, or waited for light and shadow to bring out the best in what might otherwise be a dull scene. The great thing about photography is that no matter what one's level of expertise, anyone can make a memorable photograph. A slightly out-of-focus photo that holds great sentimental value is as prized by its creator as the photo taken by the advanced amateur who has mastered a new technique.

All of us have the ability to see people, places, events, emotion, and to capture those special moments in time. If we are fortunate, we may create great photographs. And, if we have a special story to tell, our pictures can tell it for us. Even across international boundaries and language barriers, we can speak to each other through our photographs.

Photographs that speak to the variety of human experience are what KINSA is all about. Each of the photographers whose photographs appear in this book have shared their memories of a special time and place in their lives. They have given us, and themselves, a record—a lasting gift of one special moment. They celebrate their world with each of us by sharing the record of something they care about that, in turn, touches us, moves us, and relates to each of our lives.

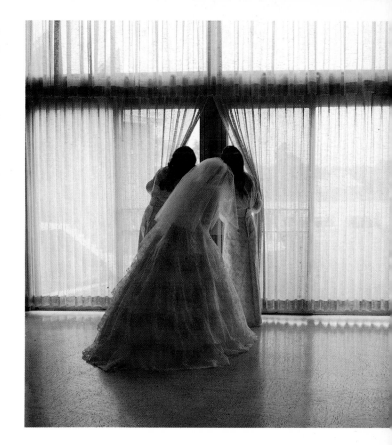

TOP LEFT: A celebration hug in a limousine, 1987.

TOP RIGHT: A polar bear floats in the summer heat, 1974.

ABOVE: Anxious wedding party awaits the music, 1974.

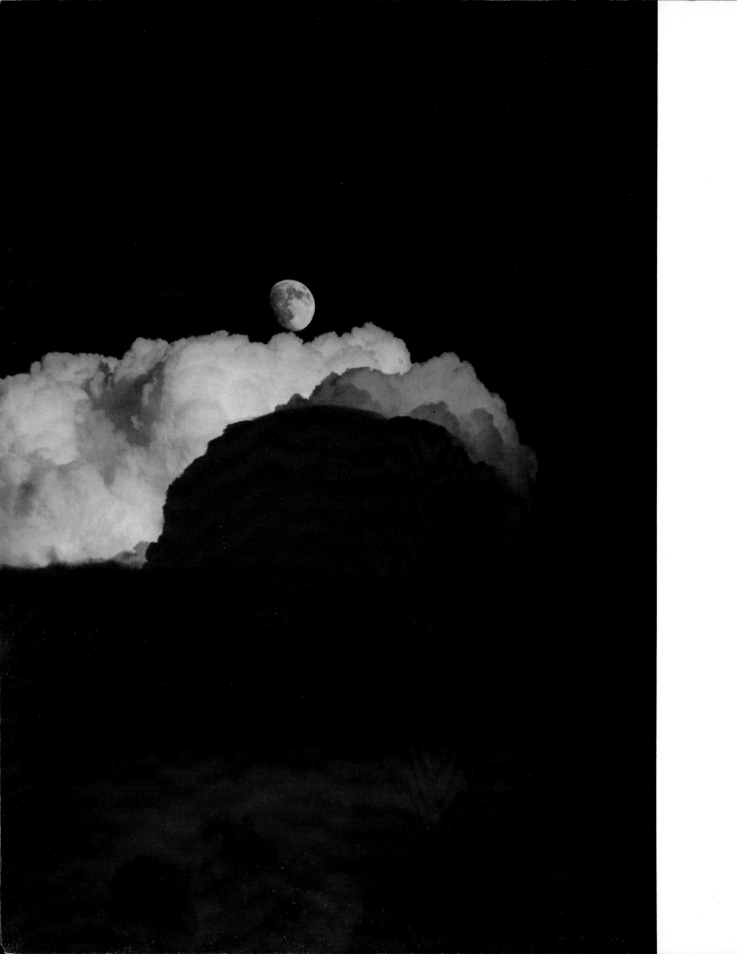

CHAPTER

II

THE YEAR'S BEST

Every one of the winners was selected from an international field of more than 500,000 pictures. All were taken on KODAK Film by amateur photographers in the United States and throughout the world.

Here are people—funny, eye-catching, and moving. Caught at home and at play, every photo tells a story about life. There are warm and cherished moments, heart-stopping thrills, and tender looks at love. Young and old, friends are found on every page.

Here are pets and other animals—old family friends and surprising glimpses of wildlife and nature. From unexpected behaviors to dramatic appearances, every dog, cat, fish, and fowl is a favorite for the camera's lens.

Here is the world—striking, scenic pictures of mountains, oceans, lakes, and rivers. From autumn colors to desert sands, breathtaking views capture a variety of moods and moments in the always-changing landscape.

Here are all the special moments—captured on film. Never-to-be-forgotten times and places that refresh our memories of life's treasures and joys.

Here, then, is Kodak's look at our world in 1991, the 56th annual *Kodak International Newspaper Snapshot Awards* photograph contest—Kodak's look at life.

OPPOSITE: The moon rising over sunset clouds, from the 1973 KINSA contest.

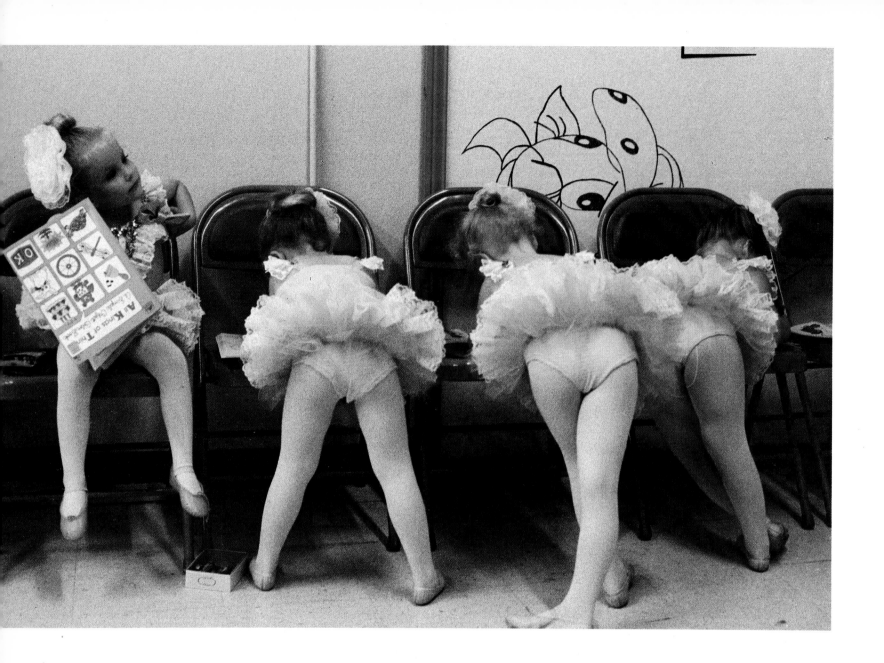

Choosing Best of Show

From the 257 finalists, seven photographs were chosen for special honor. One special photograph was selected for the grand prize award, while first, second, and third prizes were awarded to three pictures taken in color and to three in black-and-white.

In choosing as the best of this year's KINSA entries, the judges evaluated each photograph on five elements: *human interest*—the feeling it generates in the viewer, *general appeal*—its ability to catch the eye or fascinate, *uniqueness*—capturing a moment that is a stroke of luck or a chance, *composition*—containing a new or different look at a common subject, and *quality*—sharpness, exposure, and focus.

In addition, as the judges examined each photograph, they also asked, "Is it interesting? Does it have snapshot quality and appeal? What is most appealing about the photograph, and why? Would a cropping recommendation make it a winner?"

After hours of debate and discussion, the prize winners were selected. The winning photographs captured special moments that set them apart from the others. But one stood alone, a delightful photograph that captivated the judges and kept them coming back for another look. After considering a final time, the choice was unanimous.

OPPOSITE: Little ballet dancers preparing for their debut, the grand prizewinner in the 1983 KINSA contest.

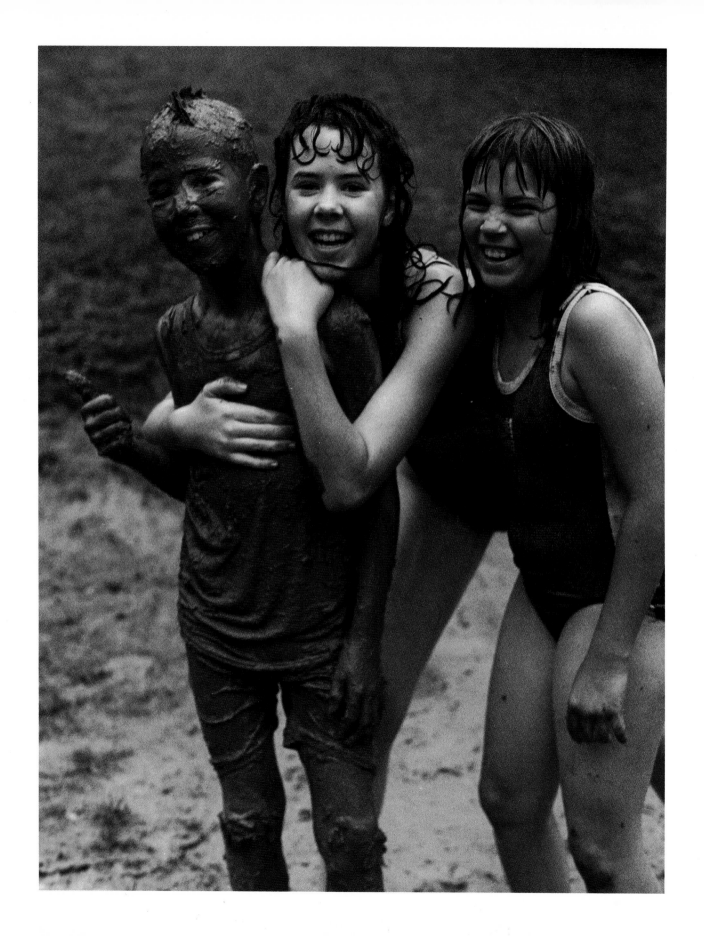

GRAND PRIZE

Playing with the Mud Monster

CONNIE S. HORN

Crooksville, OH USA

The Times Recorder

CONNIE HORN was visiting out-of-town friends when her husband called to tell her that her photo of their two children and a friend playing in the rain in the backyard had won the 1991 KINSA grand prize. She was so excited that she turned directly around and came right home again.

Her excellent photograph captures the essence of a moment that could have taken place anywhere in the world, given the mixture of children, life, summer, fun, and mud. There is innocence of feeling, the children love each other, and the subject is timeless. The situation didn't exist a moment before or afterwards and was totally unplanned. Everyone who sees it smiles and laughs with delight.

The judges and we wonder what happened next? The photo is intriguing and involving.

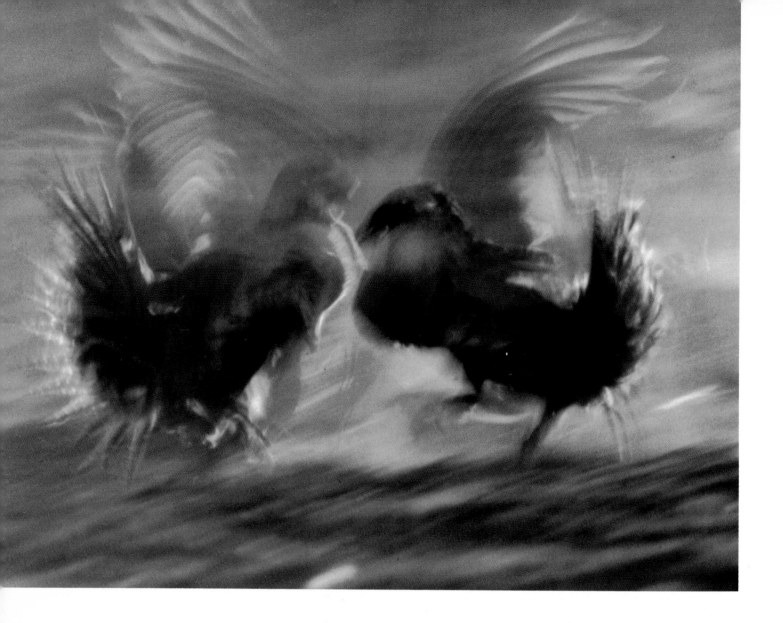

FIRST PLACE—COLOR

Fighting Sage Grouse

F. BUDD TITLOW
East Longmeadow MA USA
The Boston Globe

BUDD TITLOW used a slow shutter speed on his Pentax MX to emphasize the action and movement of male sage grouse defending their breeding territories in North Park, Colorado. His prizewinning picture records the results of patience, opportunity, and careful preparation. His artistry enhances a seldom-seen situation.

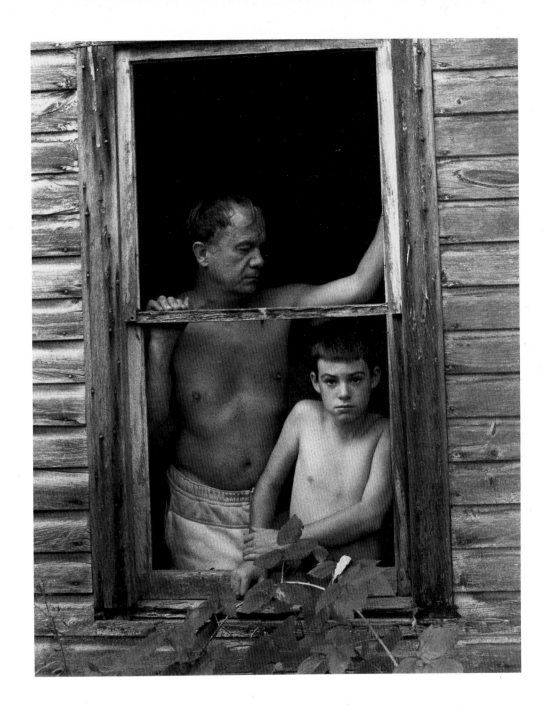

FIRST PLACE—BLACK-AND-WHITE

Father and Son

CONSTANCE FIEDLER
Stone Ridge NY USA
The Daily Freeman

This photograph by CONSTANCE FIEDLER of a father and son in an old, abandoned house rivets one's attention and evokes a strong emotional response. The son's challenging gaze into the camera is offset by the tender look of the father at his child. It is a photograph that poses a thousand questions and could only have existed in black-and-white.

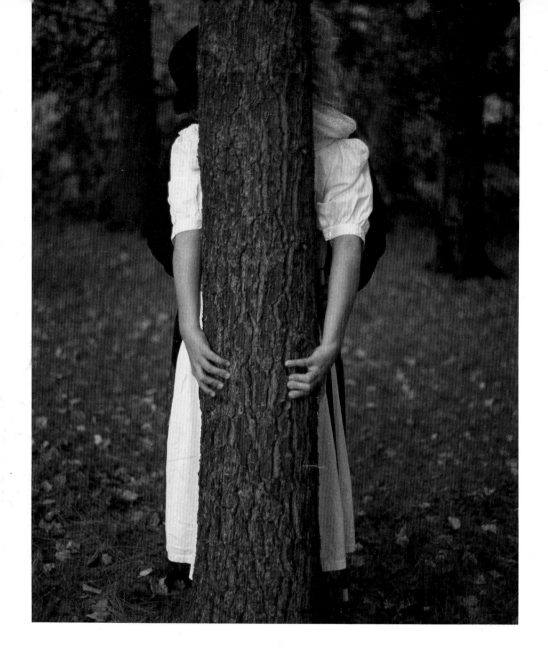

SECOND PLACE—BLACK-AND-WHITE

Romance

STEPHEN H. SHEFFIELD
Wellesley MA USA
The Boston Globe

This couple embracing behind a tree, by STEPHEN SHEFFIELD, suggests feelings beyond the image itself. There exists an enigmatic quality that raises every viewer's curiosity. Sheffield's meticulous planning of composition and exposure clarifies and simplifies his idea and the photo's metaphor.

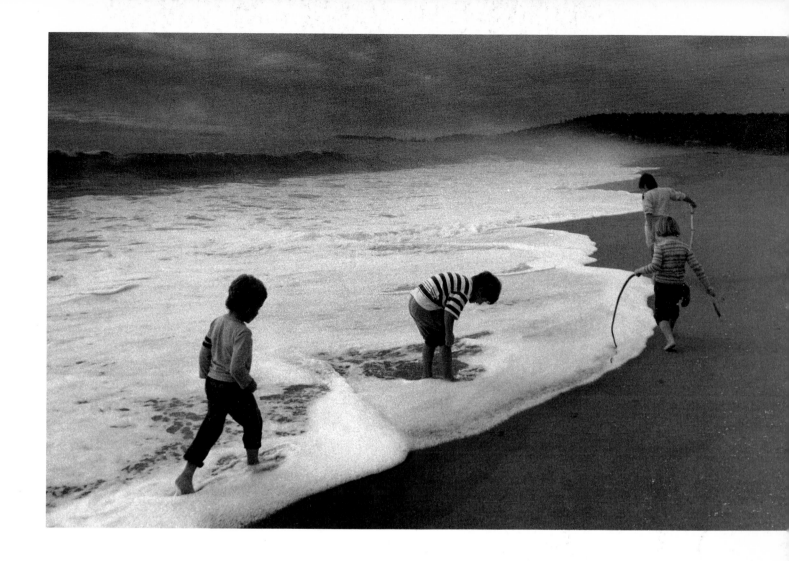

THIRD PLACE—BLACK-AND-WHITE

After the Storm

TONY MARPLE
Whitefield ME USA
The Kennebec Journal

TONY MARPLE took this photo of his children playing in the waves after an October tropical storm-lashed Reid State Park in Georgetown, Maine. It conveys a sense of the moment with good composition and captures the spirit of vitality—the very essence of a snapshot. It radiates with the children's joy.

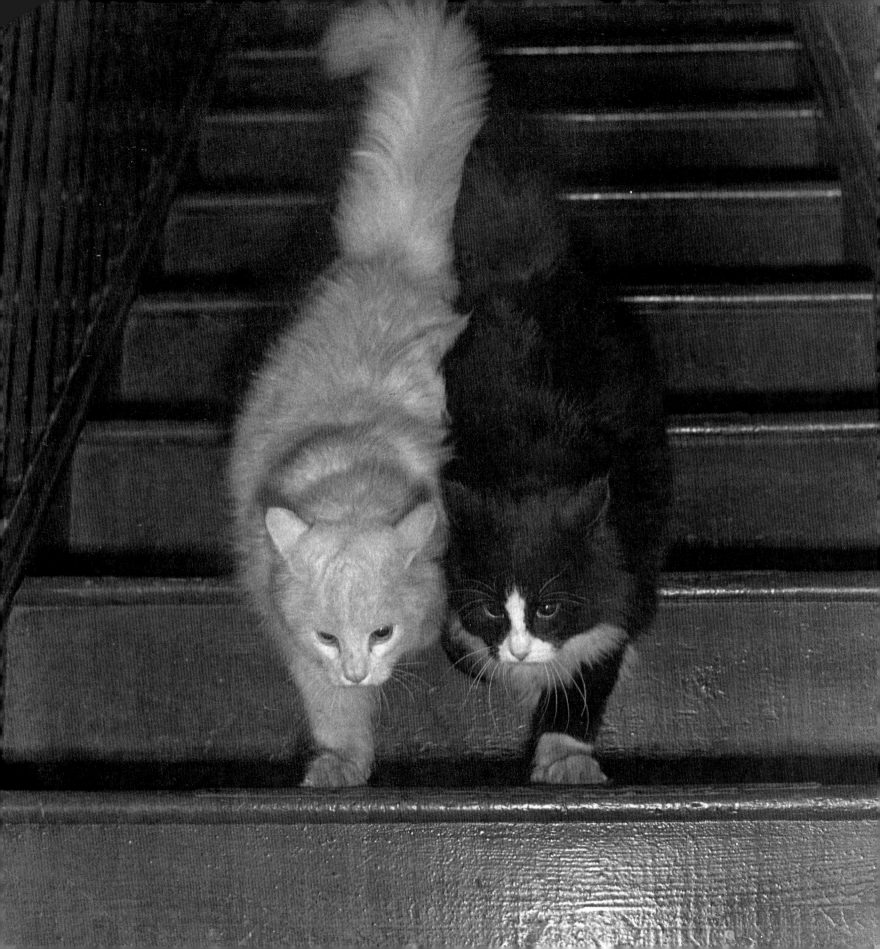

THE KINSA AWARDS

THE JUDGES DIVIDE THE BEST KINSA PHOTOGRAPHS INTO TEN CONTENT CATEGORIES, MIRRORING PATTERNS THAT MOST AMATEUR PHOTOGRAPHERS follow as they take pictures. In each category, five photos are distinguished further, receiving honor awards of $250, indicating the best pictures in that category.

Five of the 10 subject categories are taken from the great themes of photographic art—people, abstracts, still life, action, and landscapes. Since photography's earliest beginnings as an art form in the mid-1800s, these subjects of enduring value have been pervasive. To reveal a subject, a photographer may wield light, shadow, color, or tone, much like an artist wields a paintbrush. Composition is especially important in the abstracts, still life, and landscape categories, while the subject matter is considered most important in people and action photographs.

Kodak chose three other subject categories because of their enduring interest—seniors, environment, and animals. Here, the pictures convey visual messages about their subject matter, drawing the viewer closer to the content and stirring emotions. The last two content categories showcase the advances in the frontiers of film technology—color prints and color transparencies.

OPPOSITE: Black-and-white cats descending a staircase, from the 1956 KINSA contest.

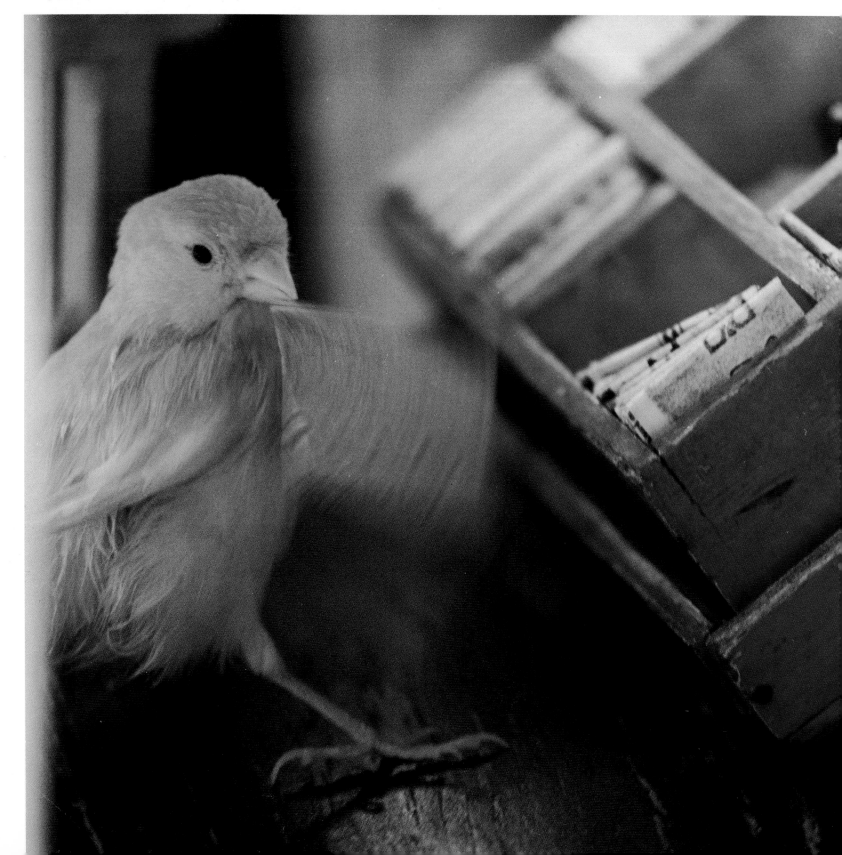

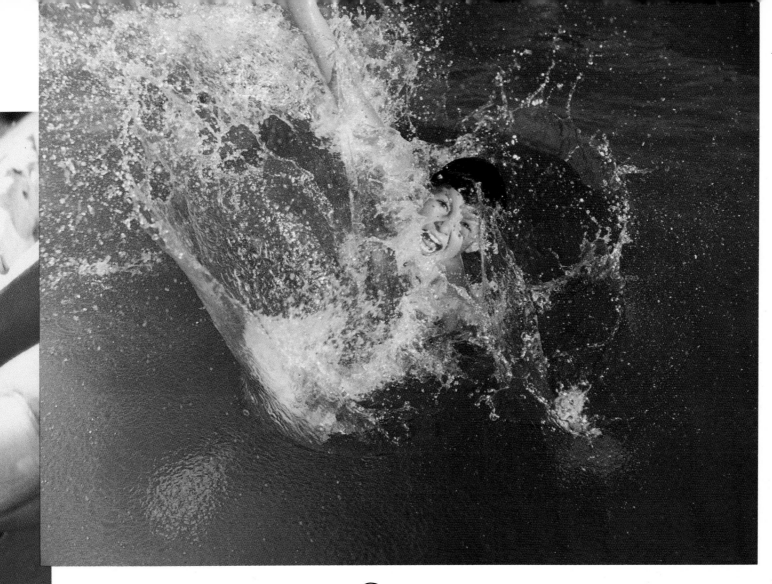

Splash ABOVE: Bright sunlight and a fast shutter capture the exact moment of the boy's plunge.
HONOR AWARD
JOAQUIN SARGIO MENDOZA GONZALEZ
Hermosillo MEXICO *El Imparcial*
KODAK GOLD 100 Film

Little Bird of Luck
OPPOSITE: The motion blurred perfectly in this picture of a little fortune-telling bird.
MERIT AWARD DR. JAIMIE E. ETIENNE
Tampico MEXICO *El Sol de Tampico*
KODACOLOR VR-G 200 Film

Capturing movement in still photographs, without sacrificing the details needed to convey the subject, challenges amateur photographers of sport, event, and action subjects. One basic choice is whether to freeze movement with a fast shutter or an electronic flash, or to allow it to blur with a slow shutter. The photographs selected in this category demonstrate true creativity within these guidelines and are outstanding examples of technique.

And . . . They're Off! OVERLEAF: Racehorses and jockeys become a pattern of blurred, vibrant color.
HONOR AWARD LYDIA J. CHARAK
Toronto, Ontario CANADA *The Guardian* KODAK GOLD 100 Film

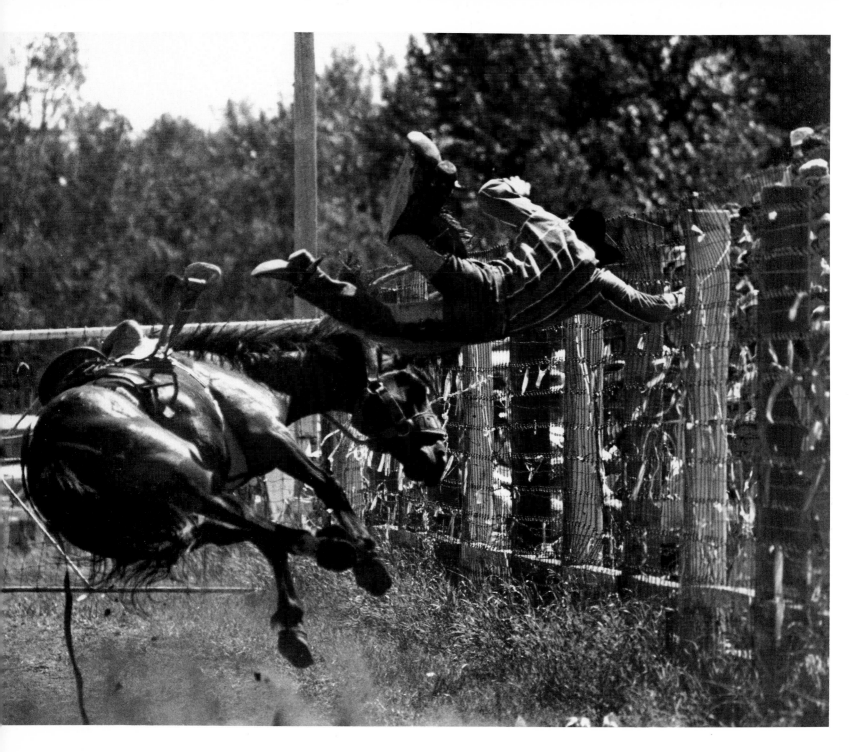

Rodeo Fun ABOVE: The bronc bucks off the cowboy, but loses its own footing, too. The unusual angle makes the picture.
HONOR AWARD GARFIELD SPETZ
Saskatoon, Saskatchewan CANADA *The Star Phoenix*
KODAK T-MAX 400 Professional Film

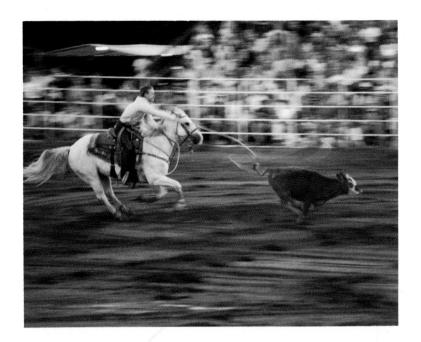

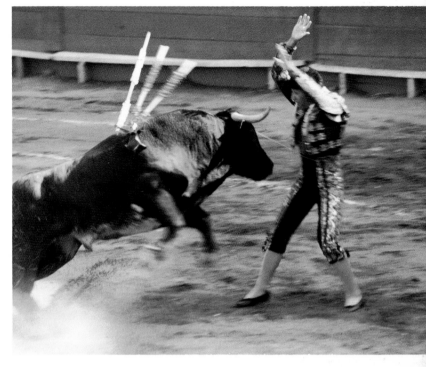

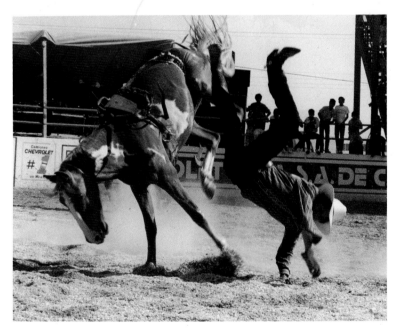

Gotcha! TOP LEFT: Calf-roping action at a rodeo in Manawa, Wisconsin.
MERIT AWARD SANDY MARTEN
Wausau WI USA *The Daily Herald* KODAK GOLD 400 Film

Disagreements ABOVE: The unanswered question—What happened to the matador?
HONOR AWARD SRA. ARTURO VALENZUELA DIAZ
Saltillo MEXICO *Vanguardia* KODACOLOR VR-G 100 Film

Courage LEFT: The horse and its rider are caught just touching the ground, mirroring each other.
MERIT AWARD GERARDO SALCIDO ESPARZA
Torreon MEXICO *La Opinion* KODAK GOLD 100 Film

Right Cross ABOVE: I captured the boxer's power as he trained for the Golden Gloves Championship.
MERIT AWARD ARTHUR F. HASTINGS
Whitefish Bay WI USA *The Milwaukee Journal*
KODAK T-MAX 3200 Professional Film

Jump! OPPOSITE: A jump from a bench at Marywood College, Pennsylvania, transforms person into ghost.
MERIT AWARD ANN MARIE KEENAN
Scranton PA USA *The Times* KODAK T-MAX 400 Professional Film

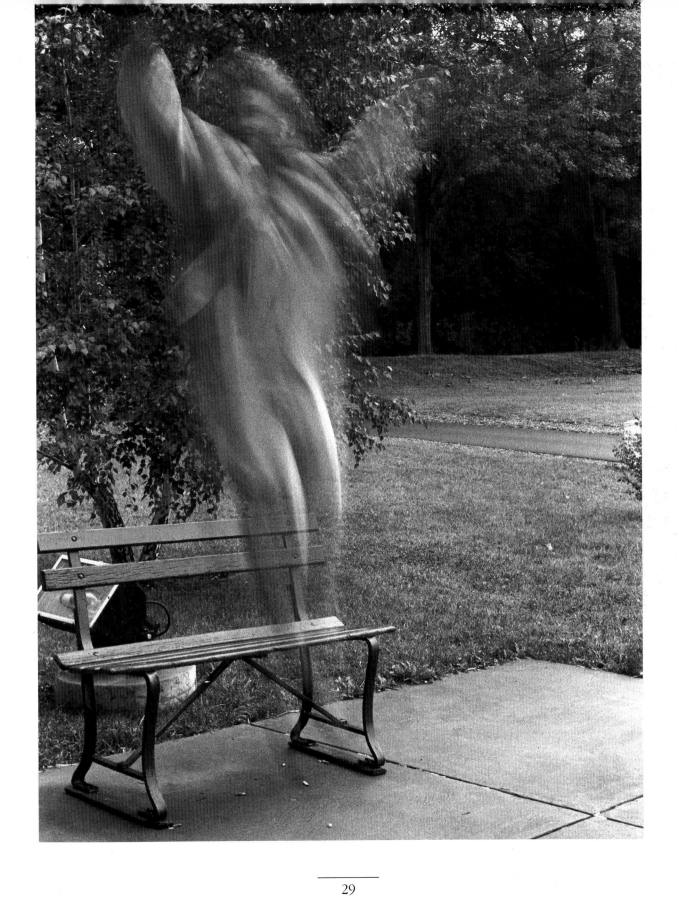

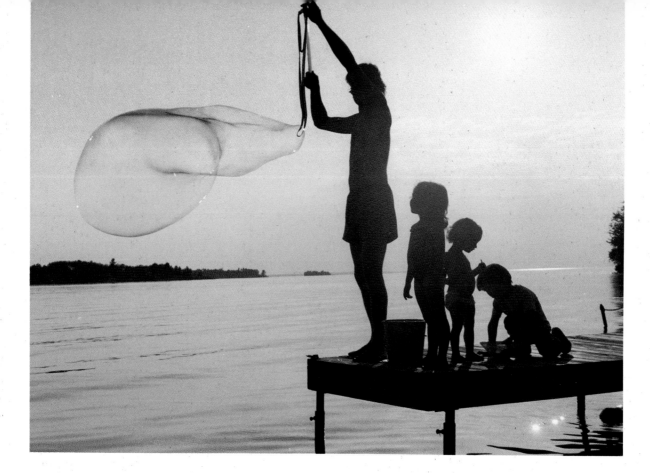

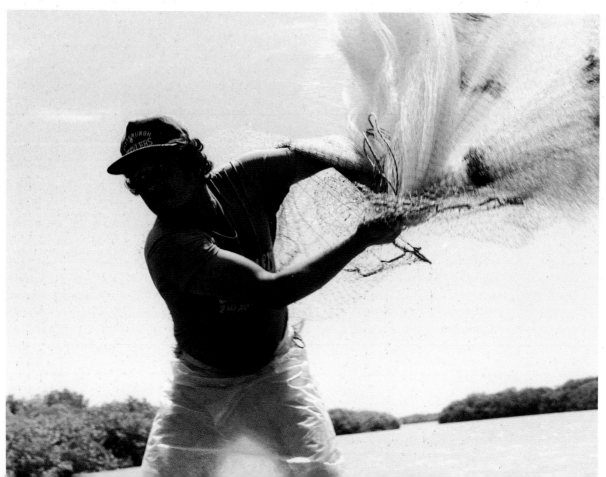

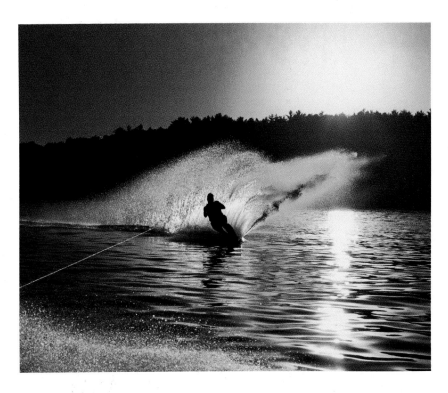

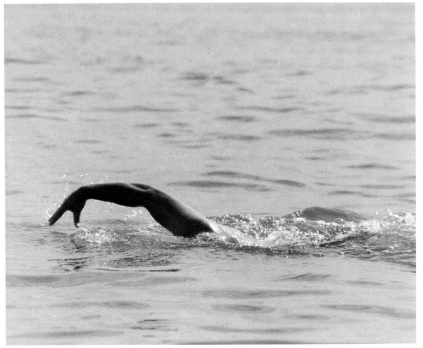

Fun in the Sun OPPOSITE TOP: People making soap bubbles, silhouetted by a sunset.
MERIT AWARD CYNTHIA C. LOYST
North Bay, Ontario CANADA *The Nugget* KODAK GOLD 100 Film

Fishing OPPOSITE: The right combination of motion and moment catches the essence of net fishing.
MERIT AWARD FERNANDO JARAMILLO
Guadalajara MEXICO *El Occidental* KODAK GOLD 100 Film

Slalom at Sunset ABOVE: Labor Day with friends—it took three pictures to get the perfect shot.
MERIT AWARD ERIC A. ZERFAS
West Bend WI USA *The Daily News* KODAK GOLD 100 Film

The Crawl BELOW: An eye-arresting photo of a swimmer's arm.
MERIT AWARD GILBERTO MORENO ROMERO
Hermosillo MEXICO *El Imparcial* KODAK GOLD 100 Film

When the Toad Came Home Portrait with goggles and
scarf, going fast.
MERIT AWARD Jann Laiti
Fairbanks AK USA *Daily News-Miner* KODAK GOLD 200 Film

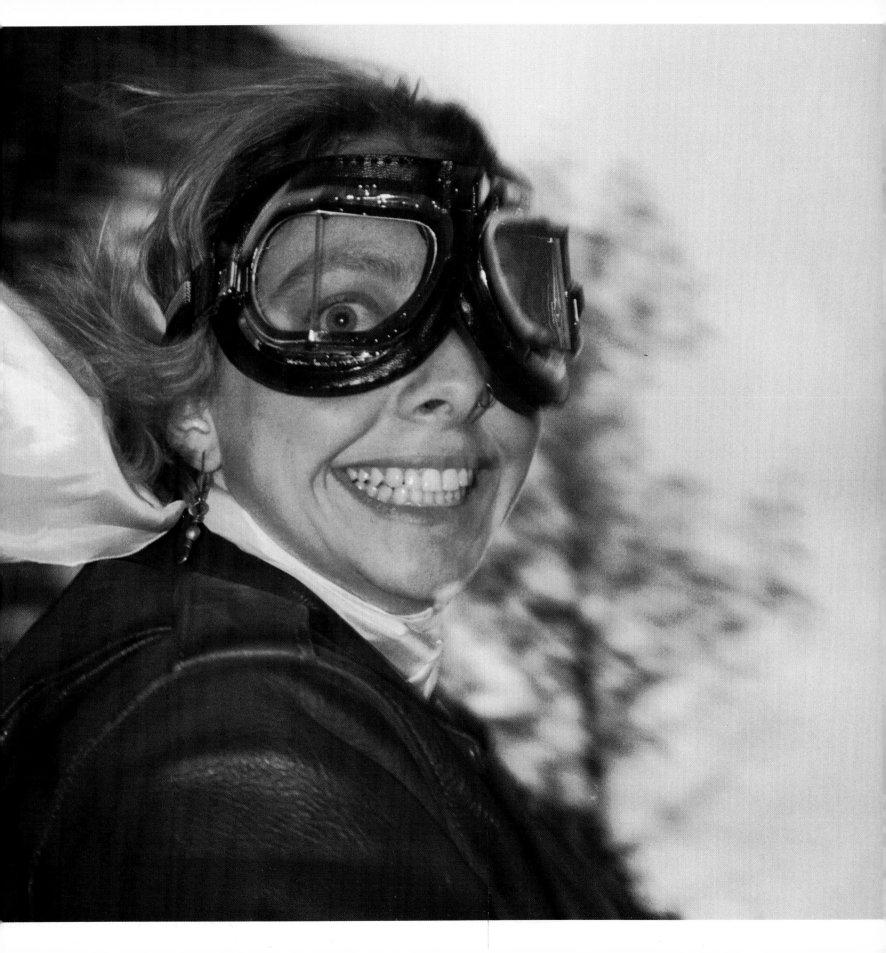

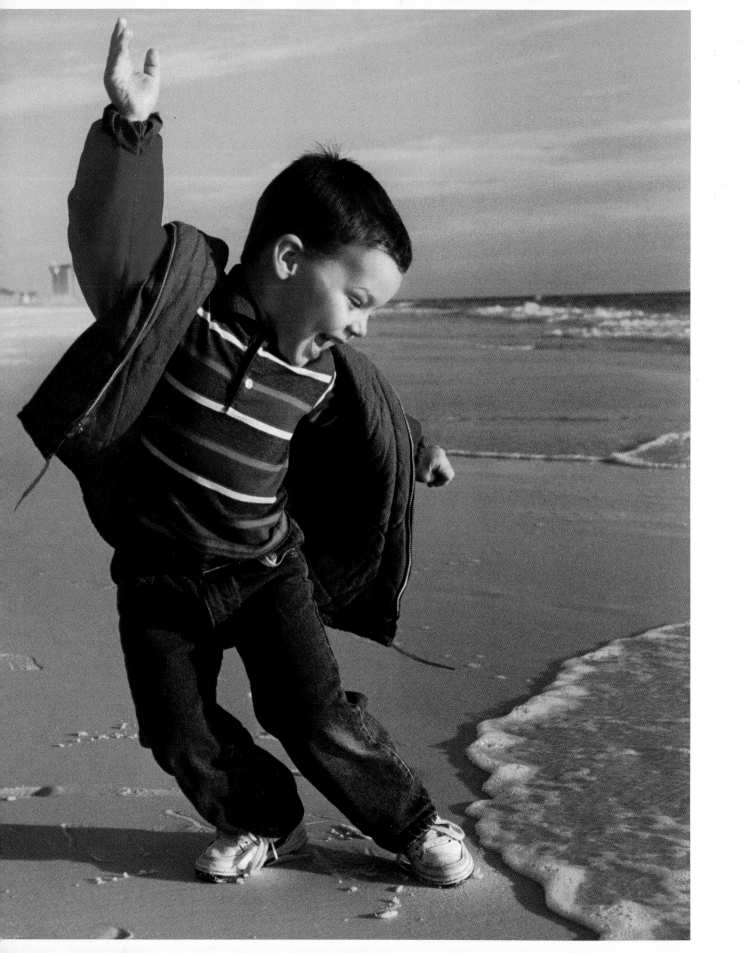

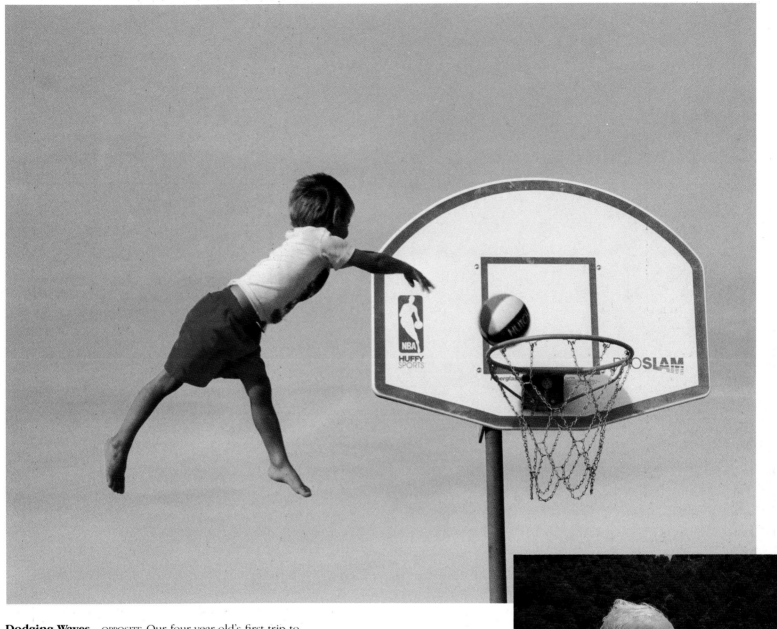

Dodging Waves OPPOSITE: Our four-year-old's first trip to the beach—having fun chasing waves but not getting wet.
MERIT AWARD VICKIE G. SELDENRIGHT
Panama City FL USA *The News Herald* KODAK GOLD 400 Film

Air Baby ABOVE: My two-and-a-half-year-old shooting baskets while airborn.
MERIT AWARD LINDA S. HOOVER
Helendale CA USA *The Daily Press* KODAK GOLD 100 Film

Cool Dude RIGHT: Our 16-month-old baby at the wheel of a 58-foot houseboat.
MERIT AWARD DEBORA L. JUNGBLUTH
Waukesha WI USA *The County Freeman* KODAK GOLD 200 Film

HUNTINGTON CITY-TOWNSHIP
PUBLIC LIBRARY
200 West Market Street
Huntington, IN 46750

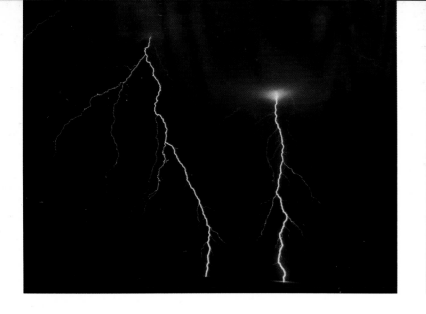

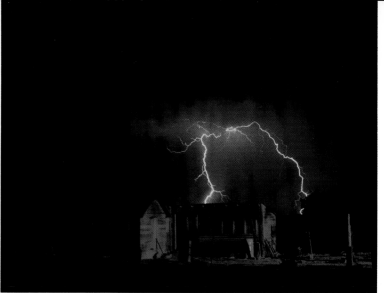

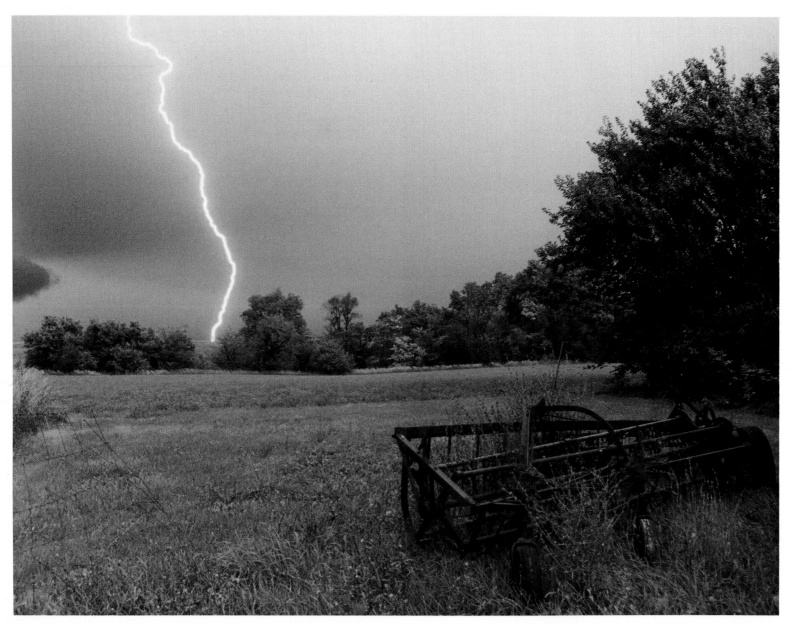

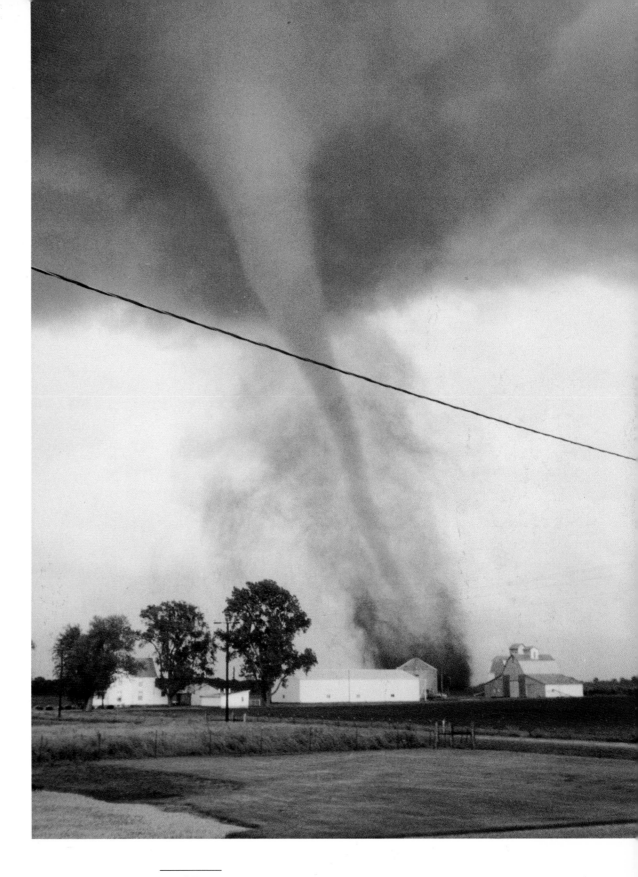

A Night of Fury OPPOSITE, TOP LEFT: Lightning storm on a wheat field in Lewiston, Idaho.
MERIT AWARD ANGIE STAMPER
Lewiston ID USA
The Morning Tribune
KODAK GOLD 200

Storm's Eerie Light OPPOSITE, TOP RIGHT: Time exposure behind my aunt's chicken shed on a farm in Kirk, Colorado.
MERIT AWARD
STEPHEN MICHAEL SCHNEIDER
Springfield OR USA
The Register-Guard
KODAK GOLD 200 Film

Storm Across the Prairie
OPPOSITE, BOTTOM: A bolt of lightning over our field on a stormy afternoon.
MERIT AWARD MARIANNE KEENE
El Paso IL USA *The Pantagraph*
KODAK GOLD 400 Film

Too Close for Comfort!
RIGHT: Tornado approaching my neighbor's house in Findlay, Illinois.
MERIT AWARD RON RAGAN
Findlay IL USA *The Herald & Review*
KODAK GOLD 400 Film

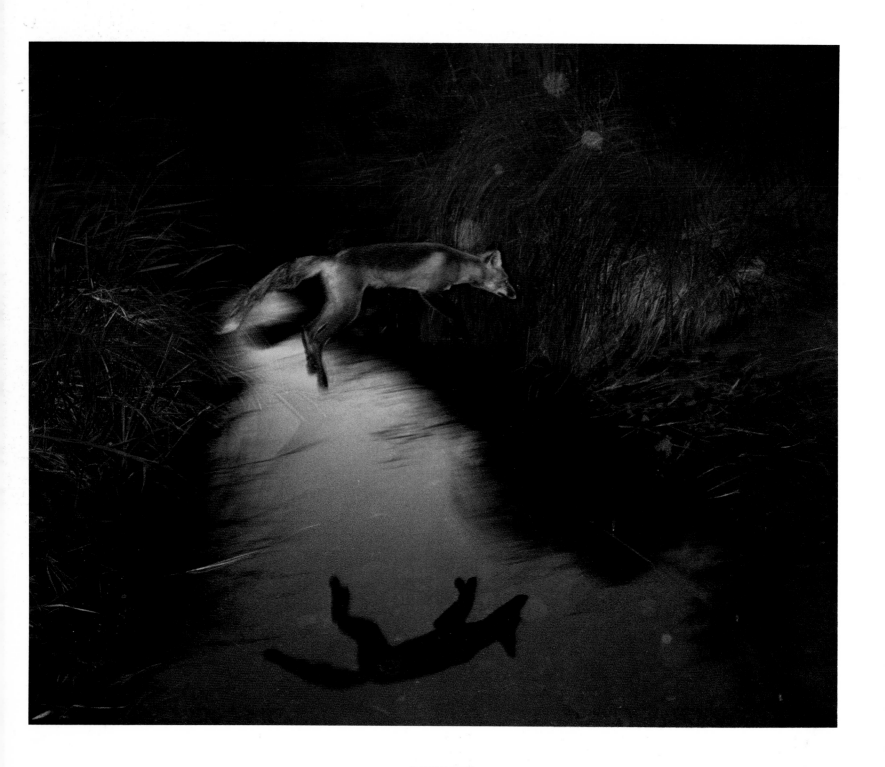

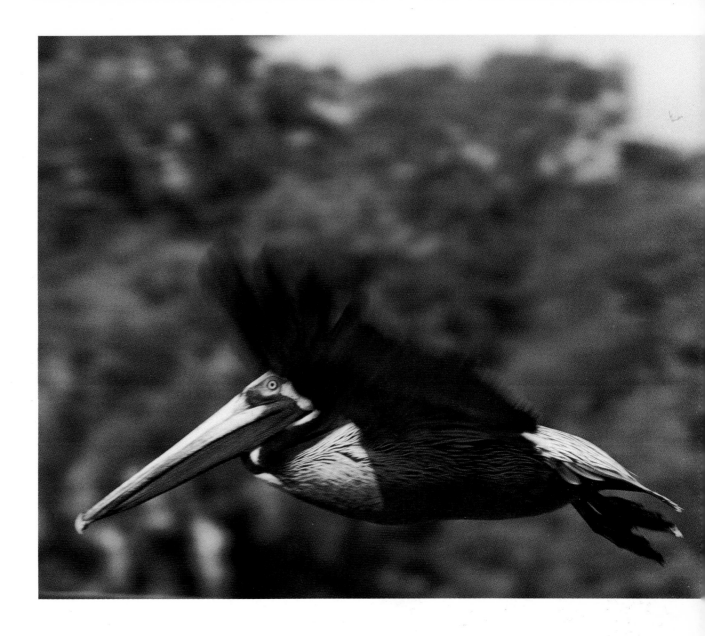

Reflecting on Nature OPPOSITE: Fox gracefully leaping over creek at Daisy Farm, in Isle Royale National Park, Michigan.
HONOR AWARD LYNNE WICKSTROM
Laurium MI USA *The Daily Mining Gazette* KODAK GOLD 200 Film

She's Got Bette Davis Eyes ABOVE: Pelican in flight—taken from a boat in motion.
MERIT AWARD BETH MILLER COPPOCK
Campbellsville KY USA *The Journal* KODAK GOLD 100 Film

FAMILY AND FRIENDS
PEOPLE

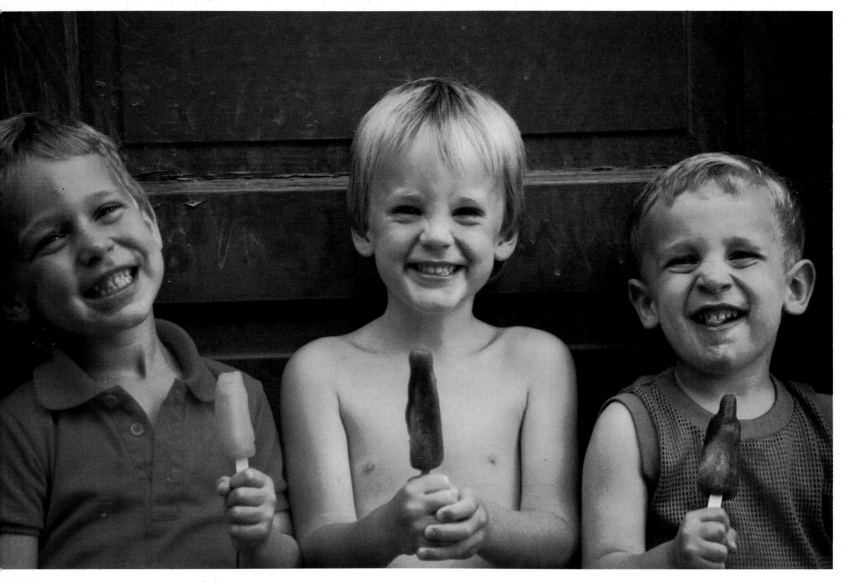

Lickin' Good ABOVE: Three boys sitting on a step at our summer home eating ice pops together.
MERIT AWARD LINDA HEIM
Delmar NY USA *The Times* KODAK GOLD 100 Film

Sweet Pea OPPOSITE: Three-year-old Kristen Sarah on vacation in Ocean City, New Jersey.
MERIT AWARD DANTE A. PARENTI
Vineland NJ USA *The Press* KODACOLOR VR-G 200 Film

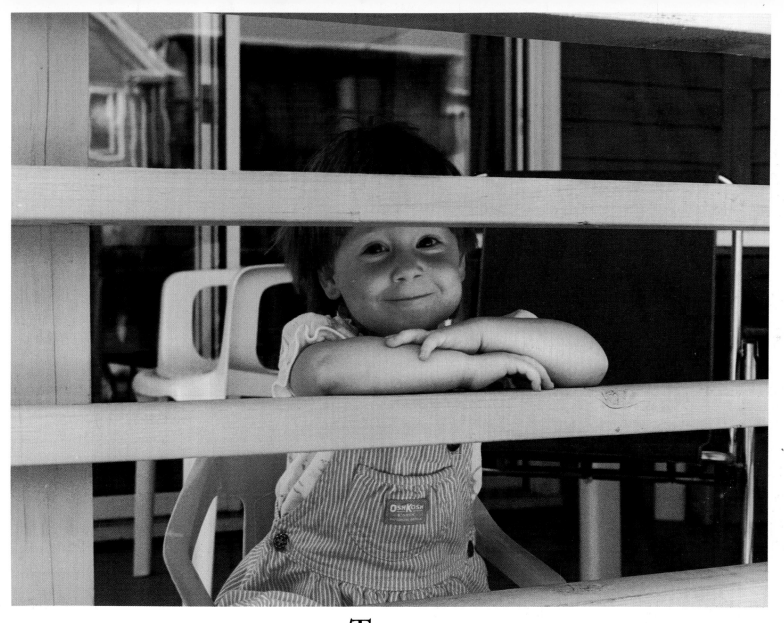

Taking good photographs of people requires a combination of luck, skill, and dedication. People's gestures, movements, and looks are momentary—and when gone, are gone forever. Without quick reflexes and an excellent sense of timing, the opportunity for memorable photographs could be over before the shutter snaps. The photographs that follow were selected because they capture people in unique and special moments and because each one tells a story.

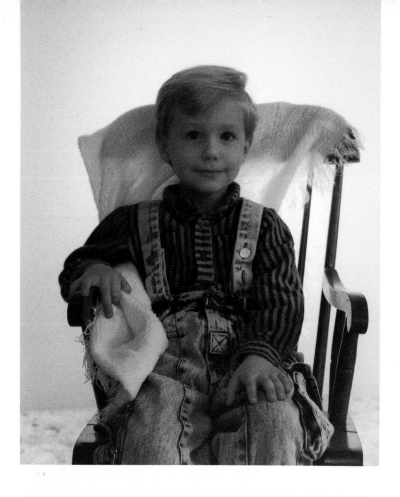

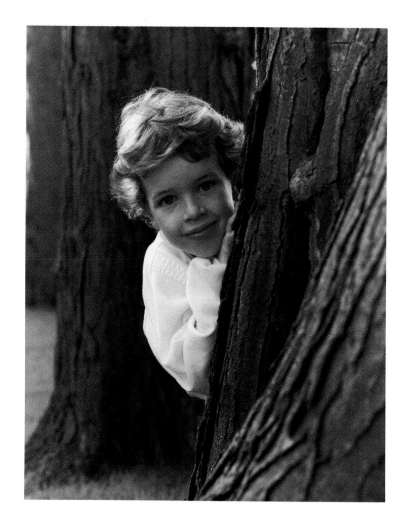

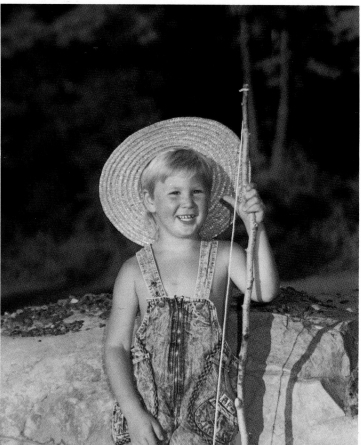

Devin! TOP LEFT: My son in a wooden rocking chair.
MERIT AWARD CINDY L. STAMPER
Lewiston ID USA *The Morning Tribune* KODAK GOLD 100 Film

A Peek from Justin ABOVE: My son, Justin, peeking around
a "double-locust tree" at our home.
MERIT AWARD CONSTANCE M. TRUGISCH
Belleville, Ontario CANADA *The Intelligencer* KODAK GOLD 100 Film

The Fisherman BOTTOM LEFT: Chad Heffner ready to fish at
Reynlow Park, Pennsylvania.
MERIT AWARD STEPHANIE L. HEFFNER
Reynoldsville PA USA *The Courier-Express* KODAK GOLD 100 Film

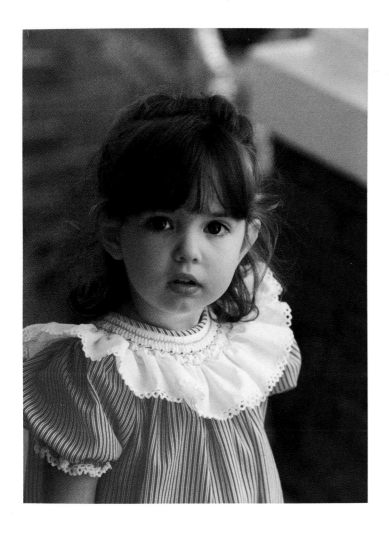

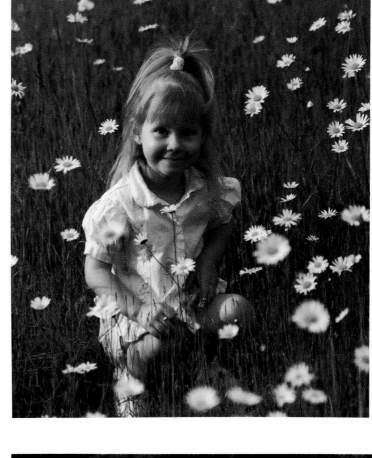

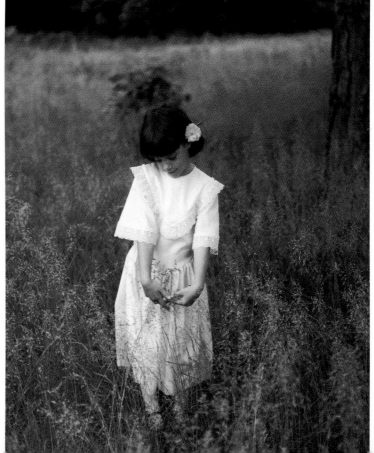

Captured Innocence ABOVE: A two-year-old on my front porch swing.
MERIT AWARD VICTORIA M. BOLLING
Auburn AL USA *The News* KODAK GOLD 100 Film

Loves Me, Loves Me Not TOP RIGHT: A girl in a field of daisies.
MERIT AWARD SHANE POWER
Port Alberni, British Columbia CANADA *The Valley Times*
KODAK GOLD 100 Film

Woodland Ballerina BOTTOM RIGHT: A little girl standing in an overgrown field, almost dancing.
MERIT AWARD SARA MALINE ADAMS
Far Rockaway NY USA *The Daily Record*
KODAK VERICOLOR III Professional Film

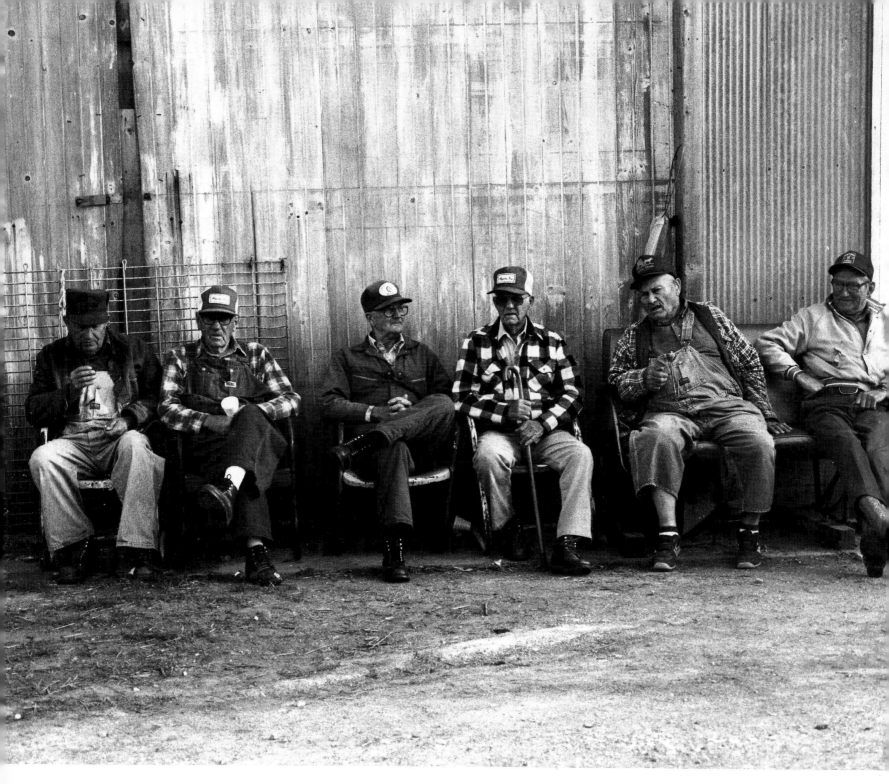

Watching the Crops Grow ABOVE: Farmers of the small town of Cropsey, Illinois, relax and talk during a weekly auction.
MERIT AWARD BRIAN E. VAUGHAN
Cropsey IL USA *The Pantagraph* KODAK T-MAX 400 Professional Film

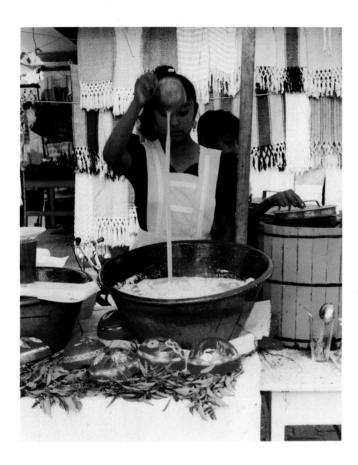

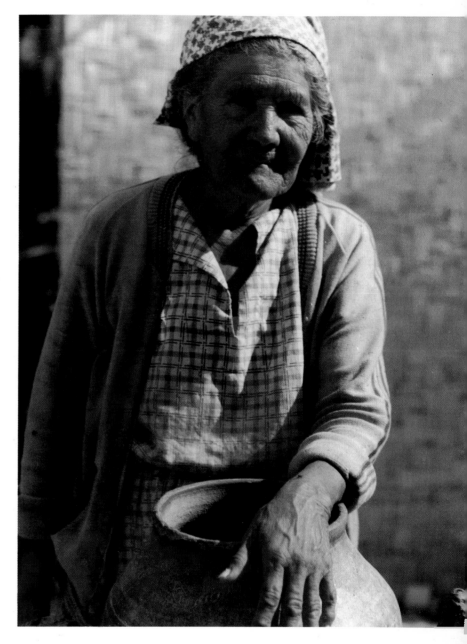

Mixing of Colors ABOVE: The simple act of a vendor
pouring batter invites and entices.
MERIT AWARD BEATRIZ E. LOPEZ MONTOYA
Oaxaca MEXICO *El Sol de Tampico* KODAK GOLD 100 Film

Maria in the Shadows RIGHT: The glowing light of an arbor
highlights every detail of Maria Sombra's face.
HONOR AWARD ARTURO VILLASENOR ATWOOD
Los Mochis MEXICO *Noroeste de los Mochis* KODAK GOLD 100 Film

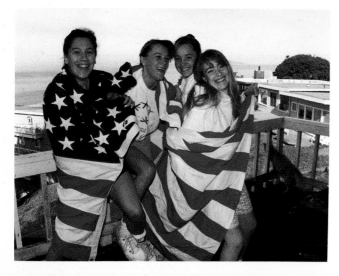

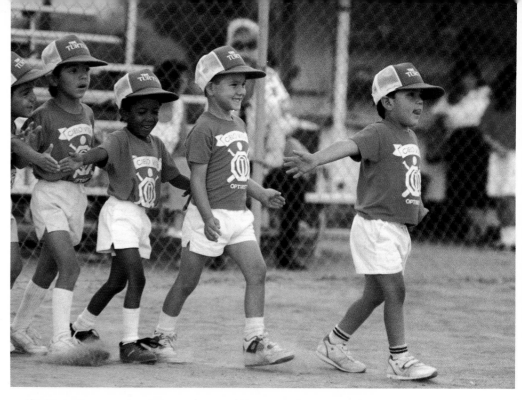

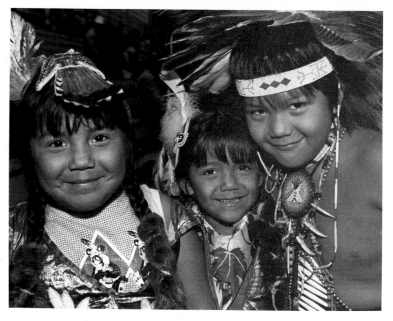

All-American Girls TOP LEFT: Teenagers wrap themselves in the American flag.
MERIT AWARD ALAN CYPERT
Watsonville CA USA *The Register-Pajaronian*
KODAK GOLD 200 Film

T-Ball High-Five TOP RIGHT: Five boys heading for a victory salute at game's end.
MERIT AWARD ARMANDO MORALES
El Paso TX USA *The Herald-Post*
KODAK GOLD 100 Film

Smiles Without End BOTTOM LEFT: Happy moments in the mountains of Chihuahua.
MERIT AWARD DR. ROBERTO LARA DE LA FUENTE
Chihuahua MEXICO *El Heraldo* KODAK GOLD 100 Film

Children at Powwow BOTTOM RIGHT: Erika, Nadia, and Thomas Holycross, all Lummi tribe children, at a Blackfoot powwow.
MERIT AWARD KAY BRIDGES
Lacey WA USA *The Olympian* KODAK T-MAX 400 Professional Film

Brothers Sharing Different Perspectives OPPOSITE: Taken after these brothers experienced their first ski lesson.
HONOR AWARD JOHN COHN
Telluride CO USA *The Times Journal* KODAK GOLD 100 Film

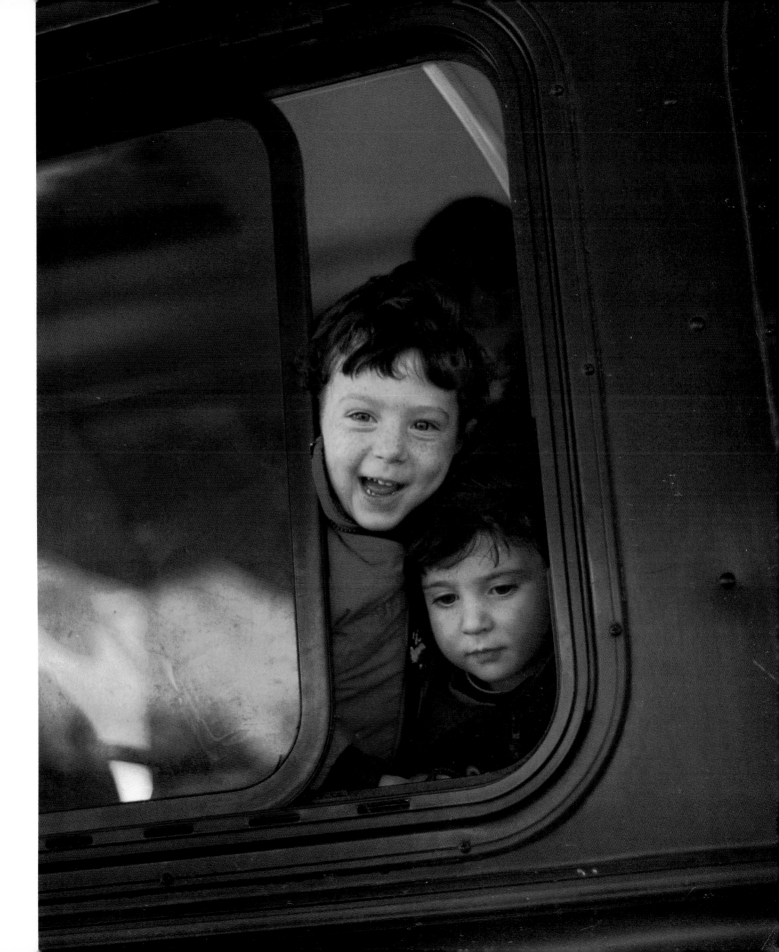

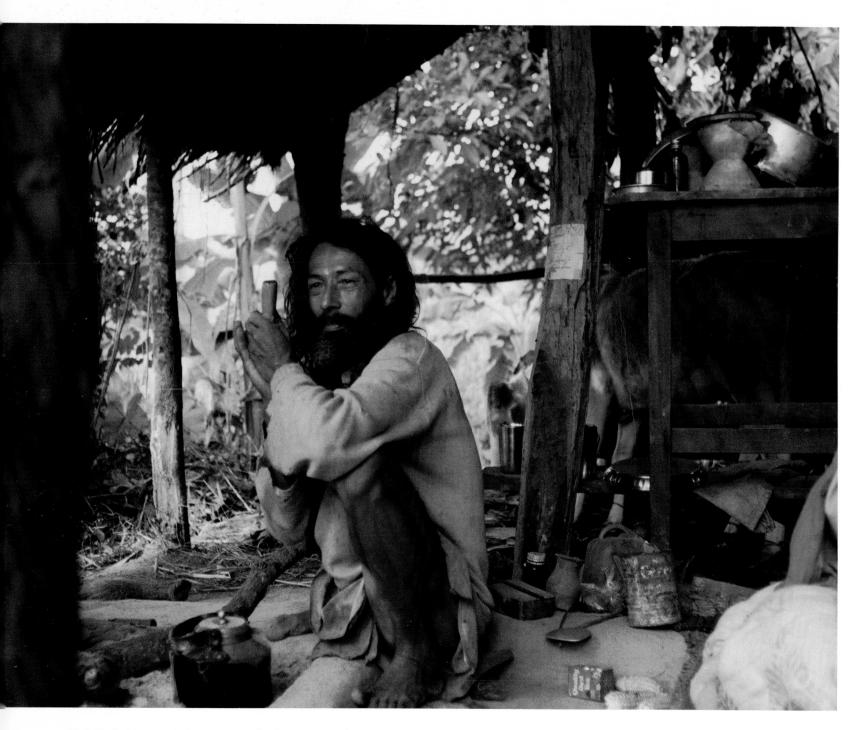

High Holy Man A holy man sits in his living area in the
mountains of Nepal.
MERIT AWARD BETSY E. YOUNG
Zanesville OH USA *The Times Recorder* KODAK GOLD 200 Film

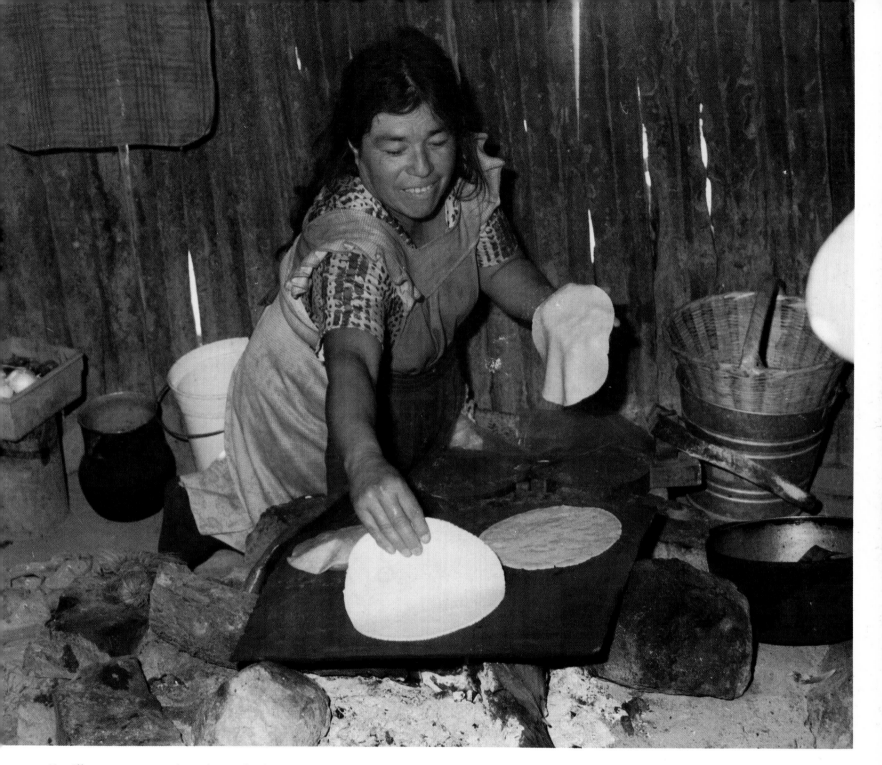

Tortillas A woman cooks at the ranch of San Luis Potosi in
Chihuahua, Mexico.
MERIT AWARD Sra. Norma Corral de Rocha
Chihuahua MEXICO *El Heraldo* KODACOLOR VR-G 100 Film

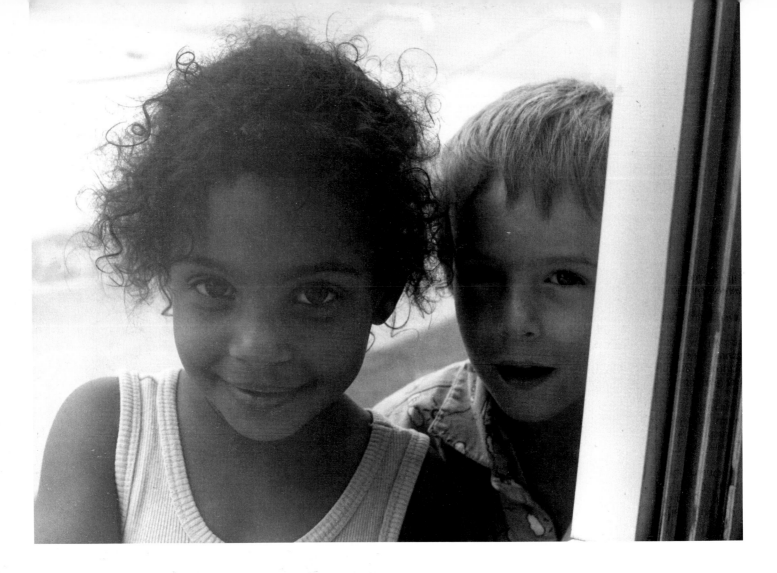

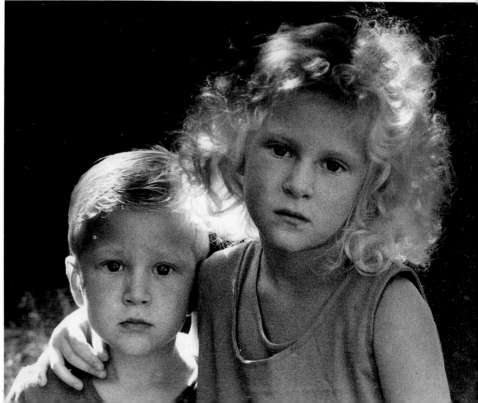

Wide-Eyed Onlookers OPPOSITE, TOP: Close-up of a girl and a boy framed in a window.
MERIT AWARD RENEE E. PAGE
Rome NY USA *The Daily Sentinel*
KODAK T-MAX 100 Professional Film

Friends Forever! OPPOSITE, BOTTOM: Tad and Kara rest in our living room after Easter lunch.
MERIT AWARD LEON F. TOMASIC
Fairbanks AK USA *Daily News-Miner* KODAK GOLD 200 Film

Two Friends at Morning Playground TOP: Friends play in the cab of a snow plow.
MERIT AWARD DEBORAH WARD LYONS
Burlington VT USA *The Free Press* KODAK GOLD 100 Film

Innocence BOTTOM: Small girl and boy, backlit, in natural sunlight.
MERIT AWARD KIMBERLY A. GEHLE-ROMBERGER
Bellvue NE USA *The World-Herald*
KODAK T-MAX 400 Professional Film

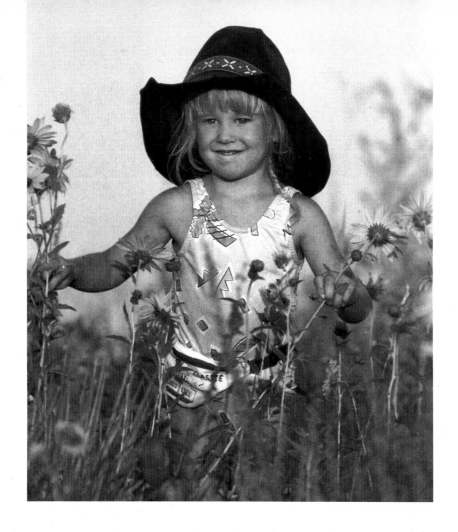

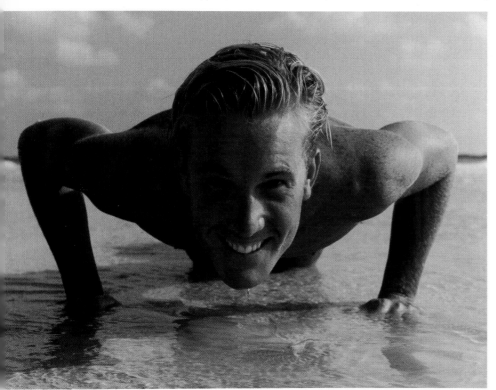

Summer Joy TOP: Cassie Mulloy walking down a sandhill full of flowers on her parents' ranch.
MERIT AWARD SIDNEY L. MILLER
Gering NE USA *The World-Herald*
KODAK T-MAX 400 Professional Film

Push-Ups in the Surf LEFT: An unusual, eye-level view from Seaside, Florida.
MERIT AWARD GEORGE M. SKAROULIS
Panama City FL USA *The News Herald* KODAK GOLD 200 Film

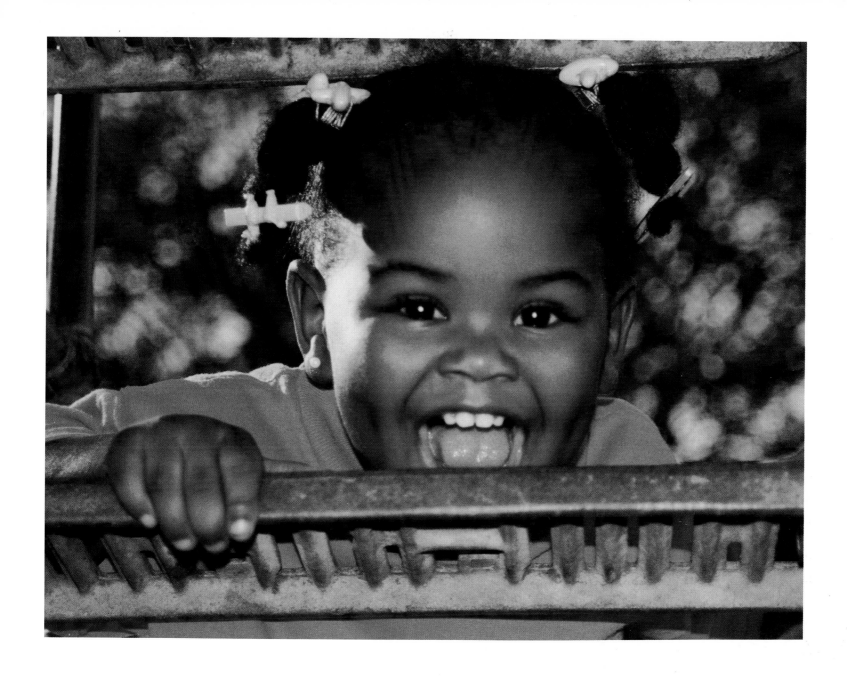

Morning Glory in Dreamland Park A two-year-old child
climbing the ladder of a park slide at a Martin Luther King
Day Celebration.
HONOR AWARD DIANE B. LIFTON
Port St. Lucie FL USA *The News* KODAK GOLD 200 Film

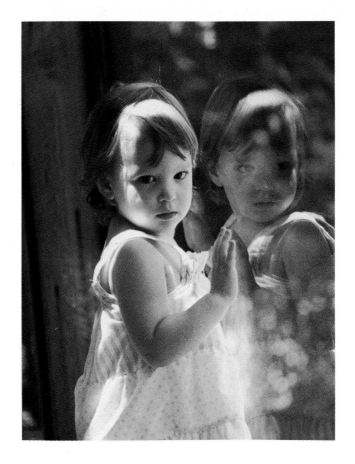

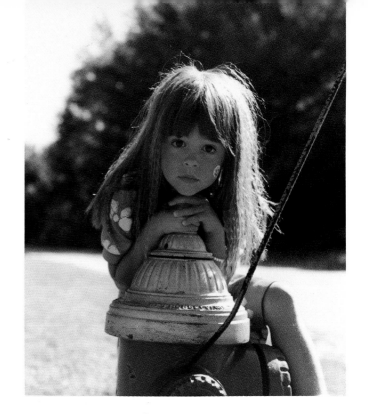

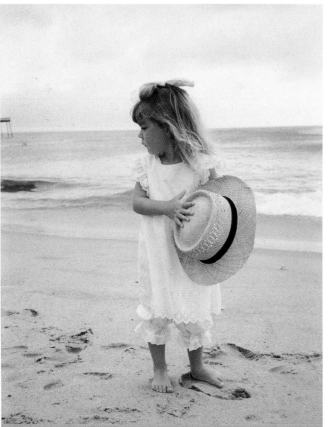

Little Girl by Window TOP LEFT: My granddaughter at a plate-glass window.
MERIT AWARD ETHEL L. GREER
Benton LA USA *The Times* KODAK GOLD 400 Film

First Day of School TOP RIGHT: Jessica's first day of kindergarten, waiting for her brother at the bus stop.
MERIT AWARD SHARMAN H. COHEN
Londonderry NH USA *The Eagle-Tribune* KODAK GOLD 200 Film

Sweet Sadie LEFT: A little girl with a big beach hat.
MERIT AWARD PAT WARTHEN
Newark OH USA *The Advocate* KODAK GOLD 100 Film

Awaiting Easter Mass OPPOSITE TOP: A child sitting in front of a church in Morelia, Mexico.
MERIT AWARD CARTER J. COREY
Fort Lauderdale FL USA *The Sun-Sentinel* KODACOLOR VR-G 400

Day for a Daydream! OPPOSITE BOTTOM LEFT: Little boy on a bike.
MERIT AWARD BUBBA PINO
Dartmouth, Nova Scotia CANADA *The Daily News* KODAK GOLD 100

Tender Tears OPPOSITE BOTTOM RIGHT: David Figueroa Sanchez suffers a disappointment.
HONOR AWARD FRANCISCO JAVIER SANCHEZ VALDEZ
Tampico MEXICO *El Sol de Tampico* KODAK GOLD 100 Film

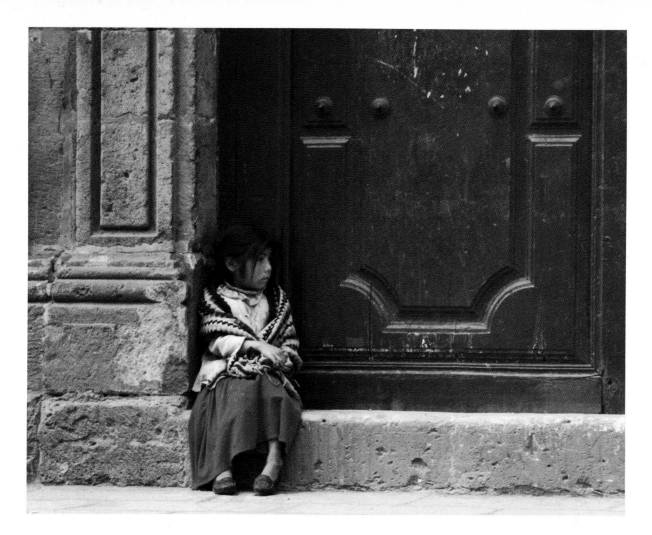

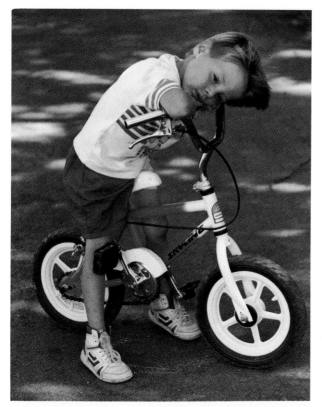

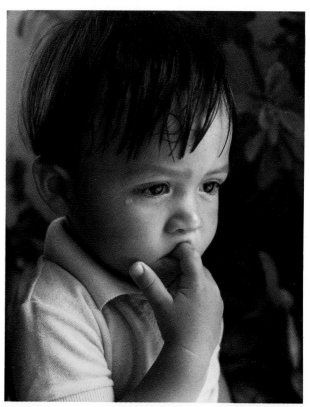

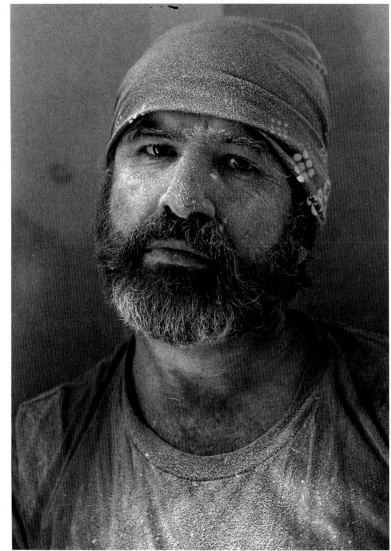

Drywaller ABOVE: My husband, Charlie, wearing a bandana and covered with dust at the end of the day.
HONOR AWARD RHONDA SCHWARZ
Baltimore MD USA *The Baltimore Sun* KODAK PLUS-X Film

Portrait of Lorrie LEFT: Taken with window light for my photo class at the community college.
MERIT AWARD MARY LOU ROUX
Rome NY USA *The Daily Sentinel*
KODAK T-MAX 100 Professional Film

Reflecting on her Twinkling Years OPPOSITE: An elderly woman, taken in Ojo Caliente, NM.
MERIT AWARD B. RICHARD TEMPLETON
Traverse City MI USA *The Record Eagle* KODAK TRI-X Pan Film

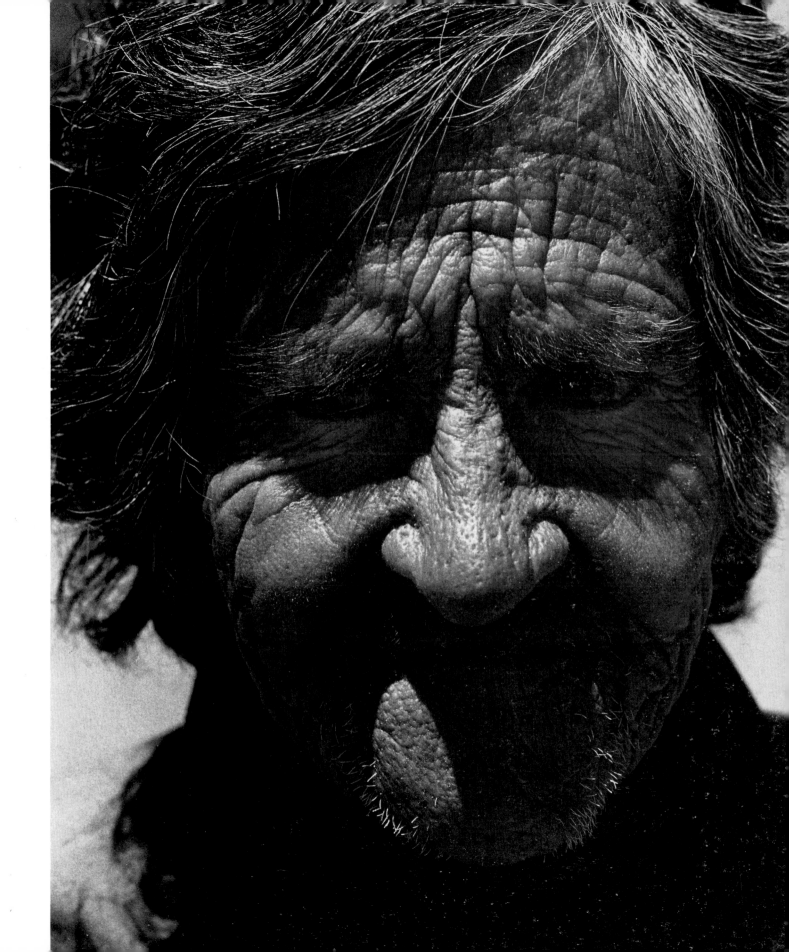

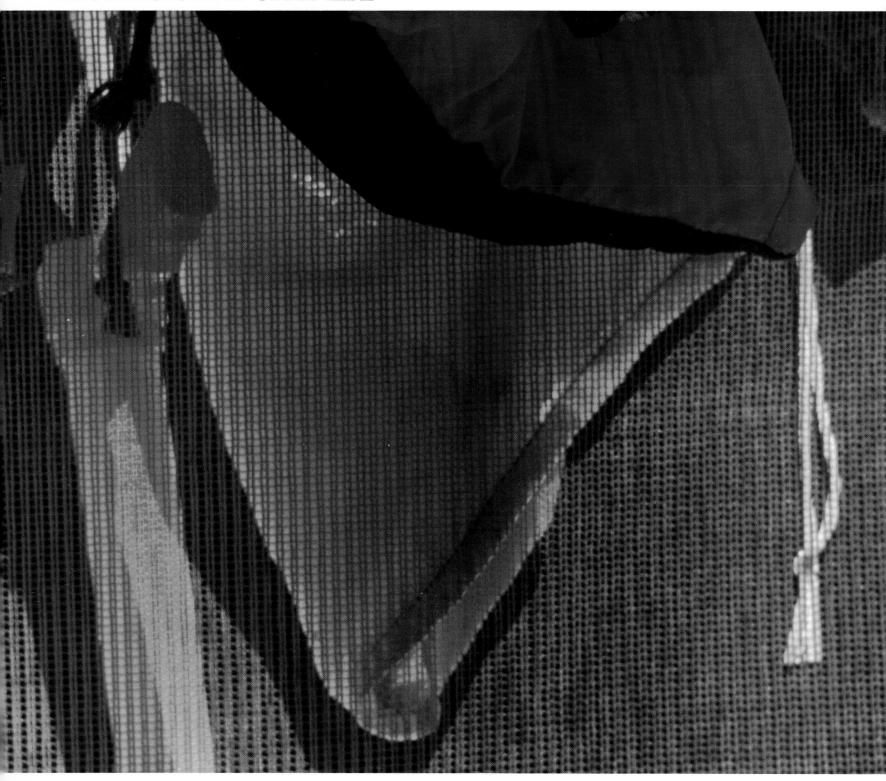

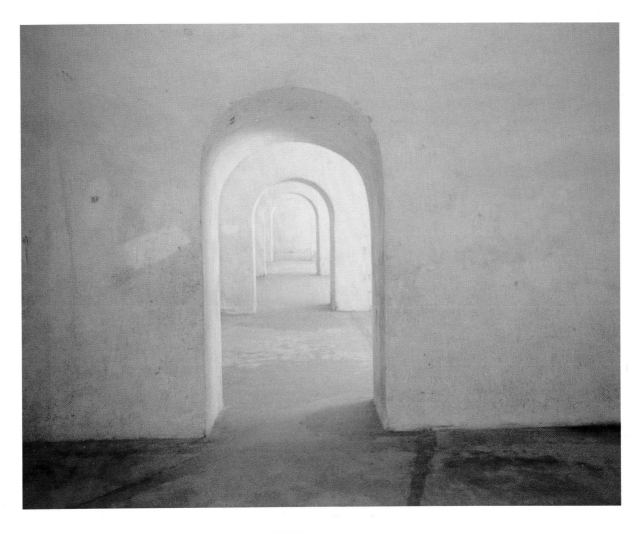

El Morro—Passages ABOVE: San Felipe del Morro Fort, Puerto Rico, dating from 1540.
HONOR AWARD KRISTIN L. THOMPSON
Nashua NH USA *The Union Leader*
KODAK GOLD 100 Film

Wet Bathing Suits Drying OPPOSITE: Bathing suits drying in the sun on a screen by my sister's pool.
HONOR AWARD DR. HOWARD LAWRENCE FREY
Mahwah NJ USA *The Times*
KODACHROME 64 Professional Film

Visual creativity is the central element in still photography as an art form. Photographers observe the form and composition of natural objects, or arrange them to create pleasing patterns of color, texture, light, and shadow. Abstract images are composed of geometric or graphic patterns, often obscuring the identity of the object being photographed. Still-life photographs, by contrast, show recognizable, inanimate subjects in a novel composition, whether found or created.

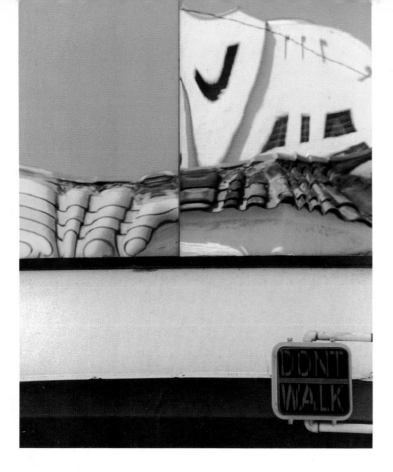

Don't Walk LEFT: Reflection on mirrored building at an intersection in Miami, Florida.
HONOR AWARD PATRICIA A. OREAL
Fort Lauderdale FL USA *The Sun-Sentinel* KODAK EKTAR 125 Film

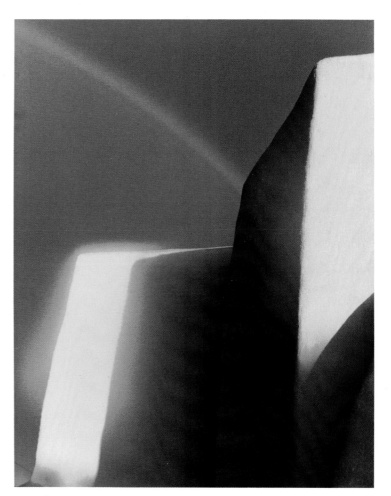

Sunset, Rainbow at Rancho De Taos RIGHT: An adobe church often painted by Georga O'Keefe, taken just before sunset with heavy mist in the air.
HONOR AWARD JOSEPH D. STRANO
Plantation FL USA *The Sun-Sentinel* KODAK GOLD 100 Film

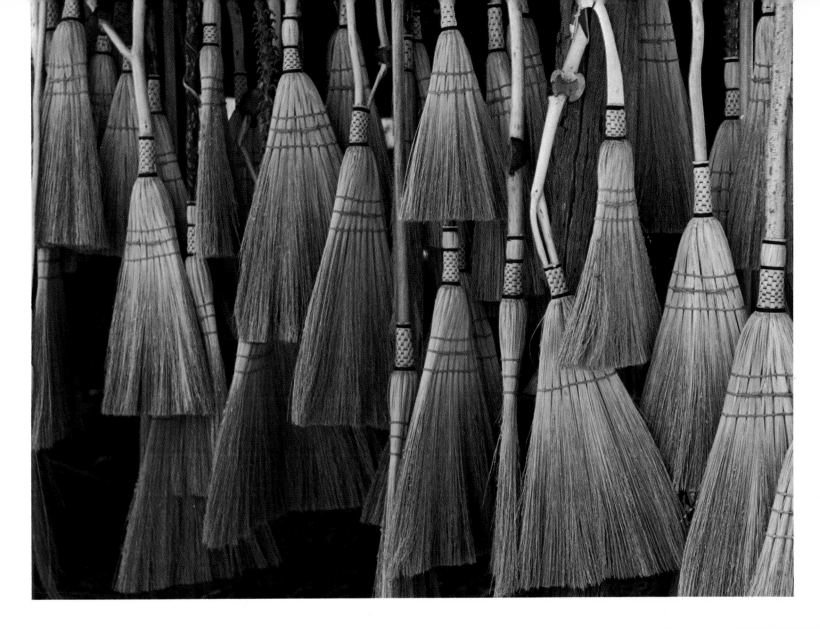

Geepers! Sweepers! ABOVE: Self-employed brooms make intriguing company.
MERIT AWARD GEORGE KLARMANN
Valrico FL USA *The Tribune* KODAK GOLD 100 Film

Flight of the Hawk RIGHT: A chance moment becomes a surreal memory.
HONOR AWARD JORGE GARCIA CAMACHO
Neza MEXICO *El Universal* KODAK GOLD 100 Film

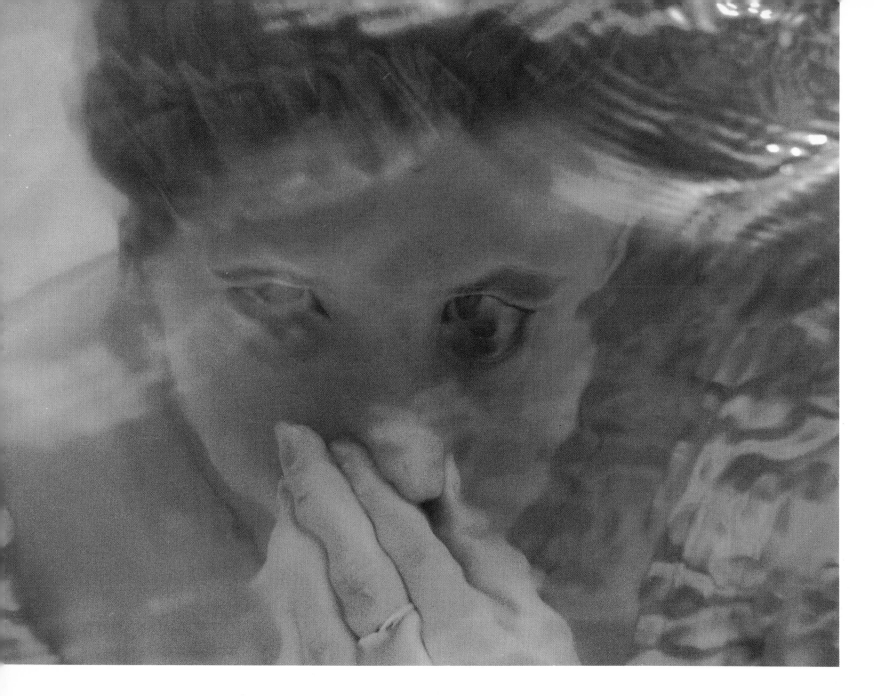

Underwater Images ABOVE: On Easter Sunday I was standing on the edge of the pool, photographing my daughter as she swam towards me.
MERIT AWARD ROBYN JACOBS
Boise ID USA *The Idaho Statesman* KODAK GOLD 100 Film

Starfish in the Wind OPPOSITE, TOP: A tide pool filled with colorful starfish. Wind whipping across the water lends an impressionist touch.
MERIT AWARD JACQUELINE GREENE
Wellesley MA USA *The Boston Globe* KODAK GOLD 100 Film

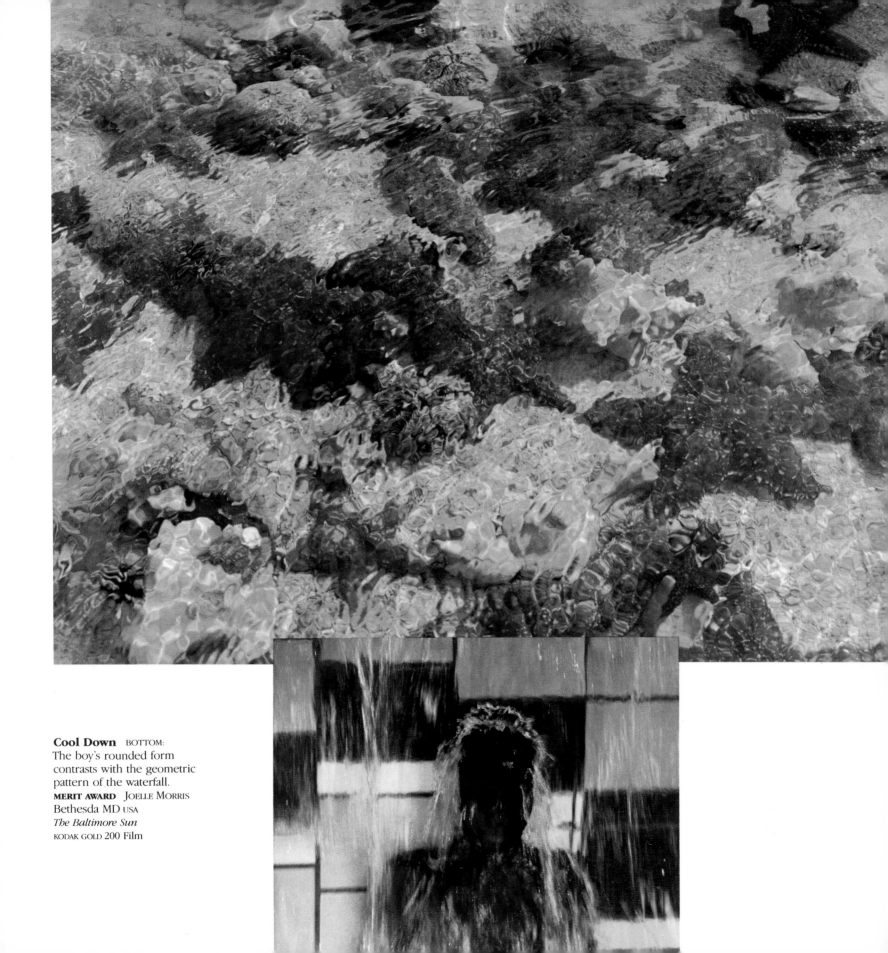

Cool Down BOTTOM:
The boy's rounded form
contrasts with the geometric
pattern of the waterfall.
MERIT AWARD JOELLE MORRIS
Bethesda MD USA
The Baltimore Sun
KODAK GOLD 200 Film

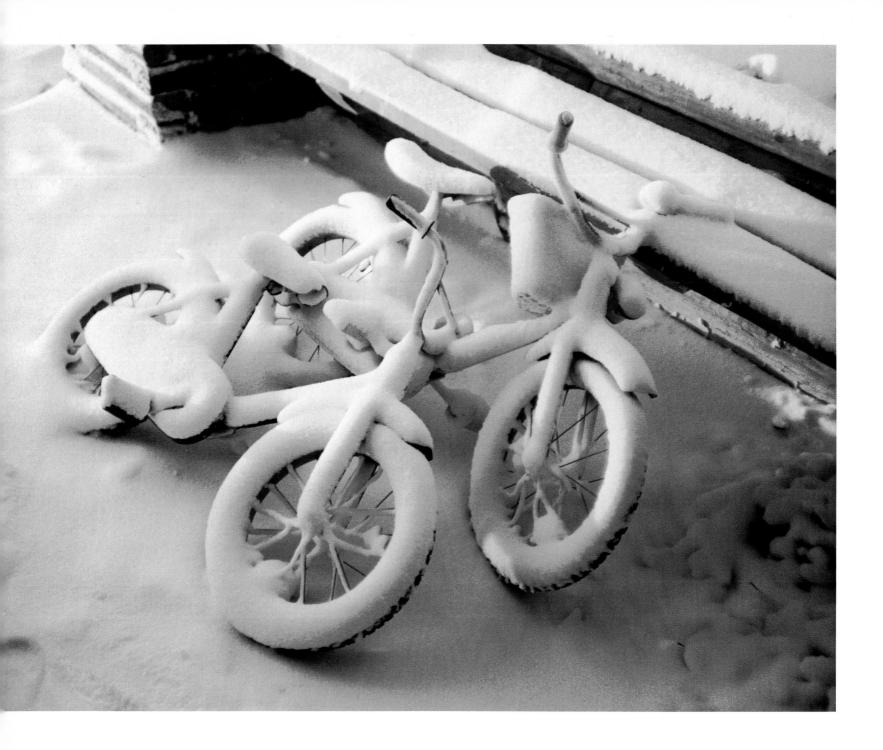

Snow Bikes Two children's bikes covered with
snow at my home in Michigan capture the essence of
summer's passing.
MERIT AWARD Tamara J. Tower-Hebert
White Pigeon MI USA *The Journal* KODAK GOLD 200 Film

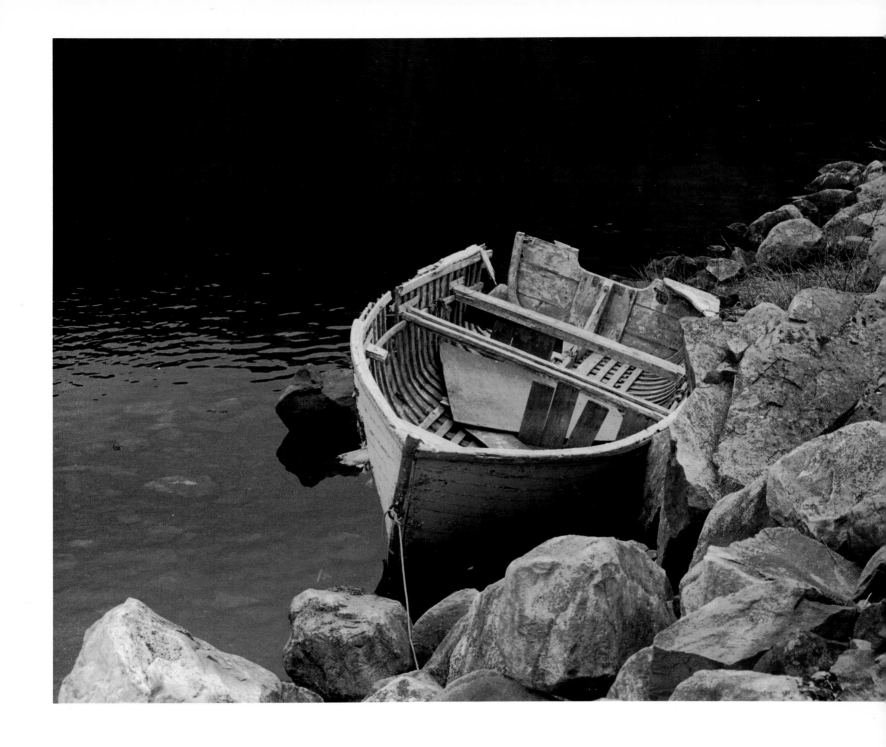

Dry Dock A broken boat abandoned on the rocks.
MERIT AWARD ROBIN V. KLARMANN
Valrico FL USA *The Tribune* KODAK GOLD 200 Film

Fourth of July LEFT: Flag, flowers, and house on Cape Cod, Massachusetts.
MERIT AWARD CONSTANCE FIEDLER
Stone Ridge NY USA *The Daily Freeman*
KODAK T-MAX 100 Professional Film

New Orleans: Censured BOTTOM LEFT: Storefront irony in New Orleans, Louisiana.
MERIT AWARD MELODY IZARD
Birmingham AL USA *The News* KODAK T-MAX 100 Professional Film

Remember Yesterday BELOW: Historical gasoline pump.
MERIT AWARD GREGG M. KARAL
Colchester, CT USA *The Press* KODAK TRI-X Pan Film

Shading Me with His Light OPPOSITE: Standing by the window, the light source makes my friend's skin look like stripes. I love the texture of her hair and the feathered hat.
MERIT AWARD PATRICIA P. EGAN
Newark OH USA *The Advocate* KODAK TRI-X Pan Film

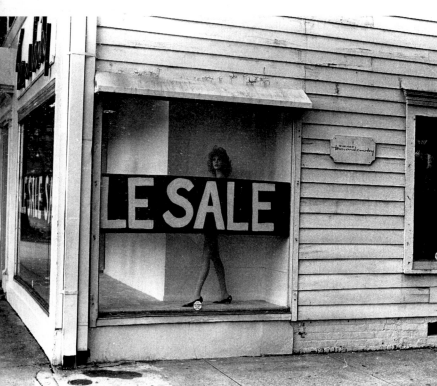

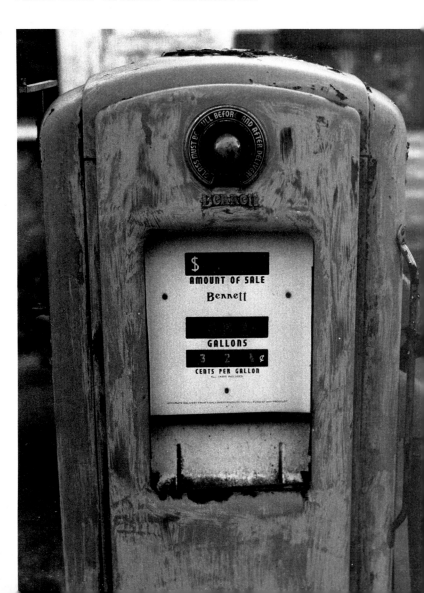

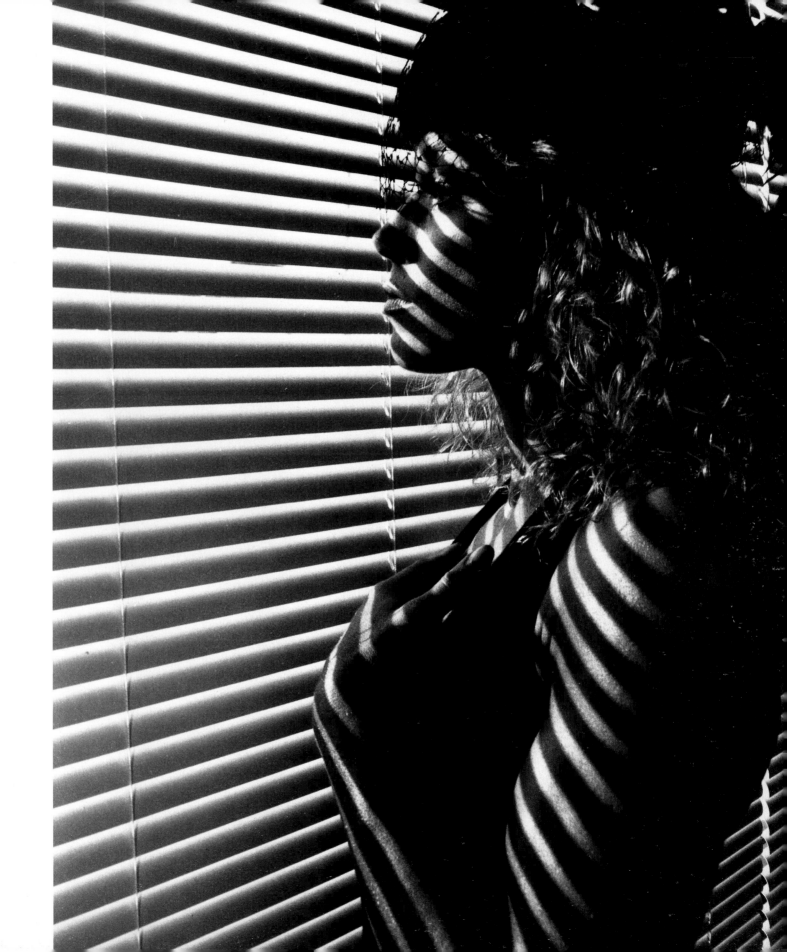

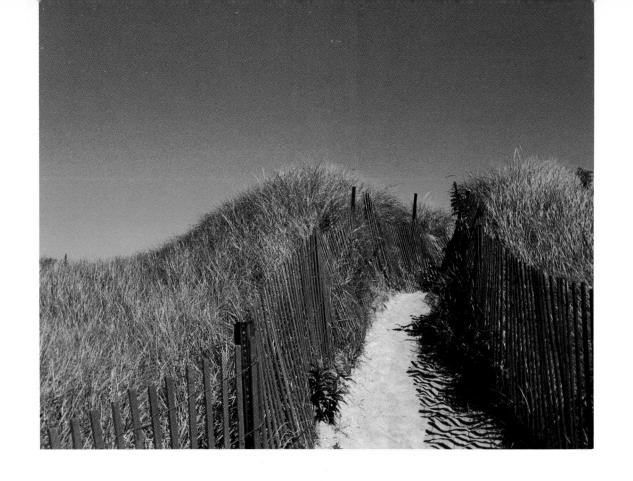

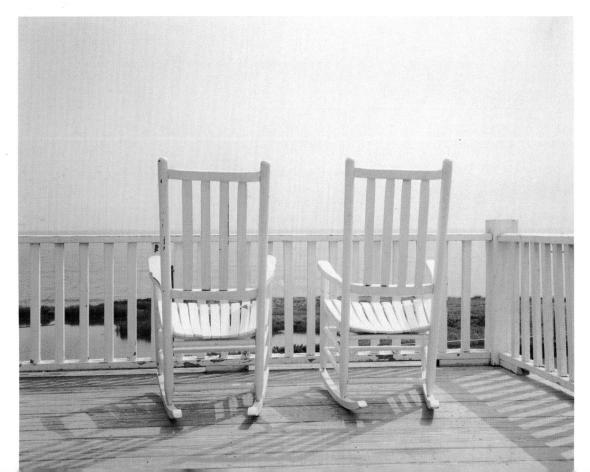

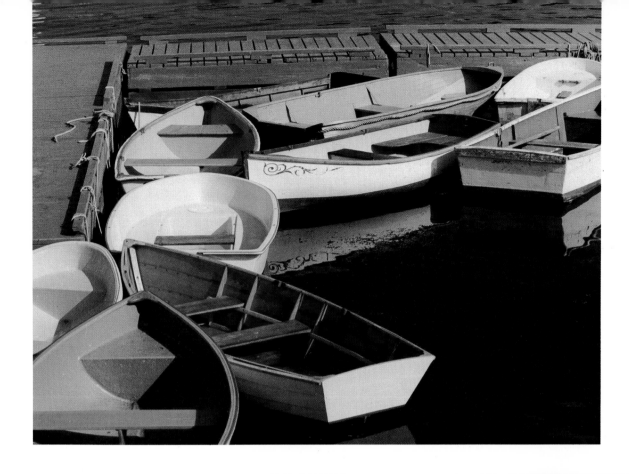

Beyond the Dunes OPPOSITE TOP: The dunes along a beach in Block Island, Rhode Island.
MERIT AWARD LORI KING
Panama City FL USA *The News Herald*
KODAK GOLD 100 Film

Chairs on the Porch OPPOSITE BOTTOM: Spring House in Block Island, Rhode Island. The chairs were already set up, waiting for my husband and me.
MERIT AWARD TRACEY LETITIA TULLIS
Bedford NH USA *The Union Leader*
KODAK GOLD 100 Film

One Oar ABOVE: Wooden rowboats docked together at Tenants Harbor, Maine.
MERIT AWARD KARIN NEWHOUSE
Stowe VT USA *The Free Press* KODAK GOLD 100 Film

Lighthouse Keeper's Pumpkin RIGHT: A pumpkin in sunlight and shadow on the steps of a white porch, Port Clyde, Maine.
MERIT AWARD CHERI JOHNSON
Richmond VA USA *The News Leader*
KODAK GOLD 200 Film

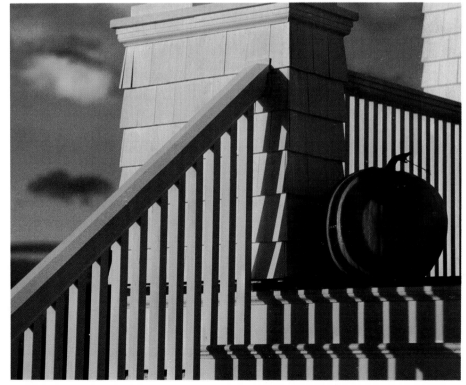

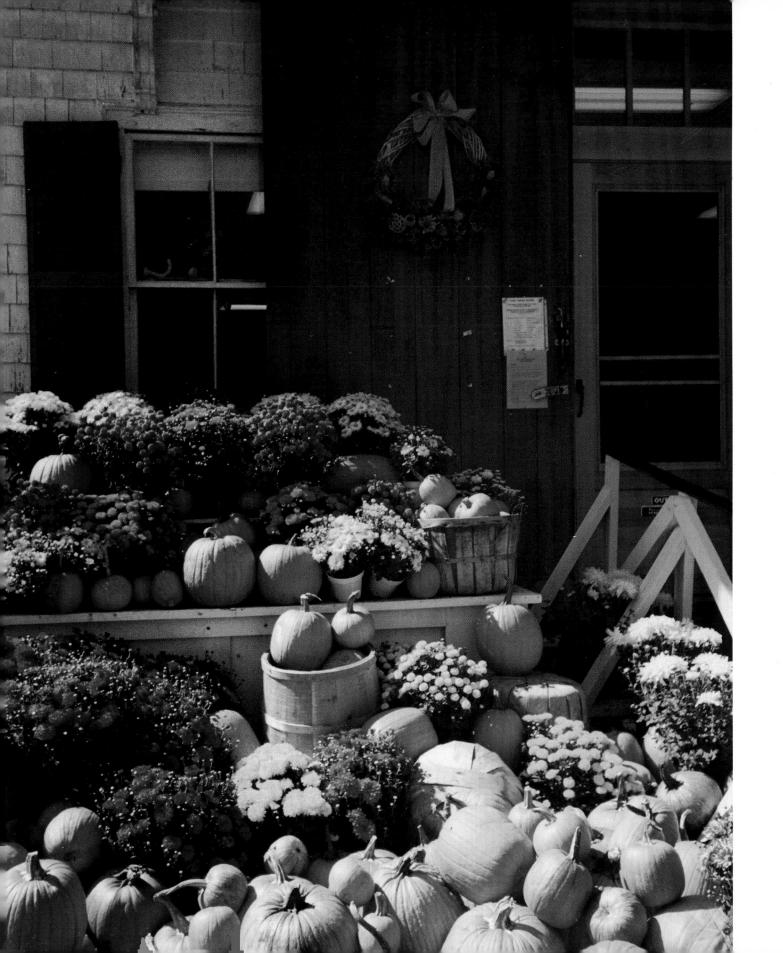

Harvest of Color OPPOSITE: Local farmstand with colorful pumpkins and mums.
MERIT AWARD JEAN A. McGOWAN
Beverly MA USA *The Evening News* KODAK GOLD 100 Film

Grand Granada TOP: Granada rose in our back yard.
MERIT AWARD CHARLES NICHOLAS FRENCH
Opelika AL USA *The News* KODAK GOLD 100 Film

The Shadows on the Wall BOTTOM LEFT: Two amaryllis plants that I keep on my kitchen table.
MERIT AWARD BARBARA FORD
Richmond VA *The News Leader* KODAK GOLD 200 Film

Set Table BOTTOM RIGHT: A single shaft of sunlight pierces the darkness of a nightclub in Leon, Mexico.
MERIT AWARD HUMBERTO ARIZPE TORRES GOMEZ
Palacio Durango MEXICO *La Opinion* KODAK GOLD 100 Film

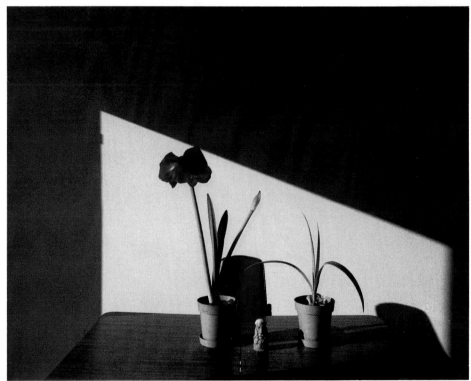

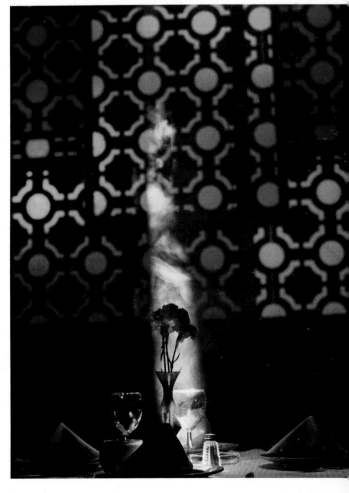

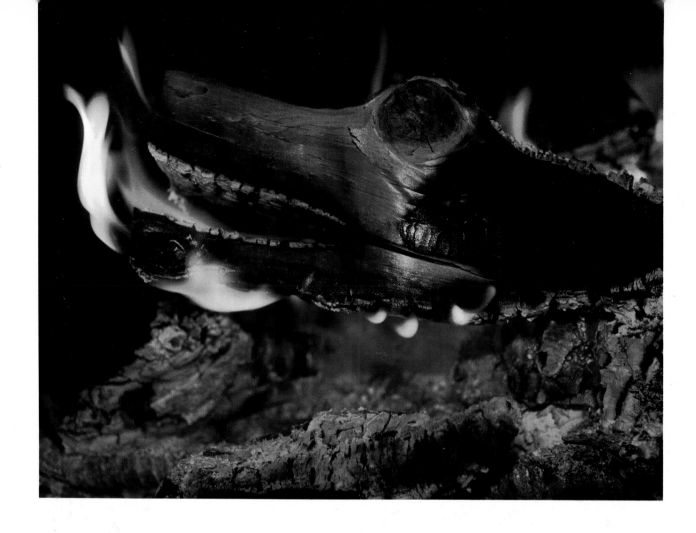

Out of the Flames ABOVE: A burning log in a fireplace
becomes a fire-breathing dragon.
MERIT AWARD James R. Sliziak
Langley, British Columbia CANADA *The Times*
KODAK GOLD 100 Film

Get Off My Rope! OPPOSITE: I noticed the tiny boat in front
of the large ships while taking pictures in the Port of Saint
John. The bow of the large ship looks like some kind of
monster peering down at the tiny boat.
MERIT AWARD Robert G. Reeves
Kennebecasis Park, New Brunswick CANADA
The Telegraph & Evening Times KODAK EKTAR 25 Professional Film

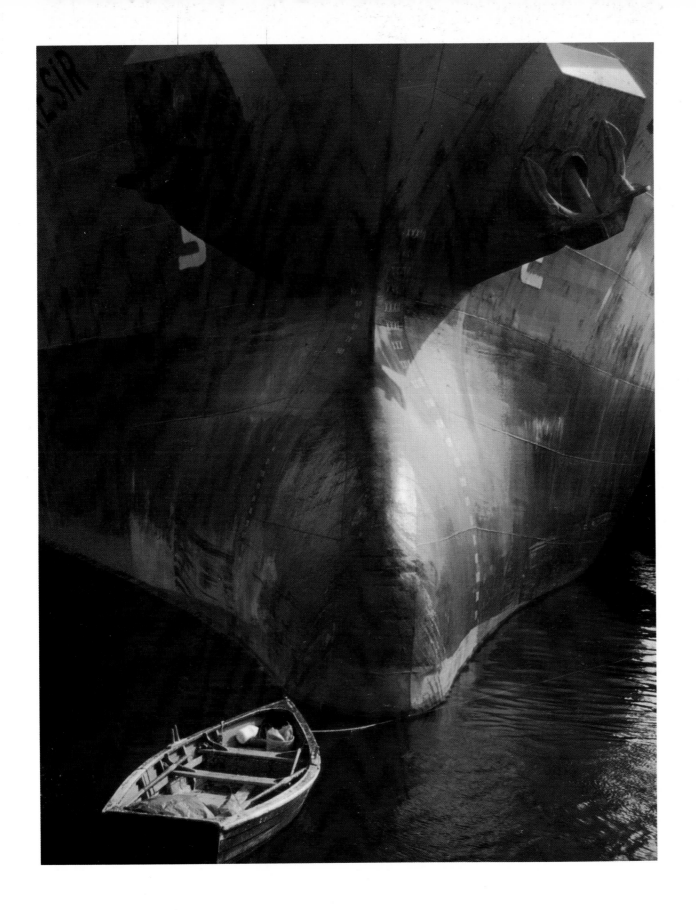

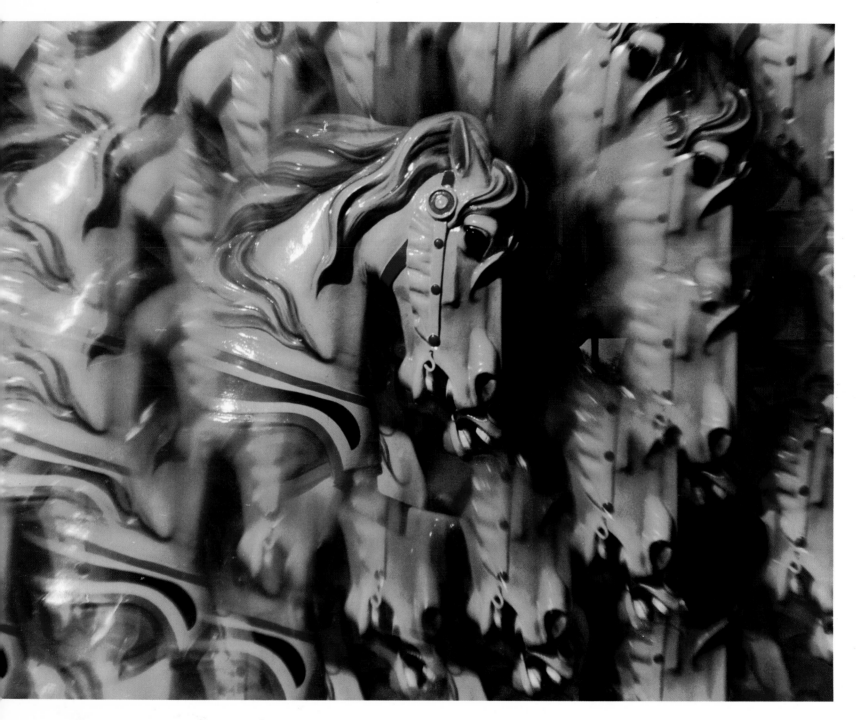

Horsing Around An image-multiplying filter makes a
striking pattern of carousel horses.
MERIT AWARD LINDA LaBONTE BRITT
Lowell MA USA *The Sun* KODAK VERICOLOR III Professional Film

Fast Paced City of Atlanta A zoom lens reveals the
hurried pace of a large city in this dramatic nighttime shot of
the Atlanta skyline.
MERIT AWARD JONATHAN WINTER
Dacula GA USA *The Daily News* KODAK EKTAR 125 Film

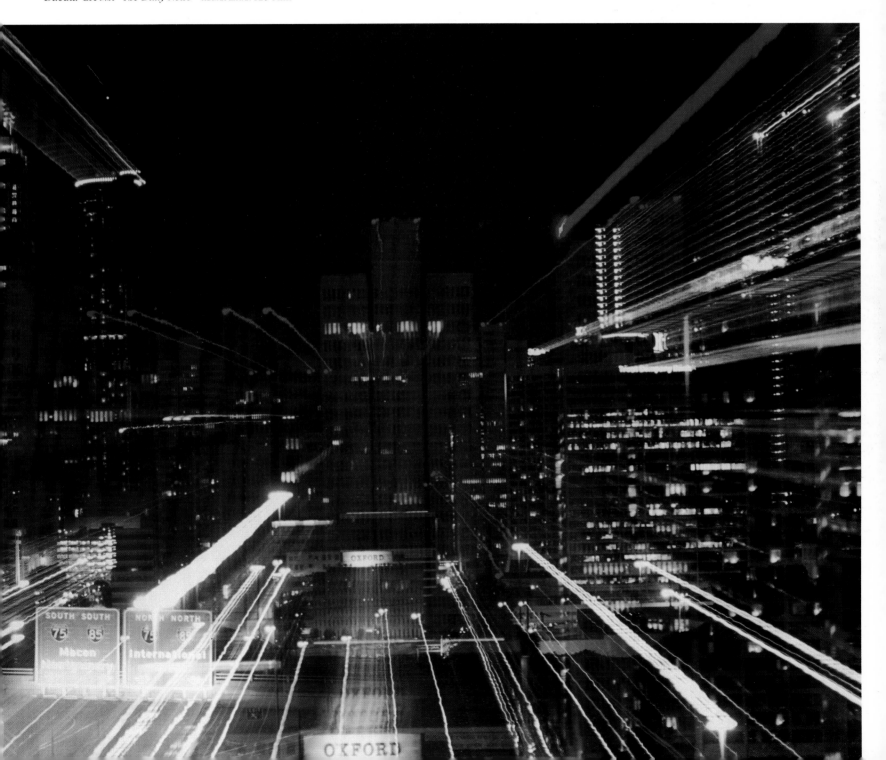

OUR CONSTANT COMPANIONS
ANIMALS

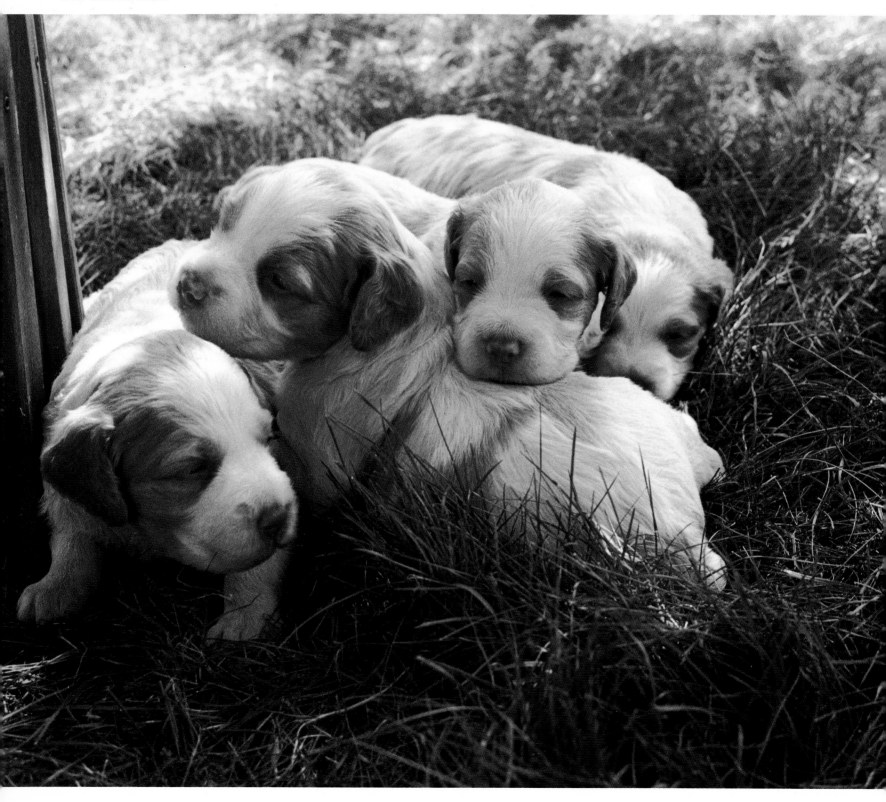

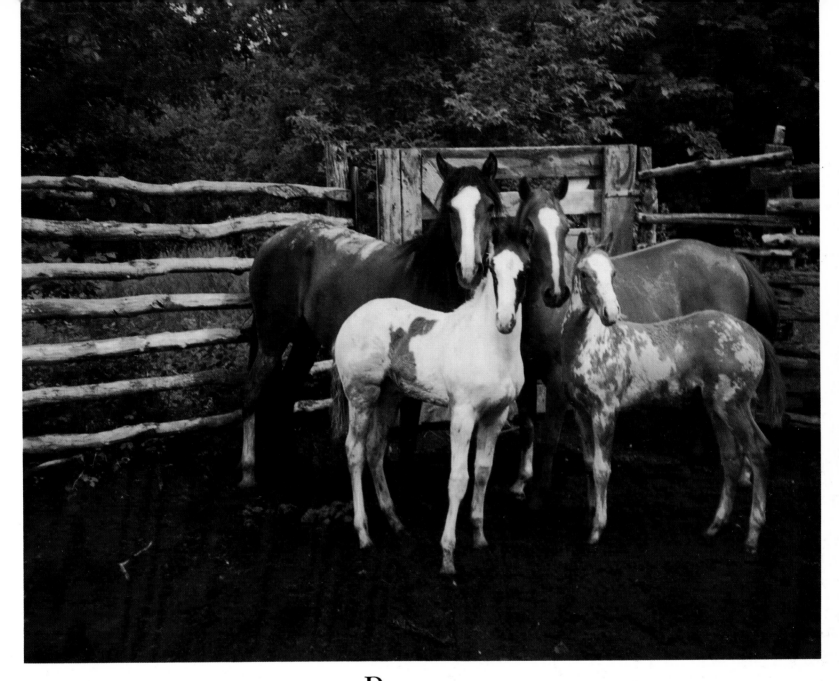

Spring Roundup ABOVE: Paint colts and mothers at a spring roundup, taken at my father's ranch in Interior, South Dakota.
MERIT AWARD RONALD E. HEATHERSHAW
Rapid City SD USA *The Tribune*
KODAK GOLD 100 Film

Let's Cuddle OPPOSITE: Two-week-old Brittany spaniel puppies bravely face the new world.
MERIT AWARD JUDY W. HEARING
Marietta OH USA *The Times* KODAK GOLD 200 Film

Pet and wildlife pictures present a challenge to the photographer. Location, lighting, and action are usually determined by the animal's habits rather than the photographer's wishes. Photographing wild animals is even more difficult in those instances where the photographer's task is complicated by unfamiliar locale, unpredictable behavior, or uncontrollable weather conditions. The photos of animals featured on the following pages acknowledge the invaluable role animals play in our lives.

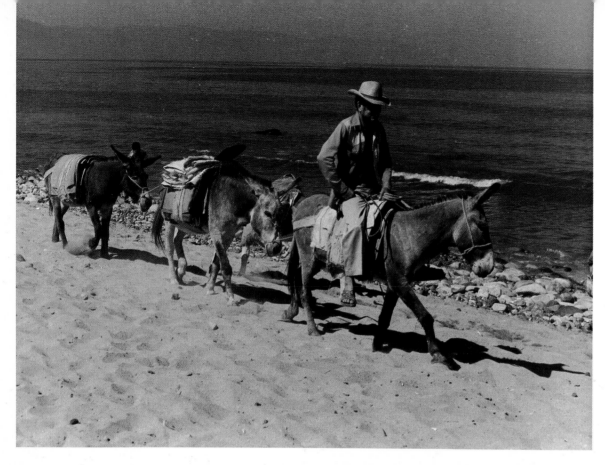

Burro Convoy LEFT: A man on the beach in Puerto Vallarta.
MERIT AWARD SRA. FELIX MARIO REOJAS
Aguayo Saltillo MEXICO *Vanguardia*
KODACOLOR VR-G 100 Film

Dreaming OPPOSITE: Sweet Jasmi Arvizo Gaytan in my house with her puppy.
MERIT AWARD JUVERA GAYTAN FIDEL
Hermosillo MEXICO *El Imparcial*
KODAK GOLD 400 Film

The Guard Cats RIGHT: Our baby sleeping with two cats in the morning sun.
MERIT AWARD LAURA L. WETTSTEIN
Wisconsin Rapids WI USA *The Daily Tribune*
KODAK GOLD 200 Film

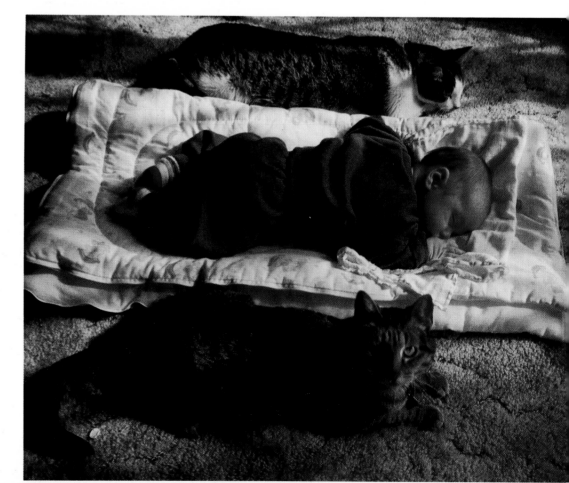

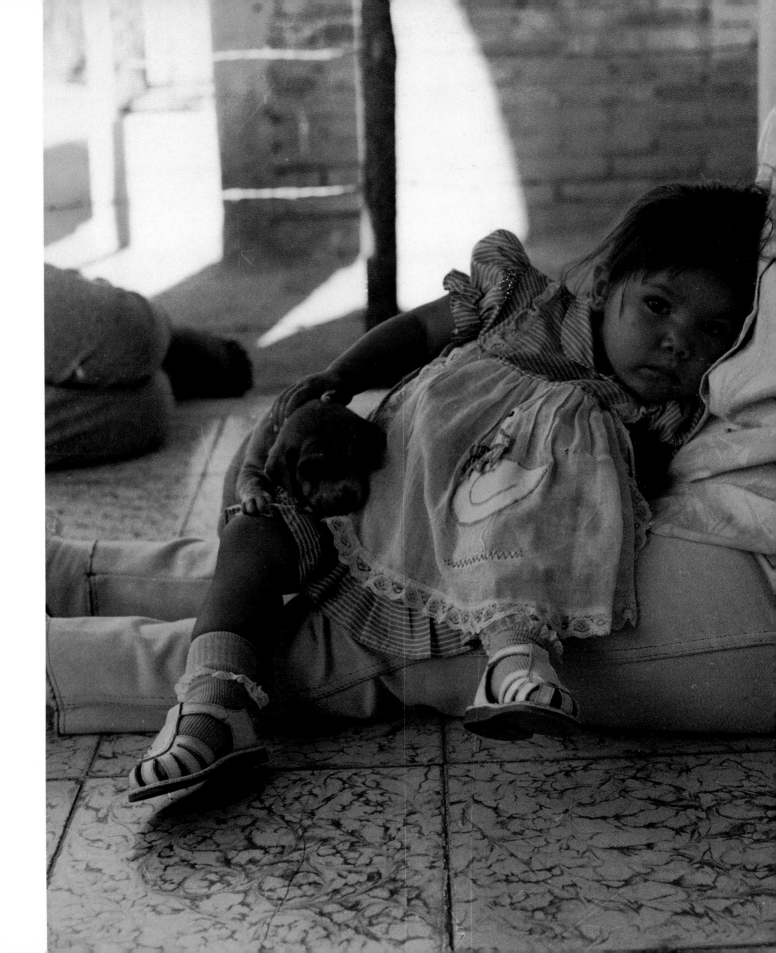

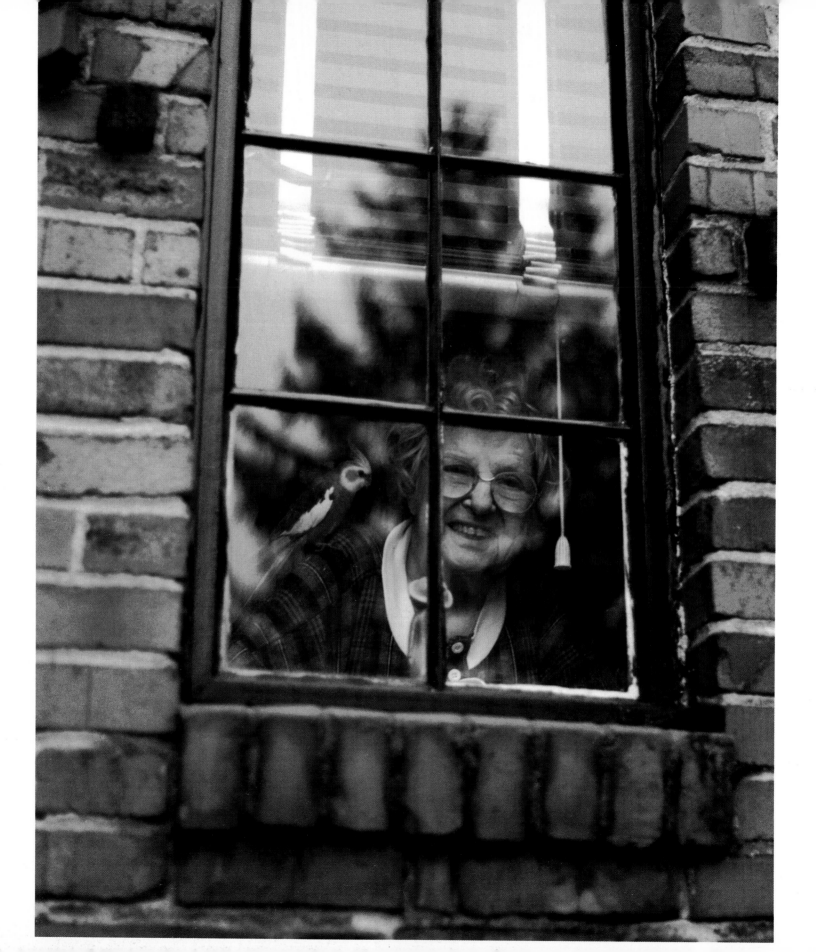

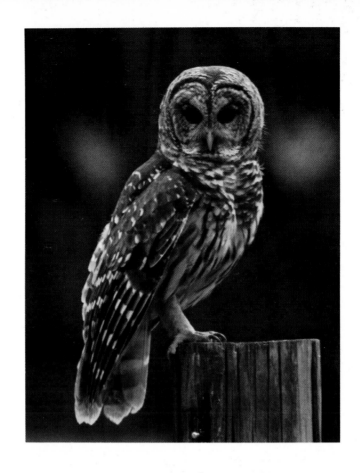

Nonny and Ernie—Together Again OPPOSITE: My grandmother with her bird, Ernie. Both have since passed away.
MERIT AWARD HEIDI K. TORQUATO
Winber PA USA *The Tribune-Democrat* KODAK GOLD 200 Film

Owl Be Watching You! RIGHT: Late afternoon on Arbuckle Creek, Avon Park, Florida.
MERIT AWARD LENNIS A. BARRINGER
Riverview FL USA *The Tribune* KODAK GOLD 200 Film

Color on a Limb BELOW: Scarlet macaw at the Cincinnati Zoo.
MERIT AWARD CHARLES E. HOLLIDAY
Hamilton OH USA *The Journal News* KODAK EKTAR 125 Film

True Colors BOTTOM RIGHT: Closeup of a male peacock.
MERIT AWARD LOUISE S. CLARKE
Tampa FL USA *The Tribune* KODAK GOLD 100 Film

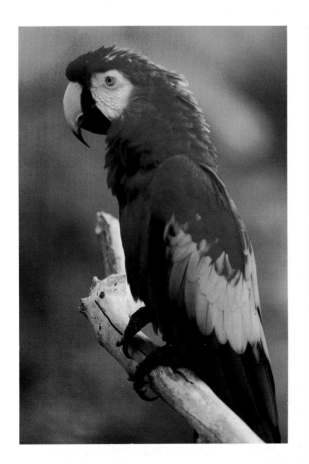

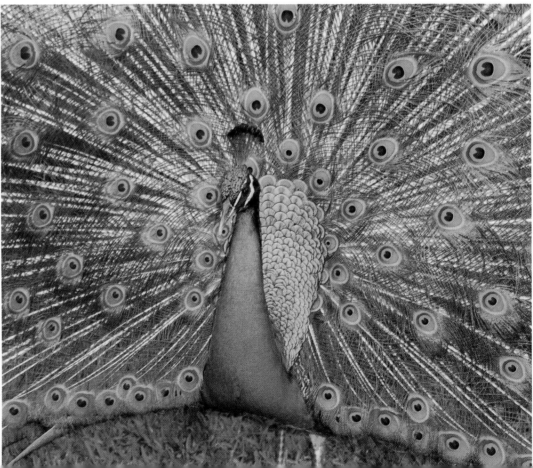

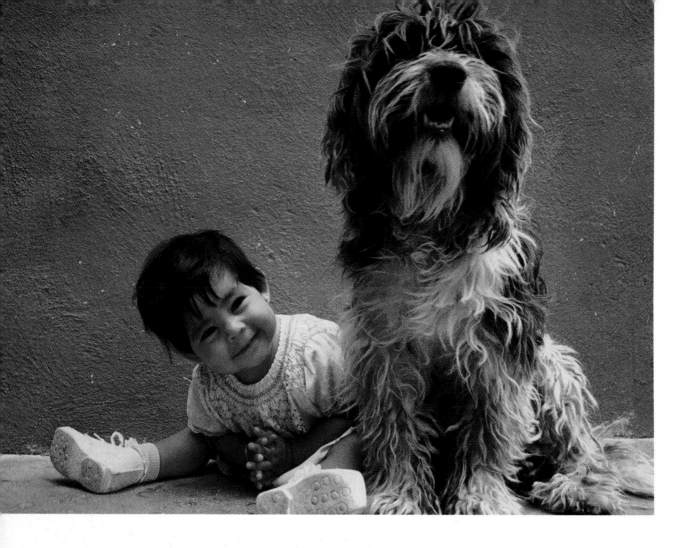

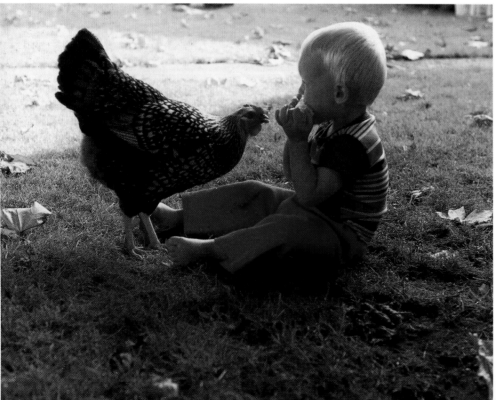

Good Friends TOP: A baby named Marisol Fragoso Gutierrez and her pup, Tequila.
HONOR AWARD SRA. MANUEL FRAGOSO ALVAREZ Saltillo MEXICO *Vanguardia* KODAK GOLD 100 Film

Sharing with Friend LEFT: Brian, two, eating corn on the cob with his pet chicken, Clucky.
MERIT AWARD DENITA OAKES Eugene OR USA *The Register-Guard* KODAK GOLD 100 Film

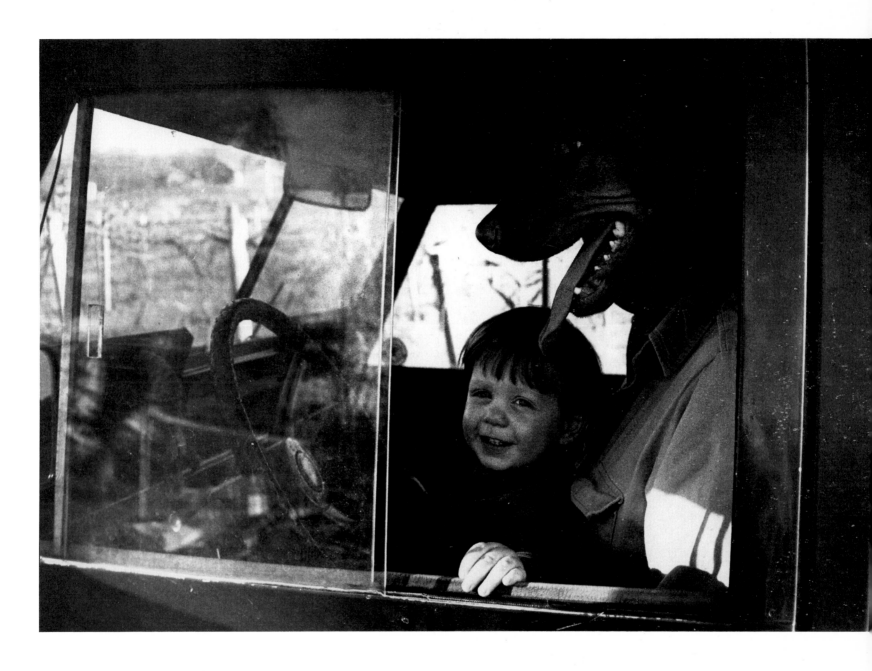

Peabody and His Boy, Sherman ABOVE: I was taking a portrait of my husband and son. Our dog, Greta, stuck her head in front of my husband for a moment.
HONOR AWARD CHERYL LAPPAS BERNIK
North East PA USA *The Times-News*
KODAK T-MAX 400 Professional Film

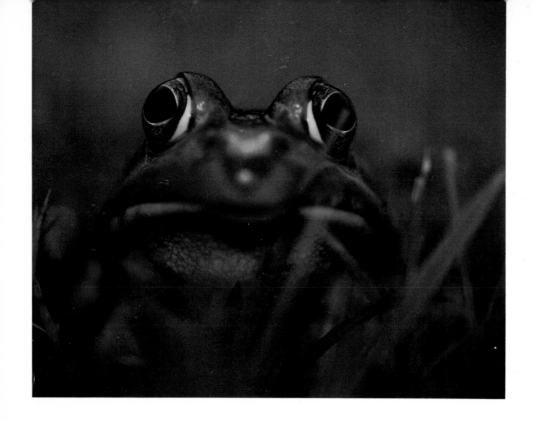

Ole' Big Eyes LEFT: Bug's eye view of a frog.
HONOR AWARD LORETTA MINNICK
Milford IN USA *The Journal-Gazette*
KODAK GOLD 100 Film

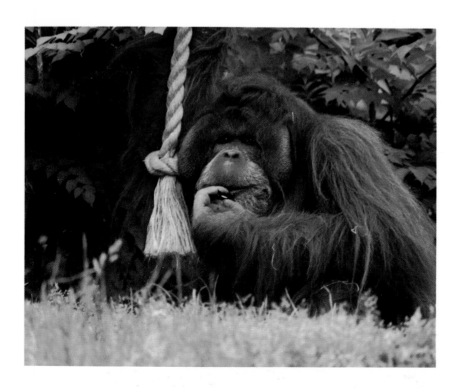

Dog on the Run ABOVE: My dog, Courtney, was running, and I wanted to take a picture of her. My dad helped me understand how to do this.
MERIT AWARD DAVID RYAN
Brookfield WI USA *The Milwaukee Journal*
KODACOLOR 110 Film

Oh, What a Day! LEFT: Orangutang at the Philadelphia Zoo.
MERIT AWARD TRISHA O'GORMAN
Summit Hill PA USA *The Times News*
KODAK GOLD 100 Film

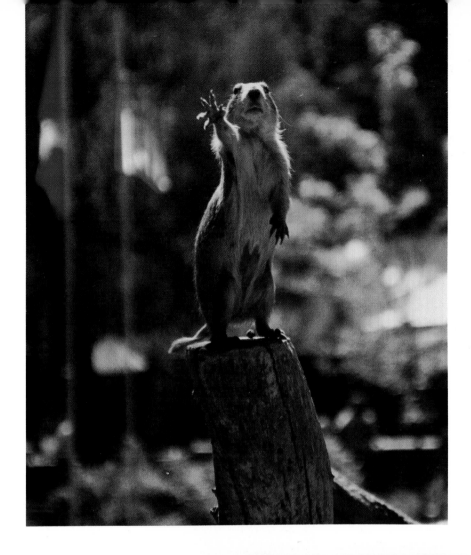

And, if I'm elected . . . LEFT: Prairie dog at York Wild Animal Kingdom in Maine.
HONOR AWARD LORRAINE DENICOURT
Reading MA USA *The Eagle-Tribune*
KODAK GOLD 100 Film

Posing Pretty BELOW: White cat in a bed of red impatiens flowers.
MERIT AWARD ELINOR MOELLER
Tripoli IA USA *The Daily Register*
KODAK GOLD 400 Film

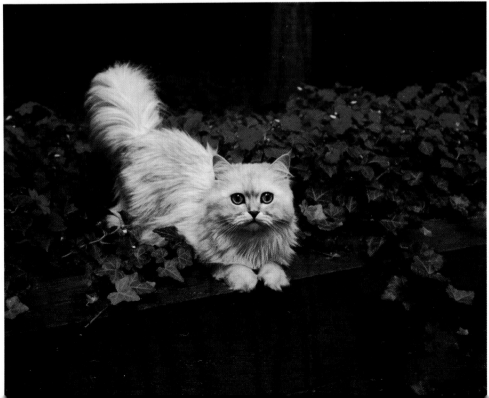

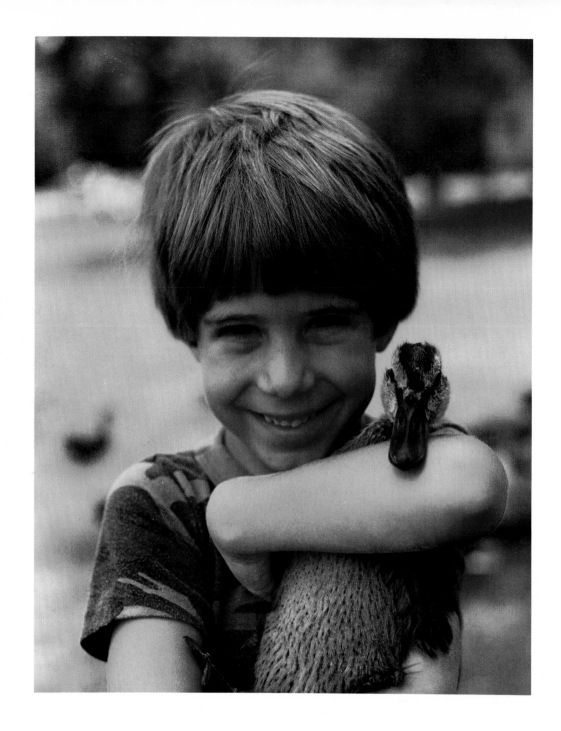

Best Friends A small seven-year-old boy
holding a wild duck.
MERIT AWARD LINDA L. FUGE
Johnstown PA USA *The Tribune-Democrat*
KODAK GOLD 100 Film

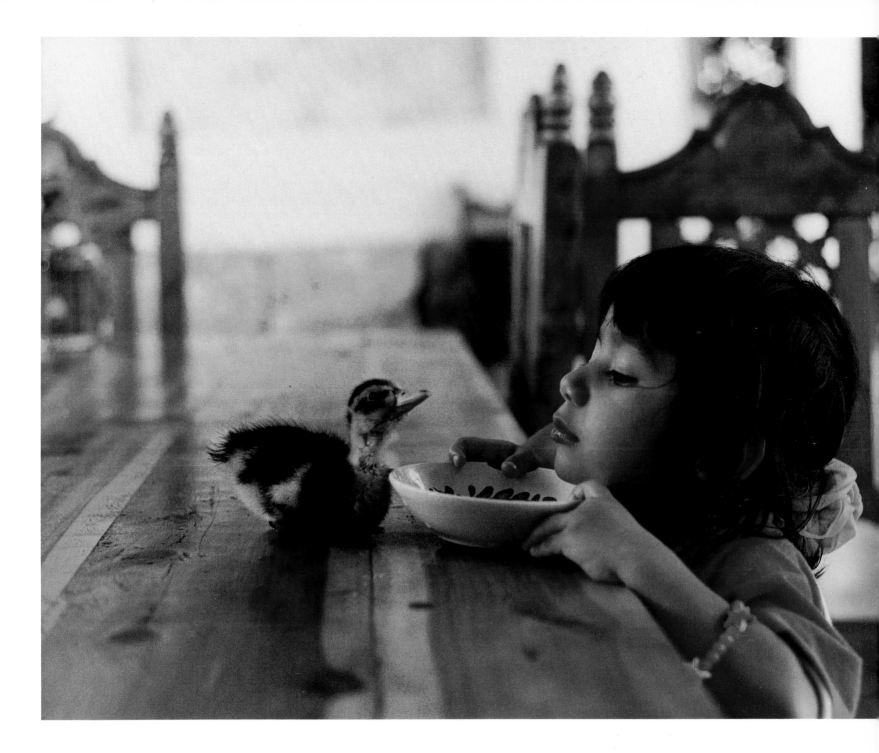

My Little Duck My daughter tempting her pet with a special treat.
MERIT AWARD JUAN IGNACIO ORTEGA JIMENEZ
Lindavista MEXICO *El Universal* KODAK GOLD 100 Film

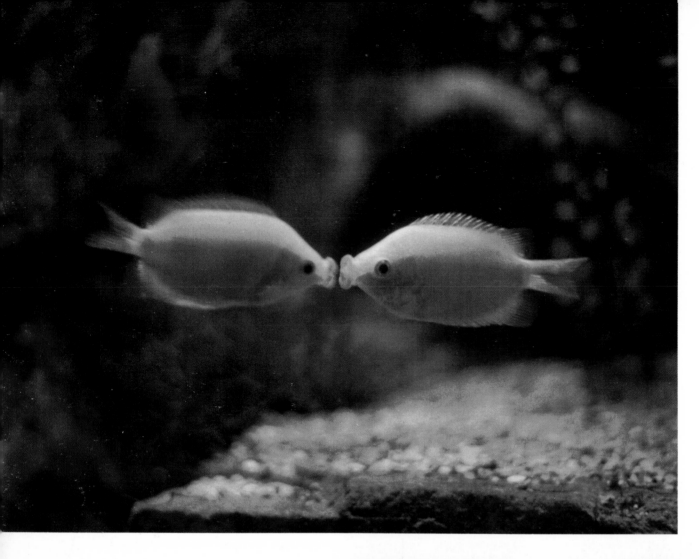

Love Bubbles ABOVE: Fish kissing? Not really. Just a reflection from the wall of the aquarium.
MERIT AWARD GUSTAVO A. BONILLA GARCIA
Monclova MEXICO *Vanguardia*
KODACOLOR VR-G 100 Film

Good to the Last Lick RIGHT: Shar-pei puppies making a mess of themselves while eating baby rice.
MERIT AWARD RUSS WALLACE
Asotin WN USA *The Morning Tribune*
KODAK GOLD 100 Film

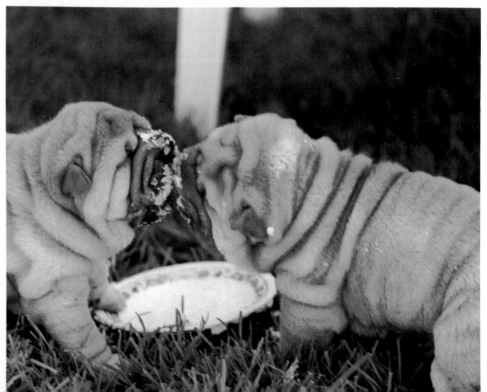

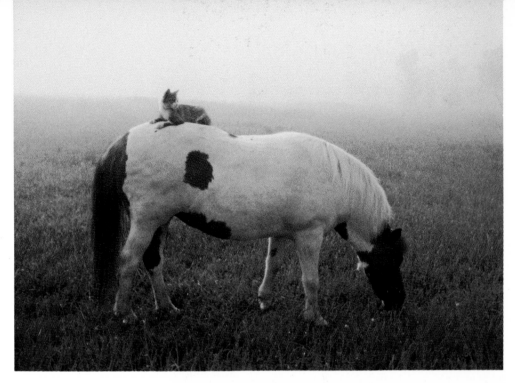

Home on the Range LEFT: My pony with our cat on her back, the only dry place on a foggy day.
MERIT AWARD CYNDI HAYES
Cambridge Springs PA USA *The Times-News*
KODAK DISC Film

Waiting for the Next Meal BELOW: Two pigs in a pen on my father's farm in Rockville, Virginia.
HONOR AWARD JENNIFER LYNN RADA
Glen Allen VA USA *The News Leader*
KODAK GOLD 100 Film

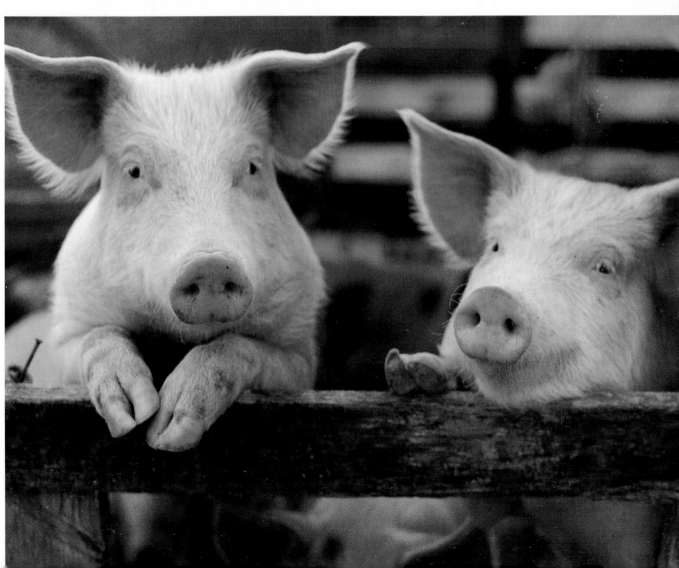

GRAND VISTAS
LANDSCAPES AND SCENICS

The Pond ABOVE: The peace and stillness of an autumn sunset.
HONOR AWARD CULLEN NUGENT
Lumsden, Saskatchewan CANADA
The Leader-Post
KODAK VERICOLOR III Professional Film

Hindered Sunrise
OPPOSITE: Looking east into an overcast sunrise with morning mist covering a lake near Carey, Ohio.
MERIT AWARD JOHN A. KELLER
Bucyrus OH USA *The Inquirer*
KODAK GOLD 200 Film

One never tires of the beauty of nature as expressed in photographic vistas of sea, mountain, prairie, and desert. Light plays on the landscape, creating dramatic shadows in early morning or late afternoon, or landing with full force in midday. The sheer variety of scenes offered here—draped in soft and dreamy mists, or shimmering with vibrant color, or bristling with rocky crags—is a travelogue of places we have been or long to visit.

91

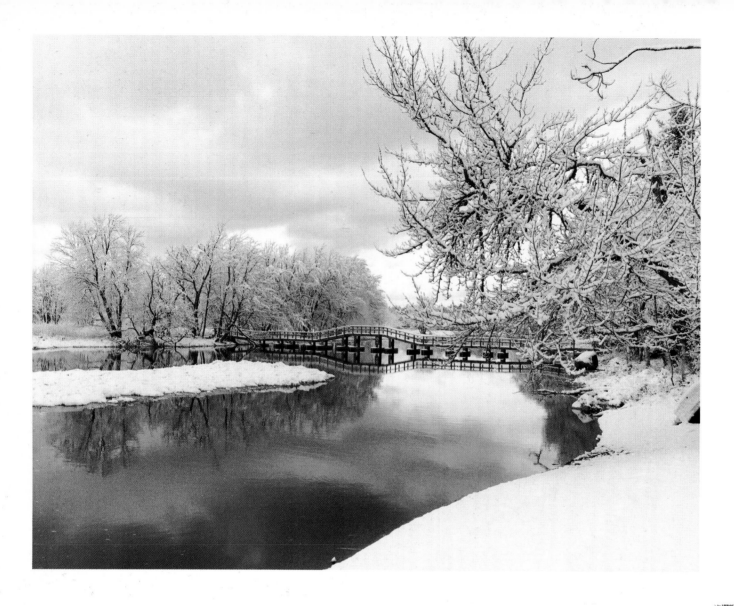

Keji at Its Best ABOVE: Winter scene in Keji National Park, Japan.
MERIT AWARD DAVE G. HISCOCK
Halifax, Nova Scotia CANADA *The Daily News* KODAK GOLD 100 Film

Morning Mist RIGHT: A silent lake with trees reflecting in the water in early morning.
HONOR AWARD GEORGE GREEN
Tewksbury MA USA *The Sun* KODAK PLUS-X Film

Winter Water Wonderland OPPOSITE: Winter slush covers the pier at Benton Harbor on the St. Joseph River at Lake Michigan.
MERIT AWARD DOUGLAS GEIGER
Sturgis MI USA *The Journal* KODAK T-MAX 100 Professional Film

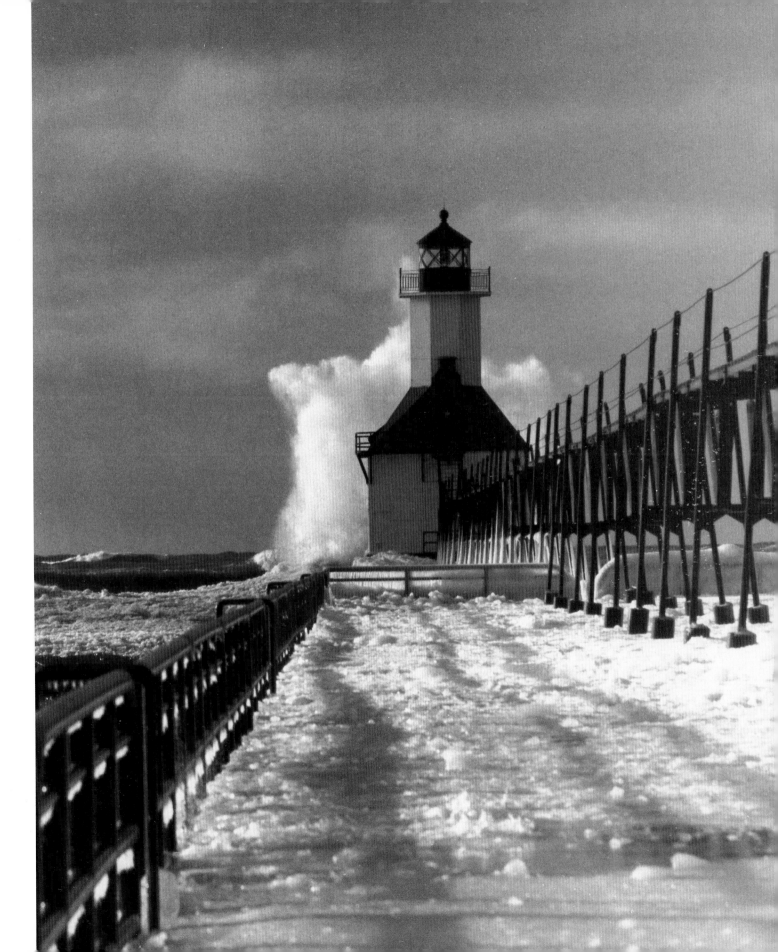

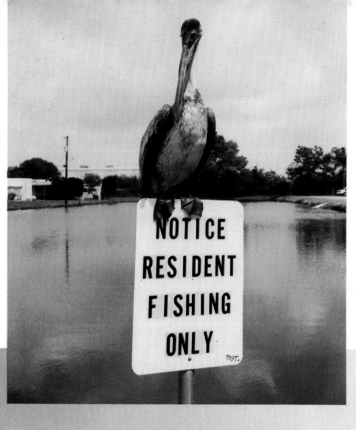

An Unwelcome Non-Resident LEFT: A pelican perched for a wonderful moment.
MERIT AWARD DUDLEIGH SCHRODER
Escanaba MI USA *The Daily Press* KODAK GOLD 200 Film

Storm Study in Blues BELOW: Stormy day on the English Channel at Sheringham, England.
MERIT AWARD JOANNE JACKSON LISK
Vidalia LA USA *The Democrat* KODAK GOLD 200 Film

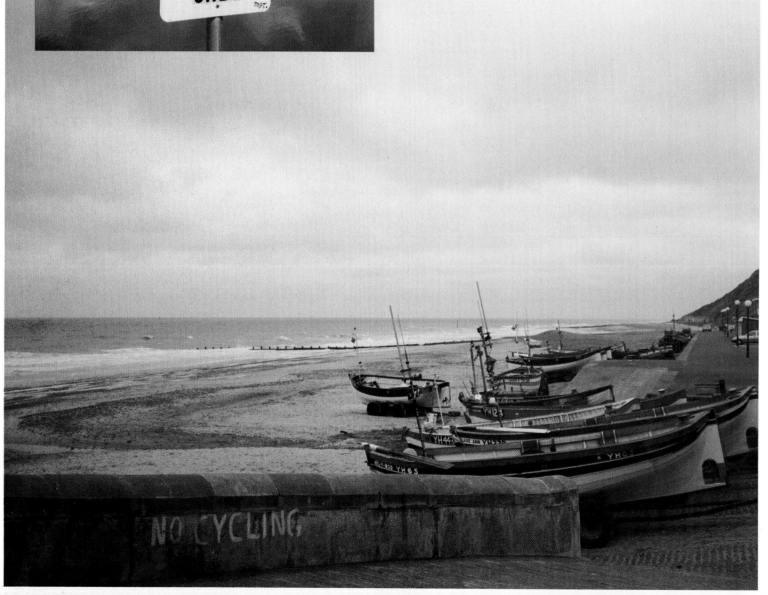

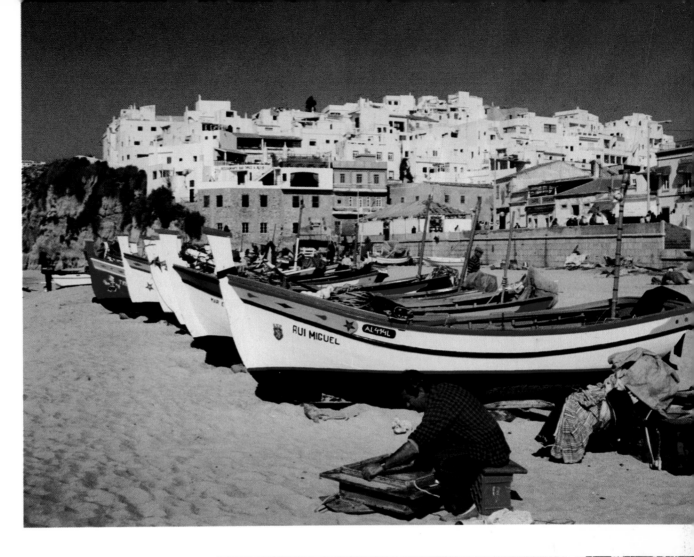

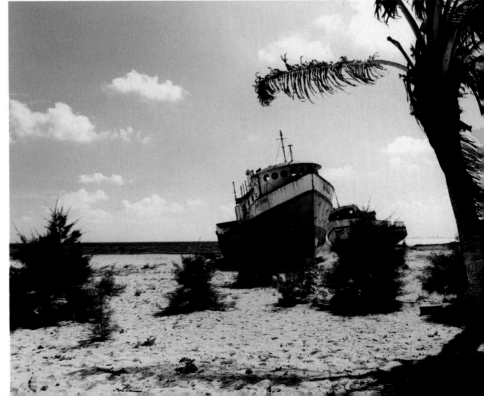

Preparing for the Catch TOP: Portuguese fisherman make
morning repairs to nets in Algarve, Portugal.
MERIT AWARD ROBERT L. VASS
West Bend WI USA *The Daily News* KODAK GOLD 200 Film

Marooned BOTTOM: Shipwrecked boats at Puerto Juarez,
Mexico.
MERIT AWARD JULIO ALBERTO SANTANA CRUZ
Cancun MEXICO *Novedades de Yucatan* KODAK GOLD 100 Film

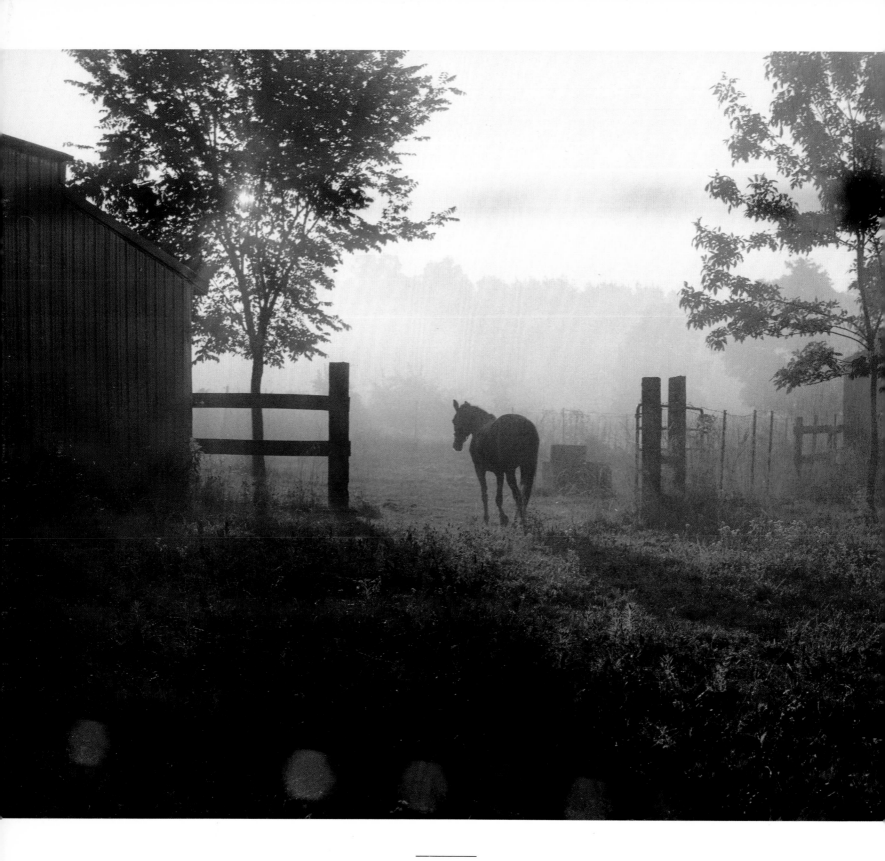

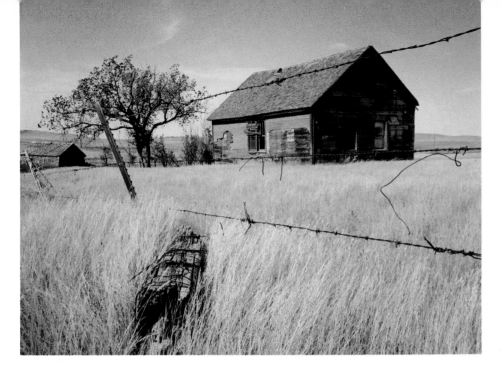

Rainbeau in the Morning OPPOSITE: A horse walking into the sun through a gate on a mist-shrouded morning.
MERIT AWARD ANN MICHELE GARRETT
Mt. Vernon IL USA *The Southern Illinoisian* KODAK GOLD 100 Film

Grampa's Farm TOP: My grandparents' homestead north of New Leipzig, North Dakota, vacant for many years.
MERIT AWARD LUCILLE BENDER
Bismarck ND USA *The Tribune* KODAK GOLD 200 Film

Hay There! BOTTOM LEFT: Bales of rolled hay surround an abandoned farm building overgrown with vines.
HONOR AWARD BARBARA A. LAWLOR
Saint John, New Brunswick CANADA
The Telegraph & Evening Times KODAK GOLD 100 Film

Summertime Adventure BOTTOM RIGHT: Eoghan Hayes in an open meadow in Easthampton, Massachusetts.
MERIT AWARD MARY M. HAYES
Lake Ariel PA USA *The Times* KODAK GOLD 100 Film

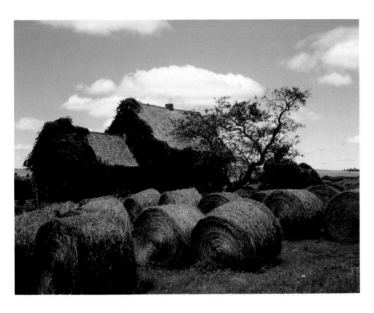

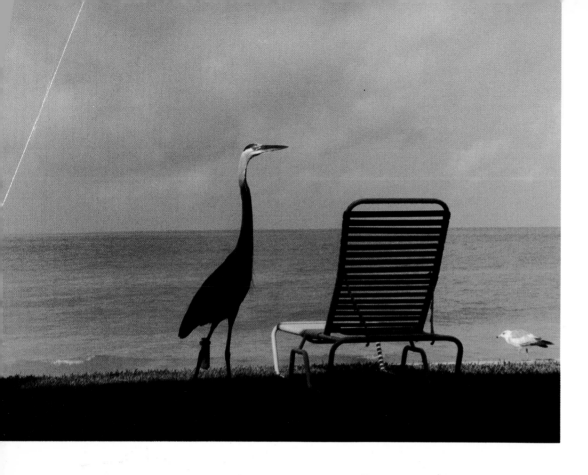

Sand, Sea, and Sky OPPOSITE, TOP LEFT: A seagull in flight.
MERIT AWARD Lori Lohmann
Fond du Lac WI USA *The Reporter*
KODAK GOLD 200 Film

Wait for Me . . . I'm Coming! OPPOSITE, TOP RIGHT: A boy buries himself in sand.
MERIT AWARD Victoria Gray
Halifax, Nova Scotia CANADA *The Daily News*
KODAK T-MAX 400 Professional Film

Girl on the Beach OPPOSITE, BOTTOM: A light-colored beach and turquoise sea on Grand Cayman Island.
MERIT AWARD Paul M. Vigneault
Manchester NH USA *The Union Leader*
KODAK GOLD 200 Film

Maybe I'll Sit a Spell ABOVE: Heron looking at a chaise lounge at Longboat Key, Florida.
MERIT AWARD Audrey E. Tracy
Orlando FL USA *The Union-Sun & Journal*
KODAK GOLD 200 Film

The Arch of Love RIGHT: Natural stone formation in Los Cabos, Mexico.
MERIT AWARD Maria Esther Juarez Segura
Col. Valle De Luces MEXICO *El Universal*
KODAK GOLD 100 Film

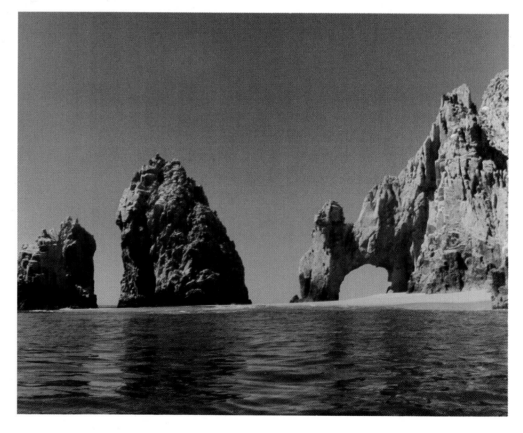

Nature's Handiwork LEFT: The sun shines through the trees into the shade of rocks at Turkey Run State Park, Indiana.
MERIT AWARD JANICE MARIE SEVERANCE
Augusta ME USA *The Kennebec Journal* KODAK GOLD 200 Film

Winter's End BOTTOM LEFT: Late winter sunset over Lake Michigan at Frankfort Lighthouse.
MERIT AWARD GLENN C. SANFORD
Traverse City MI USA *The Record Eagle* KODACOLOR VR-G 200 Film

A Venetian Alleyway BOTTOM RIGHT: Canals, colorful gondolas, and picturesque buildings in Venice, Italy.
MERIT AWARD BROOKE C. HORMAN
Doylestown PA USA *The Intelligencer-The Record*
KODAK GOLD 100 Film

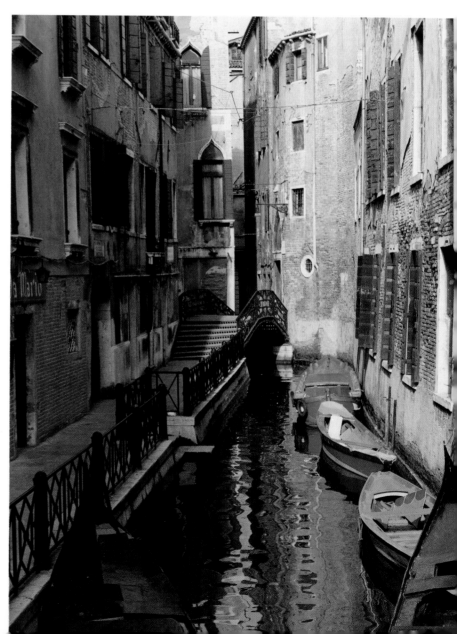

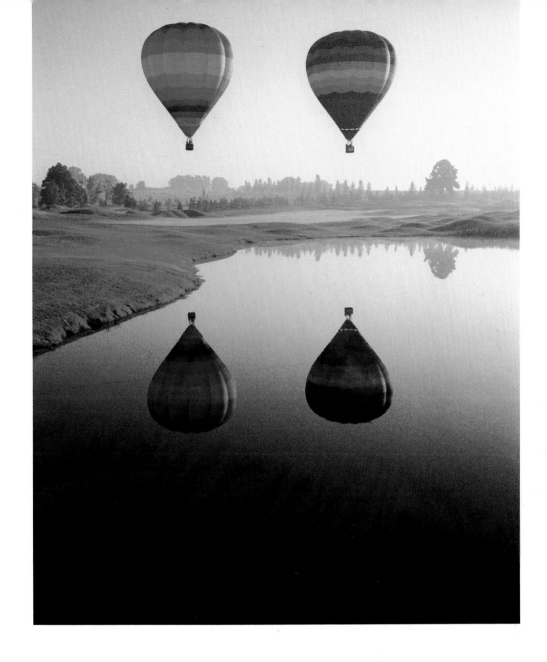

Double Your Pleasure ABOVE: Two balloons over a pond
at Grand Traverse Resort, Michigan.
MERIT AWARD DONALD WARNE
Williamsburg MI USA *The Record Eagle* KODAK GOLD 100 Film

Flowers and Fountain RIGHT: Flowers, fountains, and trees
on Vancouver Island, Canada.
MERIT AWARD DICK SOLLMANN Oxford OH USA
The Journal News KODAK GOLD 100 Film

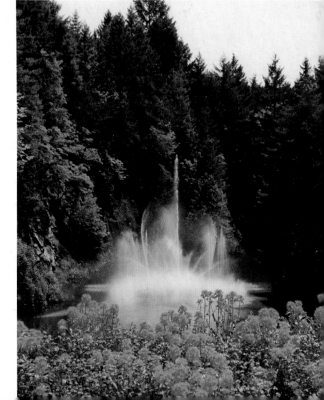

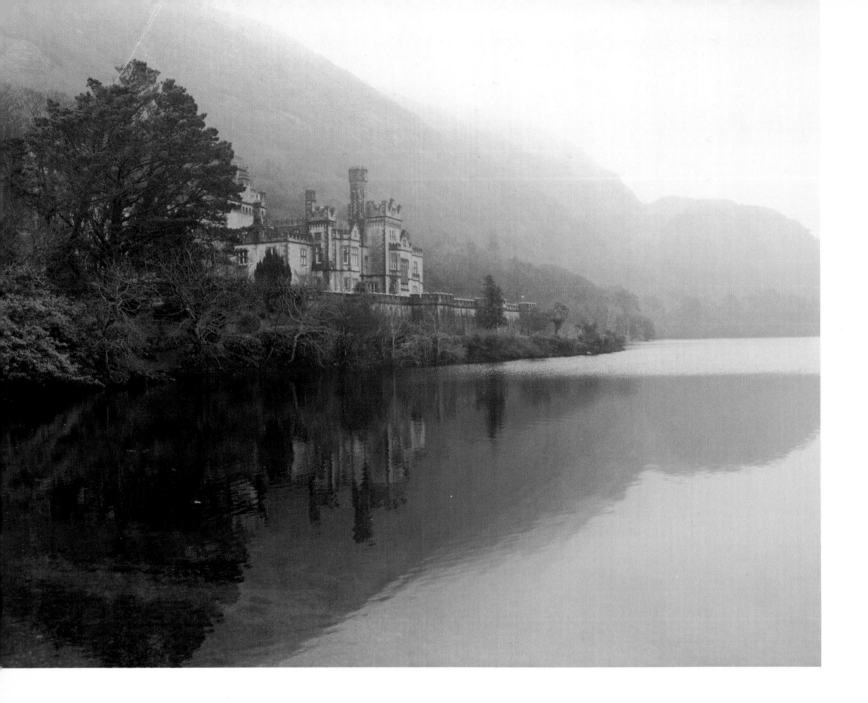

Castle and Reflections ABOVE: Connemara Castle in
Ireland, from a bridge across water in the rain.
MERIT AWARD GENE AVALLONE Henrietta NY USA
The Democrat and Chronicle KODAK GOLD 100 Film

Fountain in the Sunset OPPOSITE, TOP LEFT: In a park in the
city of Oaxaca, Mexico.
MERIT AWARD SRA. TOMAS RODRIGUEZ REYES Oaxaca MEXICO
El Sol de Tampico KODAK GOLD 100 Film

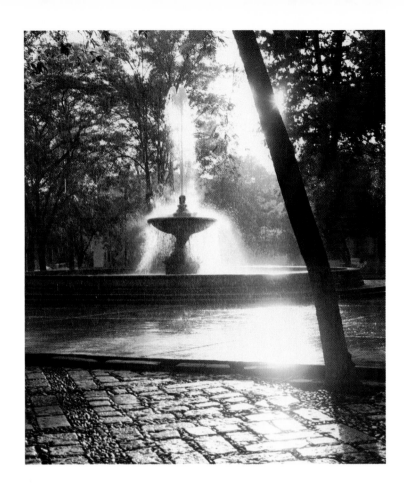

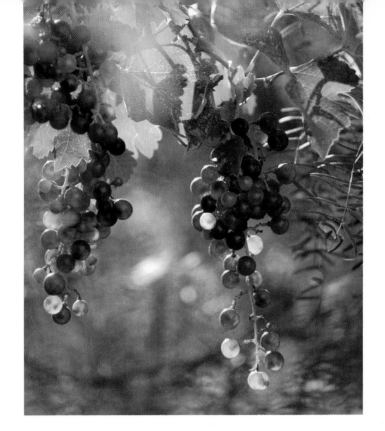

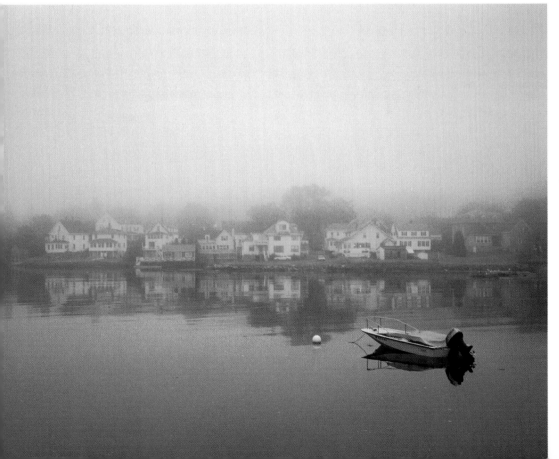

Grapes on the Vine ABOVE: Backlit grapes on a vine in Old Mesella, New Mexico.
MERIT AWARD Renate Schuetz El Paso TX USA
The Herald-Post KODAK GOLD 100 Film

Foggy Morning in Boothbay Harbor
LEFT: Houses of Boothbay Harbor, Maine, shrouded in early morning fog and reflected in the still waters, stand watch over a solitary dinghy.
MERIT AWARD Carol A. Euler Colchester VT USA
The Free Press KODAK GOLD 100 Film

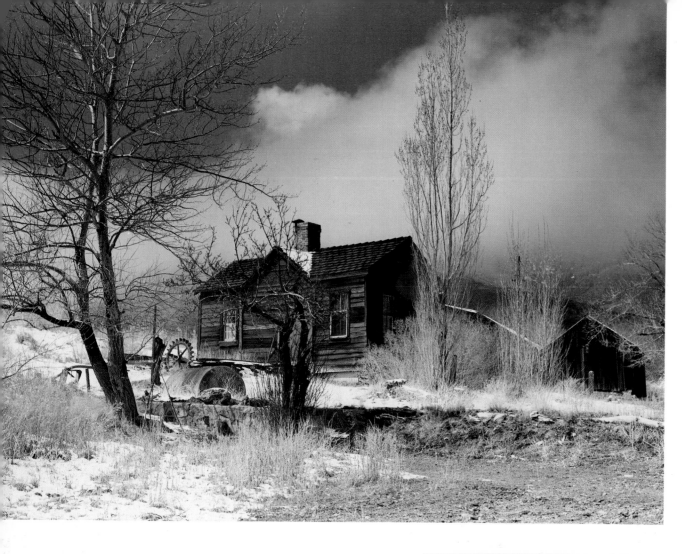

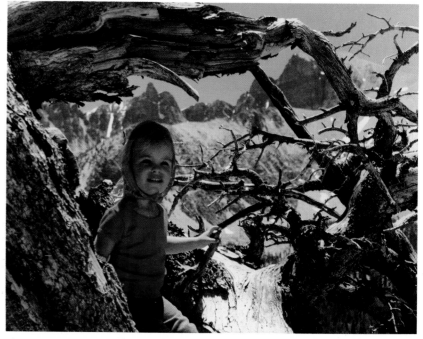

The Old Homestead ABOVE: Old house in Wrightwood, California.
MERIT AWARD NORMAN REDFORD Apple Valley CA USA
The Daily Press KODAK EKTAR 25 Professional Film

Hope in the Bristlecone RIGHT: My daughter, Emerald, in a Bristlecone pine tree at 12,000 feet in the nation's newest national park, Great Basin, Nevada.
MERIT AWARD FRANK DAVIS Ft. Wayne IN USA
The Journal-Gazette KODAK GOLD 100 Film

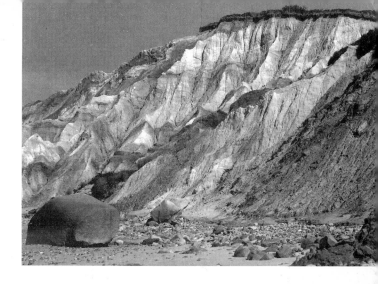

Island Erosion: Beauty Exposed RIGHT: Weathered beach cliffs exposing rock strata layers at Martha's Vineyard.
MERIT AWARD JOHN R. GLOVER Annapolis MD USA *The Capital*
KODAK T-MAX 100 Professional Film

Memories BELOW: An infrared photograph, taken on an early spring day, creates a ghost-like rendering of the scene.
HONOR AWARD DR. DONALD W. BOULAND Mt. Vernon IL USA
The Southern Illinoisian KODAK High Speed Infrared Film 2481

Sunset OVERLEAF: Sunset on a North Dakota farm.
HONOR AWARD AGNES EMINETH Baldwin ND USA *The Tribune*
KODAK GOLD 200 Film

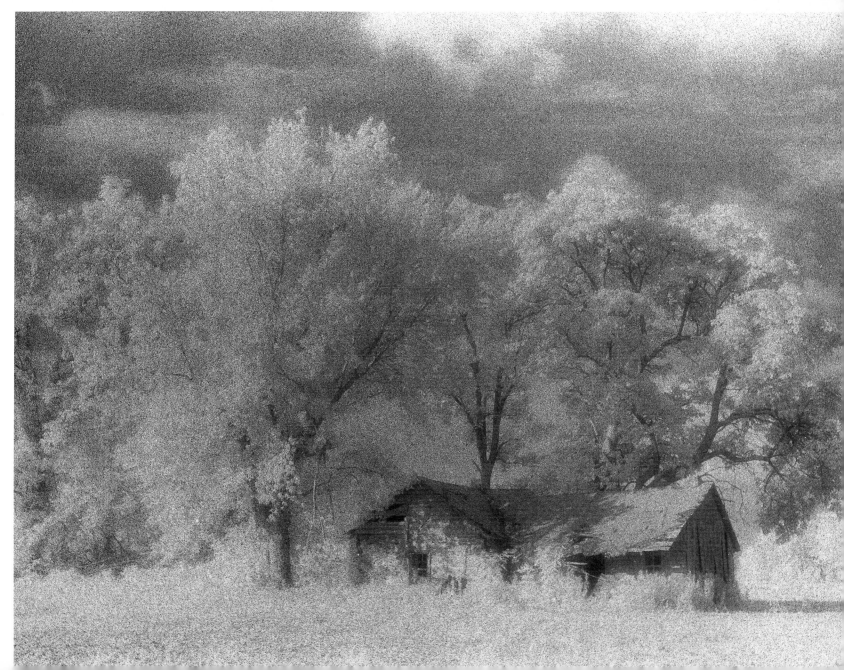

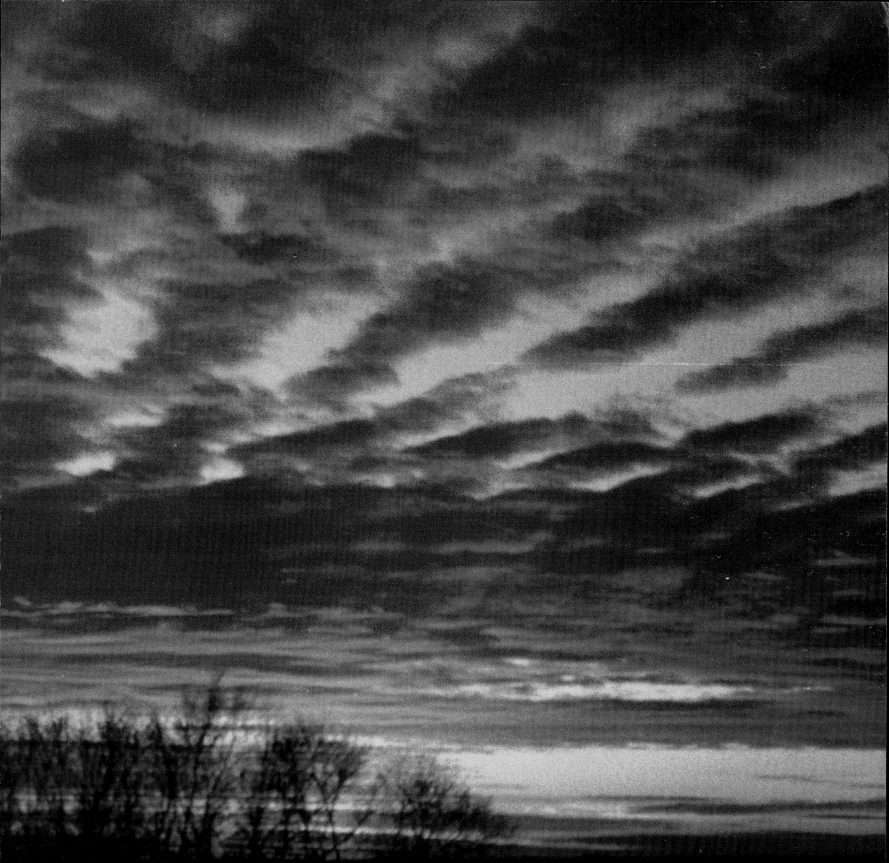

CELEBRATING OUR WORLD
THE ENVIRONMENT

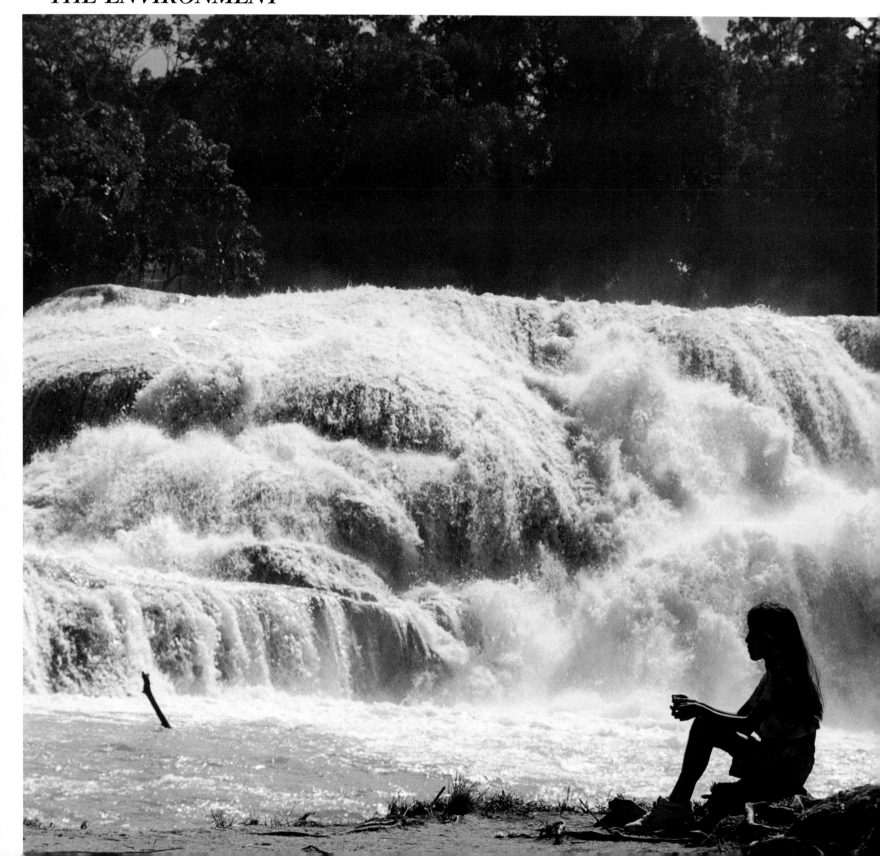

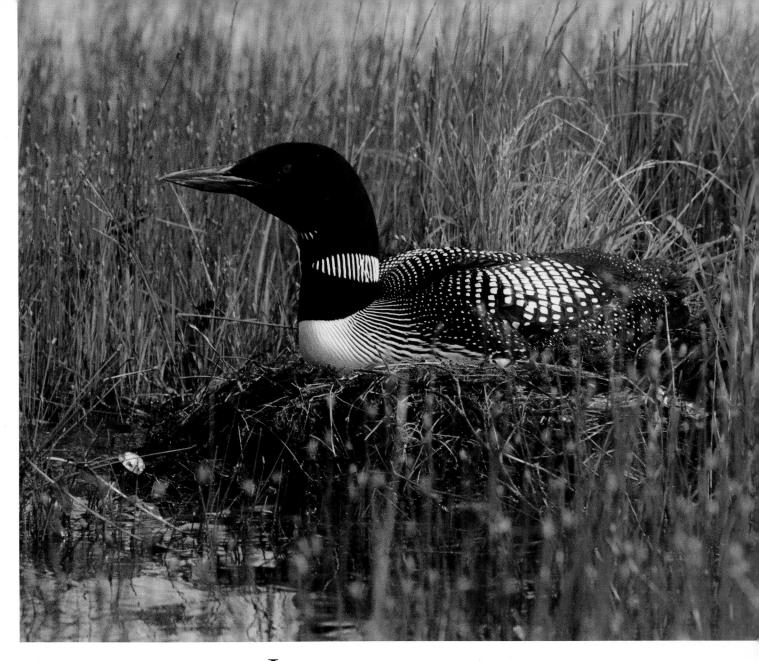

Nesting Loon ABOVE: A loon on its nest in Barry's Bay, Ontario.
HONOR AWARD
GRANT STEPHEN BOULAY
Belleville, Ontario CANADA
The Intelligencer
KODACOLOR VR-G 100 Film

Meditation OPPOSITE: Karen Cabello Gonzalez contemplates a waterfall.
HONOR AWARD
MARIO ALBERTO CABELLO PEREZ
Madero MEXICO *El Sol de Tampico*
KODAK GOLD 100 Film

I n 1990, KINSA created the environment photography category to reflect the growing concern for the health of the world and its inhabitants. Presented here are photographs of ideal environments—those we should preserve and protect, as well as those that have been restored to beauty through dedicated effort. They illustrate what is right about our world—glimpses of a healthy planet that deserves our stewardship.

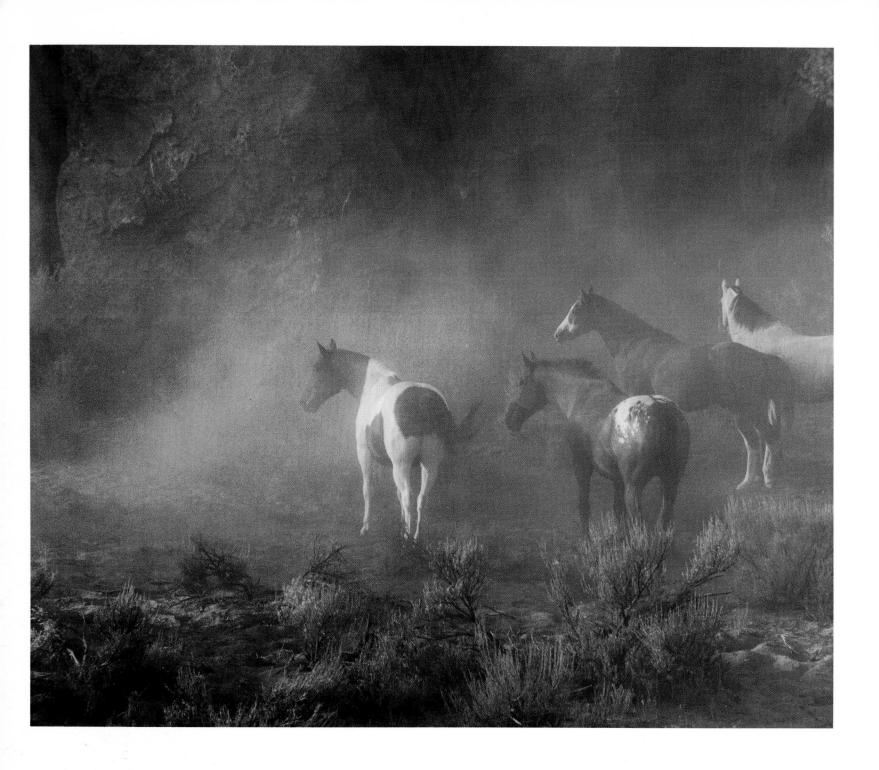

Horses in Evening Light Horses in Bend, Oregon, dust
shrouding their movement in evening light.
HONOR AWARD SHARP W. TODD Boise ID USA
The Idaho Statesman KODAK EKTAR 125 Film

Spirit Elk LEFT: Early morning in Yellowstone National Park recalls an Indian legend of an animal spirit visiting a warrior.
MERIT AWARD CARL H. LATCHFORD Rock Falls IL USA
The Daily Gazette KODAK GOLD 400 Film

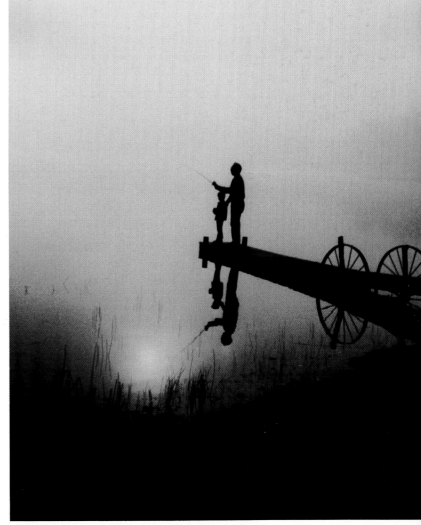

Grandpa and Josh RIGHT: A father and boy fishing from a dock during early morning fog.
MERIT AWARD KAREN BOELK Oakfield WI USA *The Reporter*
KODAK VERICOLOR III Professional Film

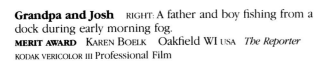

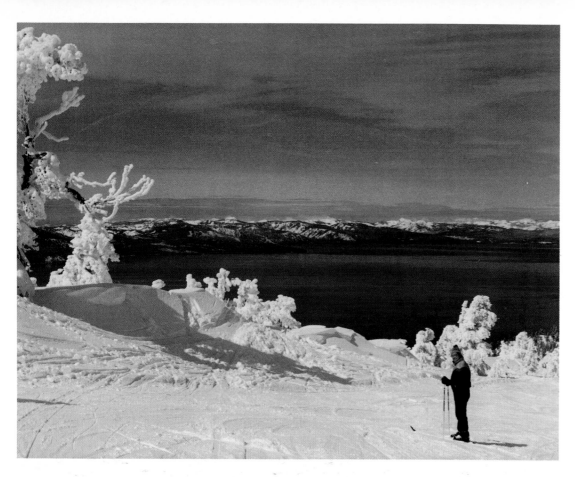

At the Summit TOP LEFT: Skiing at Lake Tahoe, California.
MERIT AWARD JAN LESCHKE Manitowoc WI USA
The Herald Times KODACOLOR VR-G 100 Film

Swan Lake BOTTOM: Swan on a lake in Germany with the Hopfen am See mountains in background.
MERIT AWARD RACHEL B. MONTMINY
Lowell MA USA *The Sun* KODAK GOLD 100 Film

New Hampshire Fall Morning OPPOSITE: Early morning near Jefferson, New Hampshire, with Mount Washington in the background.
MERIT AWARD DEBORAH A. WEBB
Great Bend NY USA *The Daily Times*
KODAK GOLD 100 Film

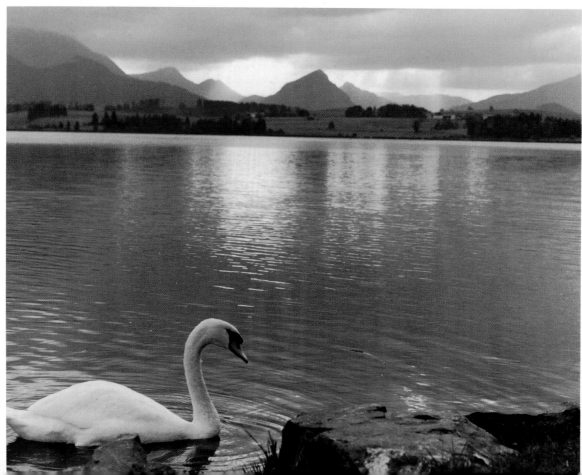

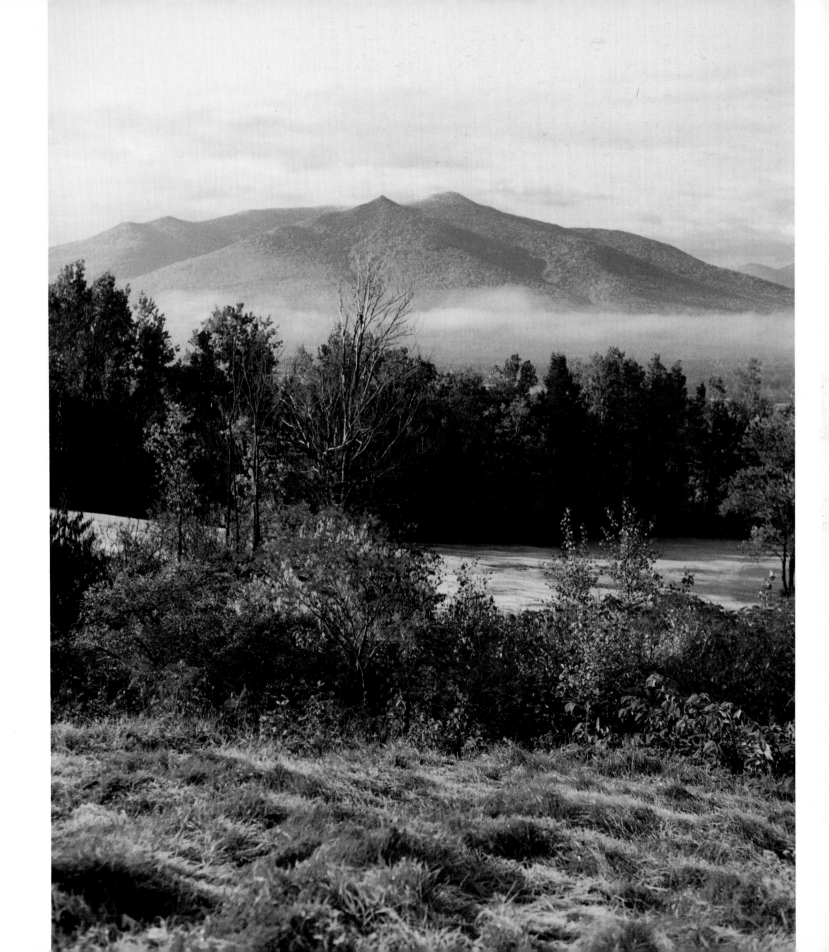

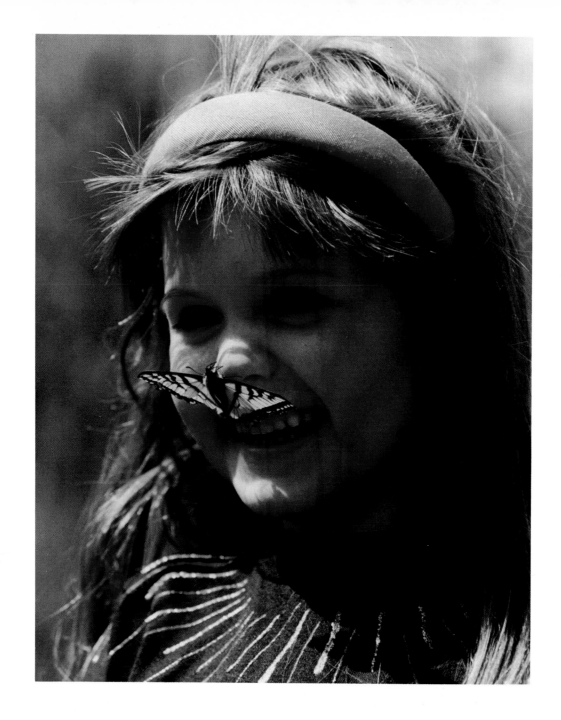

Butterflies Are Free A butterfly creates a
surprising moment for a little girl.
MERIT AWARD SALLIE REID Palmer AK USA
The Times KODAK GOLD 100 Film

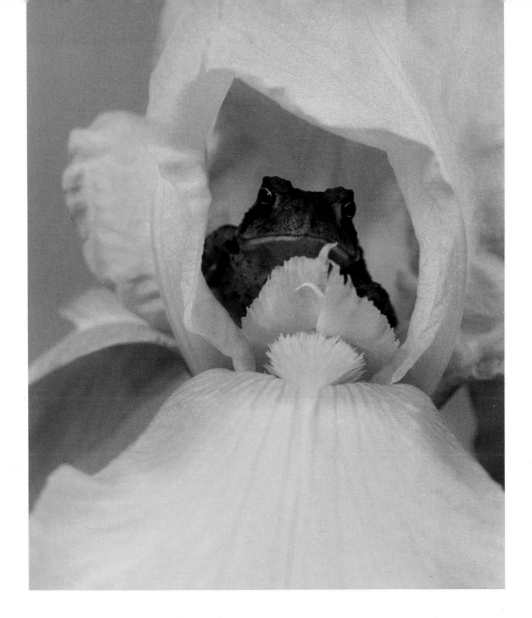

Look at Me! ABOVE: A frog sits inside a yellow iris.
MERIT AWARD DAVID L. RECONNU Charleroi PA USA
The Valley Independent KODAK GOLD 100 Film

Butterfly in Waiting! LEFT: A garden caterpillar, nibbling its way to a costume change.
MERIT AWARD CATHY STRAUB Dover OH USA
The Times Reporter KODAK GOLD 100 Film

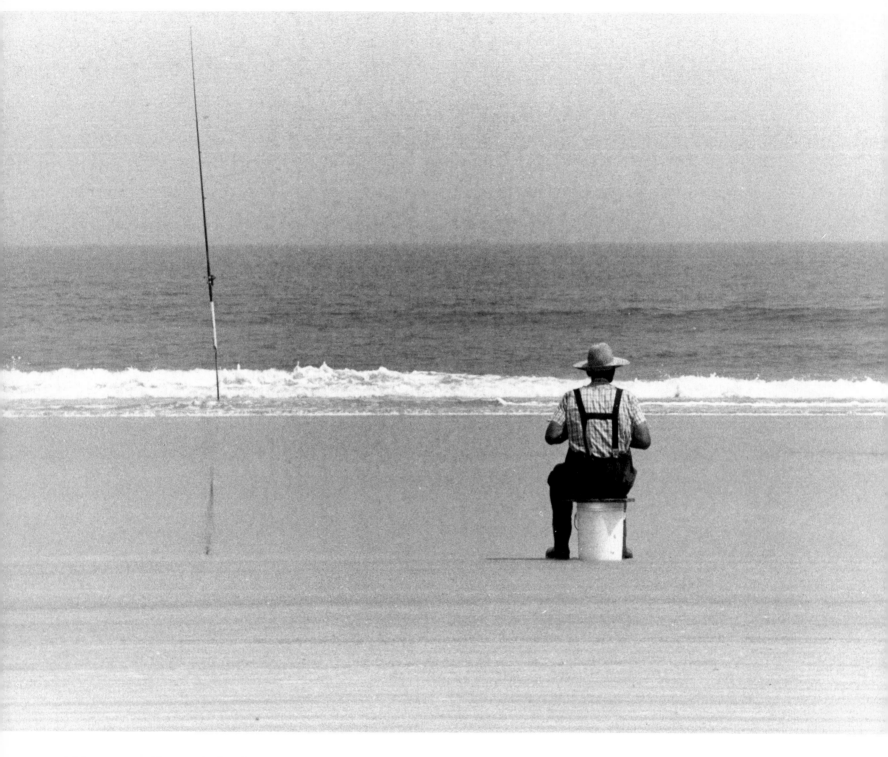

Fishing A man, fishing on the beach, captures the photographer's attention.
MERIT AWARD Lori Radosta Port Orange FL USA
The News-Journal KODAK T-MAX 400 Professional Film

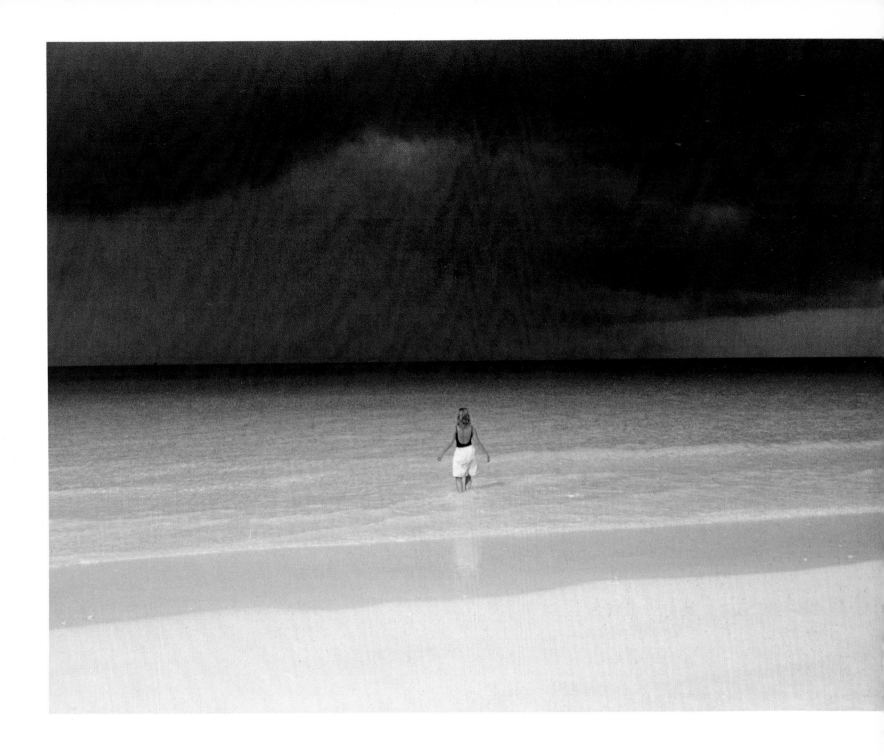

Approaching Storm Our honeymoon cruise to Eleuthera
Island. My wife wades into the sea as dark storm clouds
approach.
MERIT AWARD CHARLES LANGWORTHY Burlington VT USA
The Free Press KODAK GOLD 200 Film

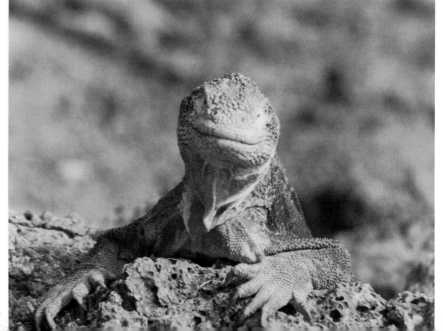

Punk-Rocker Snake ABOVE: Snake on a log with a misplaced caterpillar.
MERIT AWARD WILLIAM JAMES WHITLEY Stuart FL USA *The News*
KODACHROME 64 Professional Film

Land Iguana RIGHT: Land iguana on Santa Fe Island, Galapagos Islands, Ecuador.
MERIT AWARD DR. LINDA B. HODO Northport AL USA *The News*
KODAK GOLD 200 Film

Giraffe Taking a Drink OPPOSITE: A giraffe at a waterhole in Etosha National Park, Namibia.
MERIT AWARD RICHARD R. SCHAEFFER Mt. Wolf PA USA
The Dispatch KODAK GOLD 100 Film

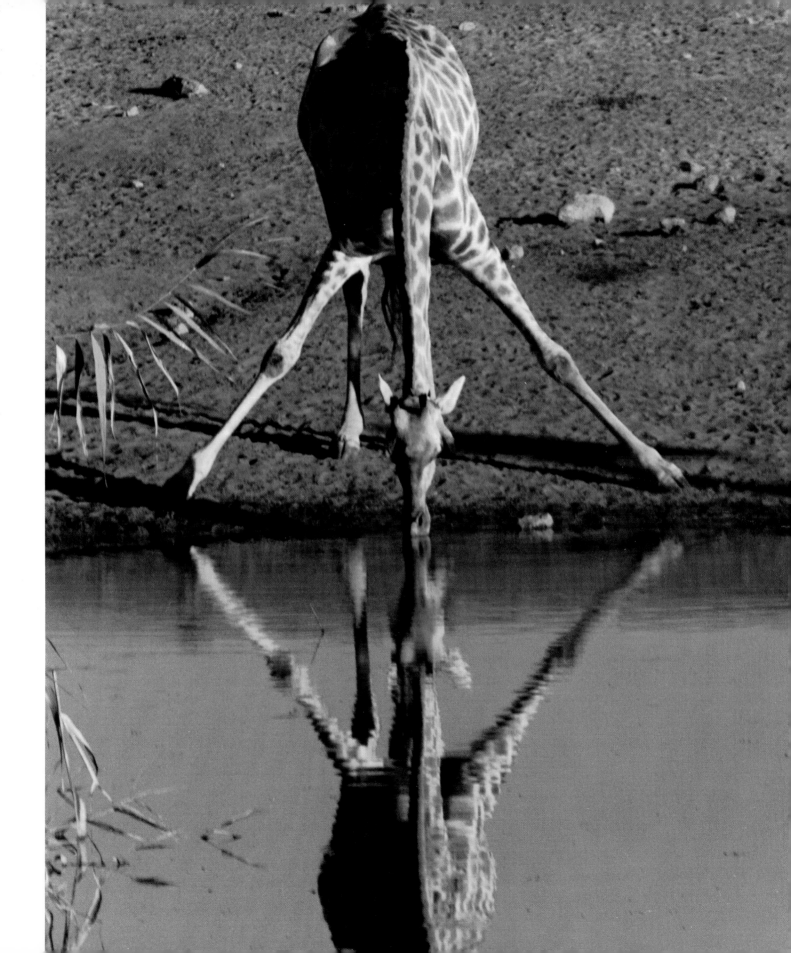

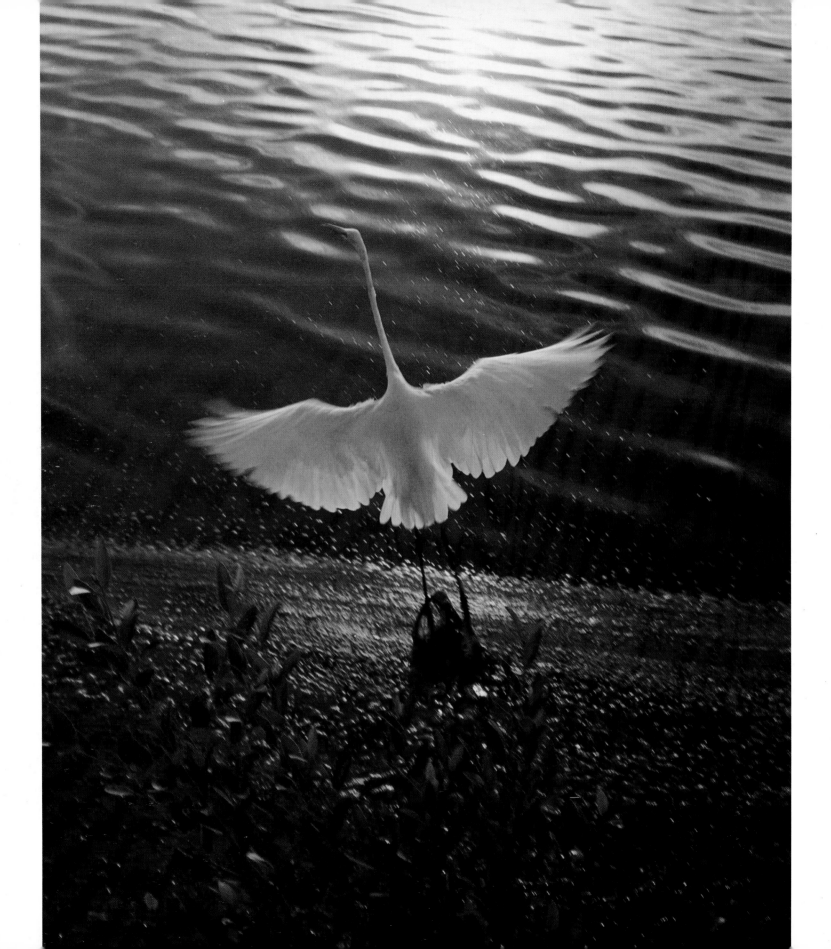

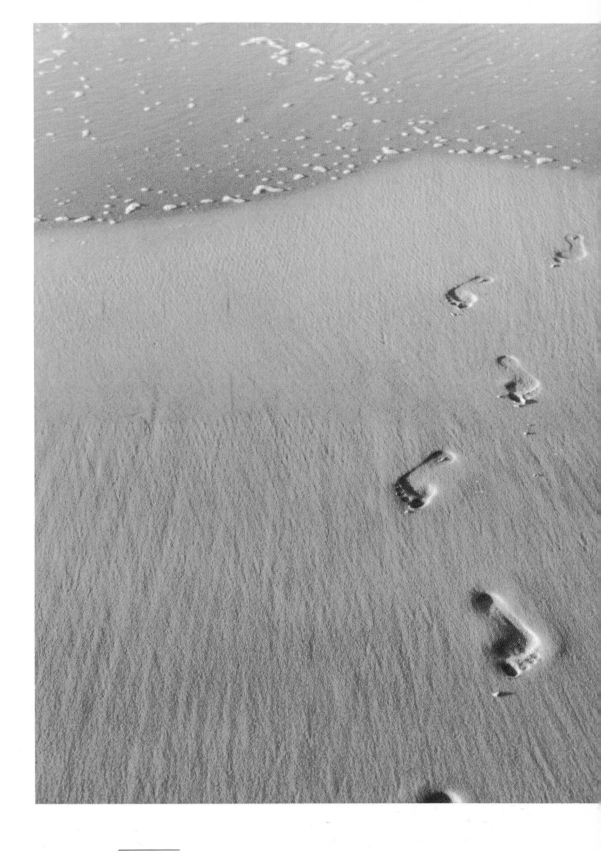

Graceful Departure
OPPOSITE: Visiting the "Ding" Darling wildlife refuge on Sanibel Island, Florida, I surprised myself by catching a great egret's takeoff.
HONOR AWARD PATRICK JONES
Greer SC USA *The News-Piedmont*
KODAK EKTAR 125 Film

Footprints in the Sand
RIGHT: Solitary, sandy footprints at a beach in Gulf Shores, Alabama.
HONOR AWARD HARRISON L. JAMES
Decatur AL USA *The Decatur Daily*
KODAK GOLD 200 Film

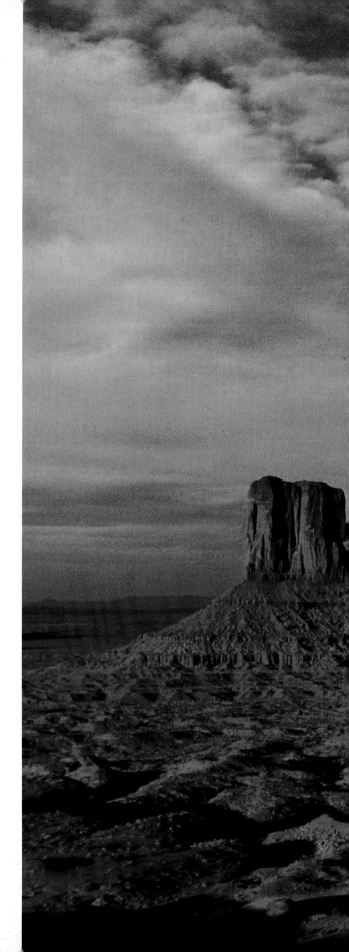

Enlarging Colors
KODAK EKTAR *FILM*

This category was established in 1990 to recognize photographs taken on KODAK EKTAR Film—a technically advanced 35 mm color negative film. Its micro-fine quality allows photo negatives only one-inch tall to be enlarged to 40 times their original size with little or no reduction in image clarity. The category includes photos ideally suited for such enlargement because of their superior composition, color, and design.

Last Rays of Lightfall Last rays of light fall onto the fantastic landscape of Monument Valley, Utah.
HONOR AWARD WES BROOME Boca Raton FL USA
The Sun-Sentinel KODAK EKTAR 125 Film

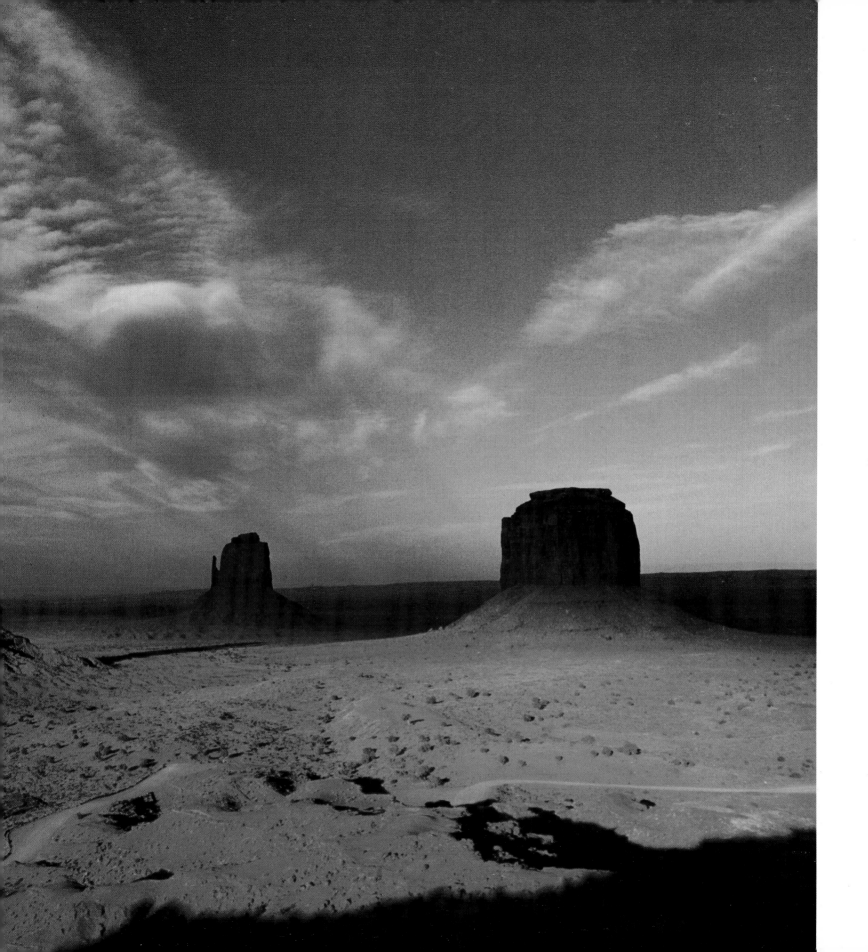

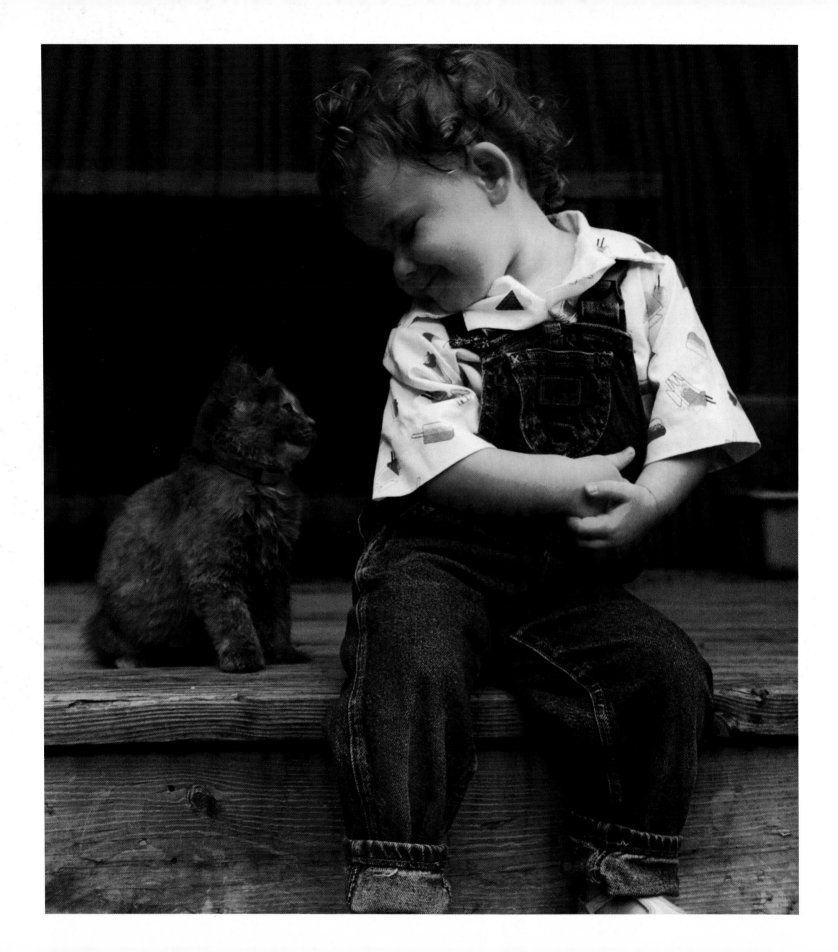

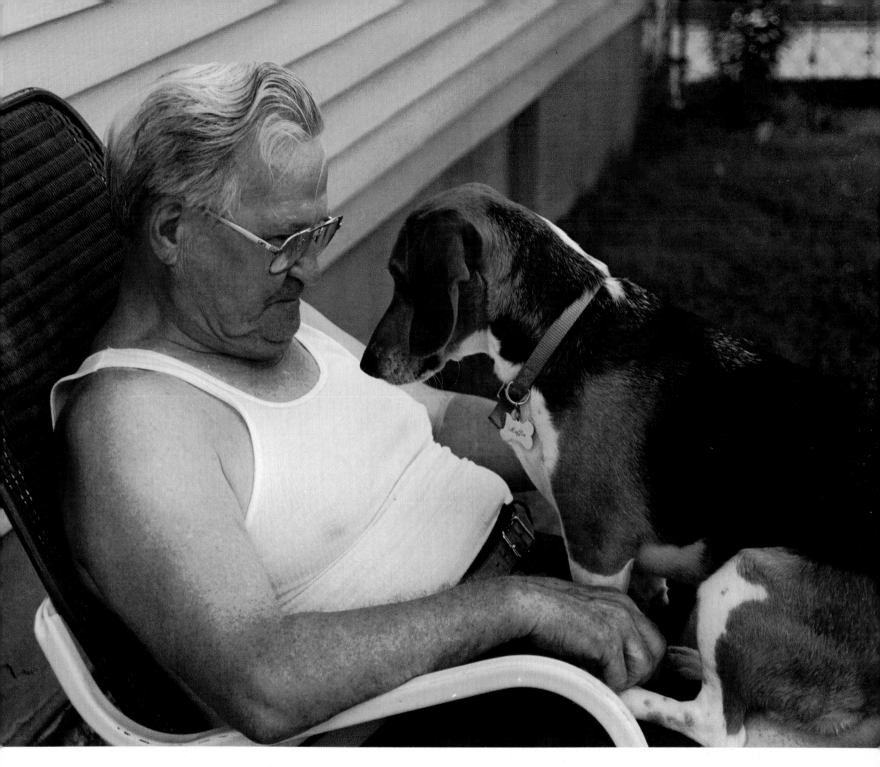

Love Between Granddaughter and Kitten OPPOSITE: I caught my granddaughter playing with our kitten and didn't have much time to plan. Mostly luck. .
HONOR AWARD EDWARD J. STOWE Traverse City MI USA
The Record Eagle KODAK EKTAR 125 Film

Bet You Blink First ABOVE: My father and Muffin—Frank has candy in his mouth, and she is waiting for her fair share.
MERIT AWARD PEGGY SLOWINSKI Buffalo NY USA
The Union-Sun & Journal KODAK EKTAR 125 Film

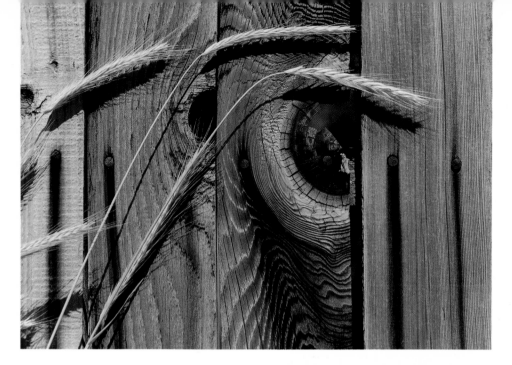

Wood 'n Grain LEFT: Closeup of weather-aged fence with wheat.
MERIT AWARD CLIFF WARNER Salt Lake City UT USA
The Big Nickel KODAK EKTAR 25 Professional Film

In My Garden BELOW: Straw hat on an antique bench in my garden is a reminder of times long since passed.
MERIT AWARD KATIE U. VANDERGRIFF
Powell TN USA *The News-Sentinel*
KODAK EKTAR 125 Film

Squash OPPOSITE: A dark-green squash with yellow flower hangs against a brick wall in Mexico.
HONOR AWARD CYNTHIA TOMCHESSON TREYBIG
Kingsport TN USA *The Times-News*
KODAK EKTAR 25 Professional Film

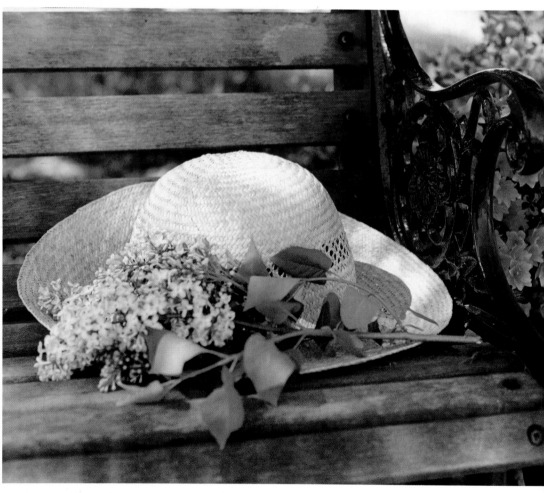

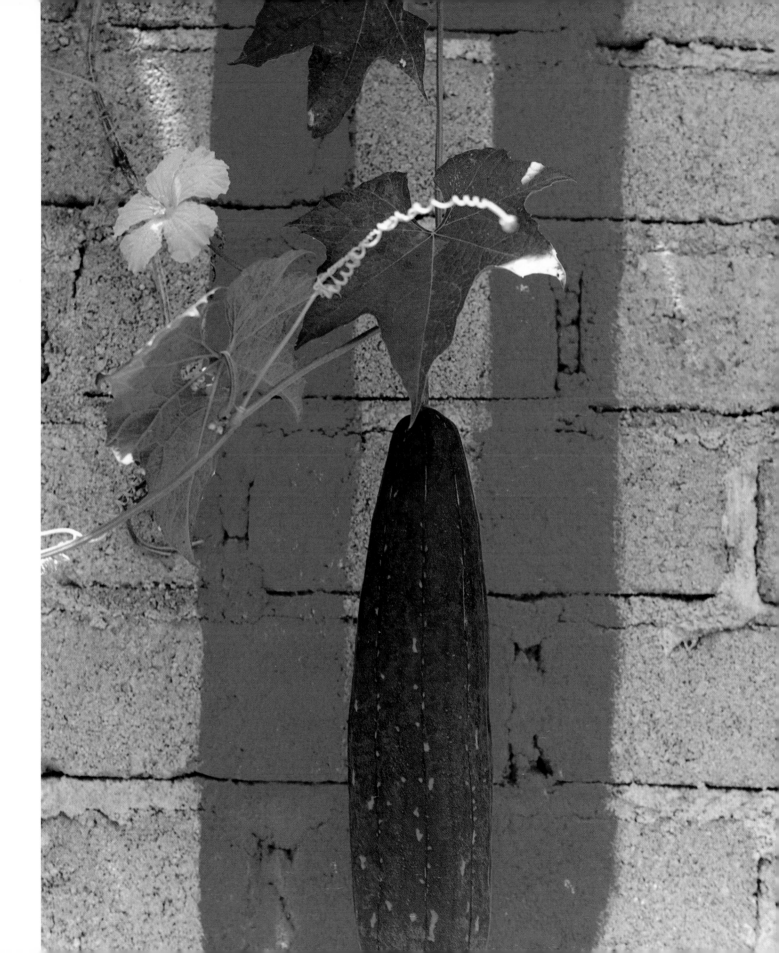

KODAK EKTAR *FILMS*

KODAK EKTAR Color Negative Film is designed for advanced amateur photographers who want to shoot top-quality color prints. EKTAR provides 35 mm camera owners a combination of sharpness, micro-fine grain, and advanced color techonology.

The two most important things to remember when selecting a film for color prints are film speed (sensitivity to light) and definition (graininess, sharpness, and resolution). To satisfy a range of photographic needs—from taking casual candids to framing the hard-to-get motion shot—Kodak manufactures three speeds of EKTAR Films—25, 100, and 1000.

EKTAR 25 Film takes pictures with details that are almost life-like in their sharpness and texture. It is the slow-speed film that Kodak recommends for photographing portraits, still-life scenes, and landscapes. It also makes lifelike enlargements.

EKTAR 100 Film is a very fine-grained, medium-speed film that is perfect for everyday picture taking. This versatile film is fast enough for most action shots and for many existing-light shots, both indoor and outdoor, and also takes sharp and colorful flash photographs.

At the fast end of the film-speed range is EKTAR 1000 Film. This film delivers sharp pictures with vibrant colors even in low-light conditions. With the camera set at high shutter speeds, this film can also freeze the trickiest fast-action shots.

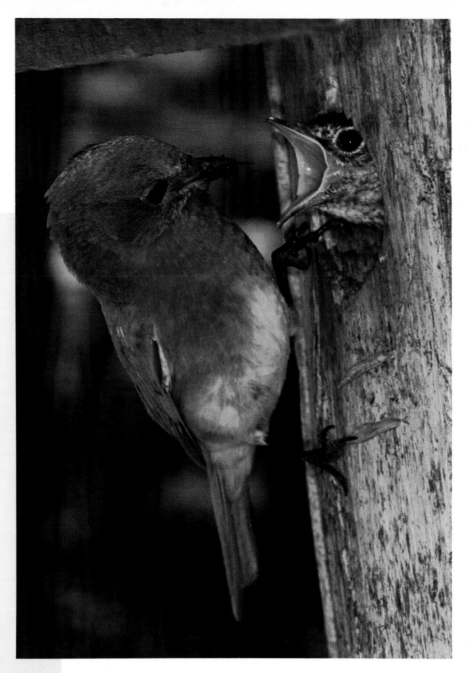

Feeding Time A male Eastern Bluebird feeding one of its young in Plympton, Massachusetts.
HONOR AWARD ALBERT A. DROLLETT Weymouth MA USA
The Boston Globe KODAK EKTAR 125 Film

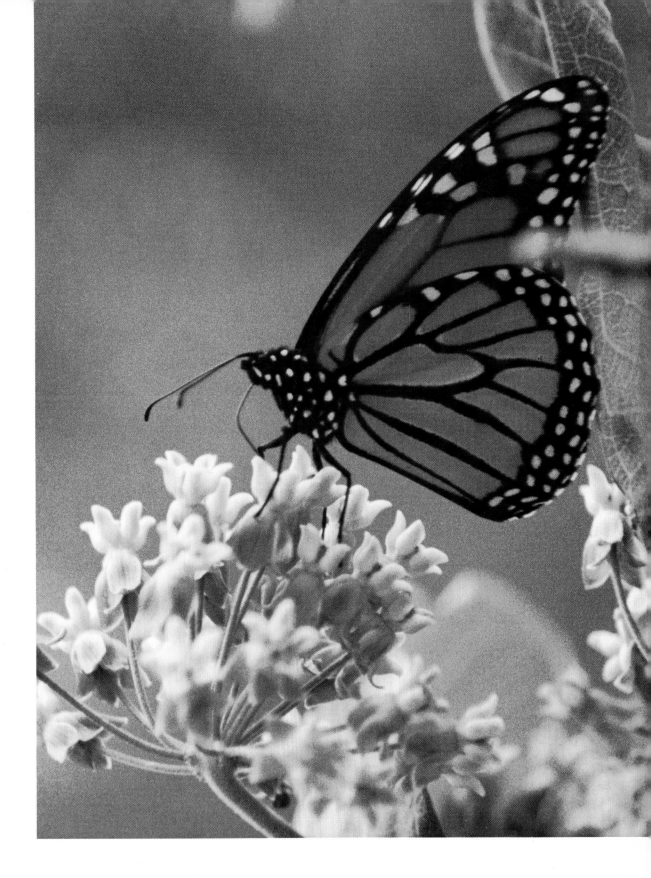

Meadow Splendor A butterfly sits on a field of milkweed blossoms outside Ebensburg, Pennsylvania.
MERIT AWARD BETH ANN OTT
Ebensburg PA USA
The Tribune-Democrat
KODAK EKTAR 1000 Film

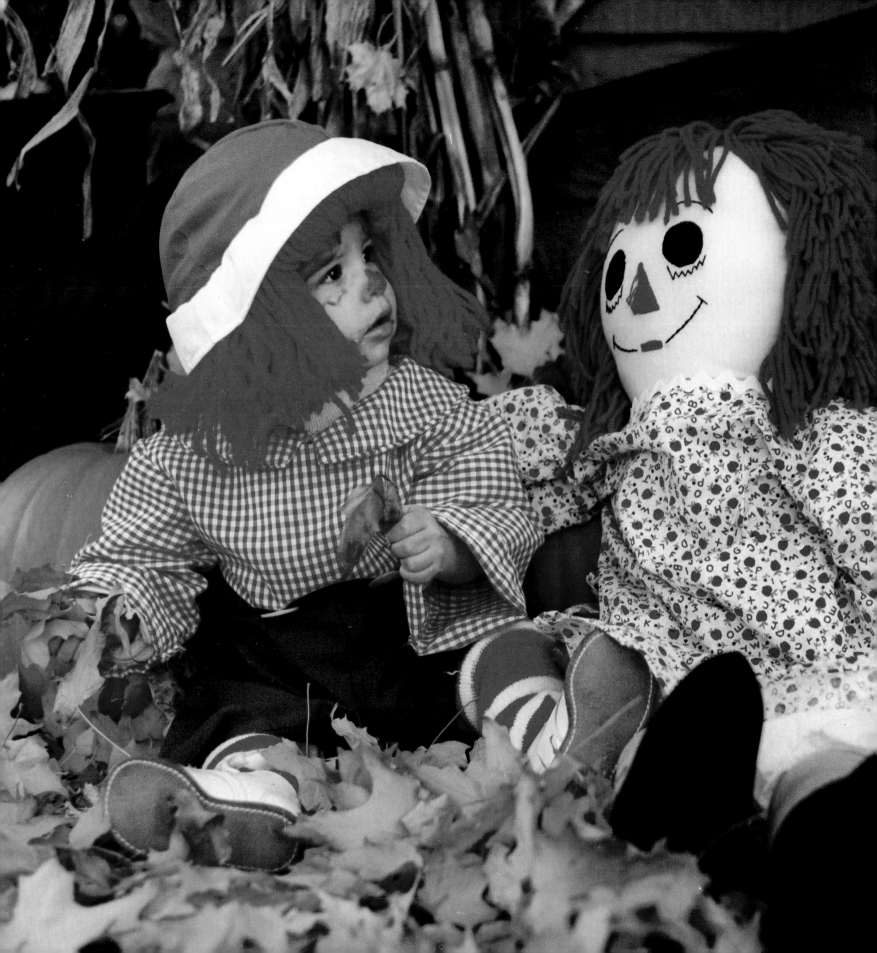

Blondes Have More Fun? Taken on Halloween—my daughter, Chelsey, was wearing her Raggedy Andy doll's clothes.
HONOR AWARD JUDY A. REHM Lockport NY USA
The Union-Sun & Journal KODAK EKTAR 125 Film

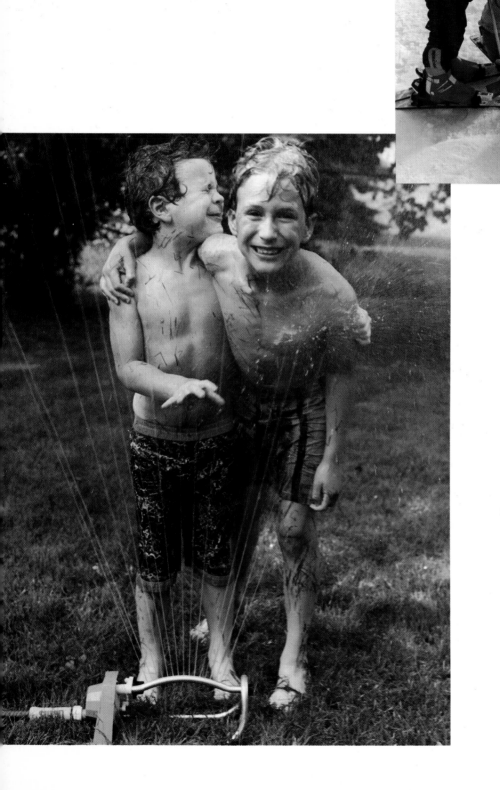

Soaked and Silly LEFT: My sons brought back my own memories by playing in the sprinkler on a hot summer day.
MERIT AWARD JEANNE KOLLMEYER Fond de Lac WI USA
The Reporter KODAK EKTAR 125 Film

Tangled Tots ABOVE: Young children learn to ski—and fall—at Interlachen, Switzerland.
MERIT AWARD SKIP LOWERY Ormond Beach FL USA
The News-Journal KODAK EKTAR 125 Film

A Summer to Remember OPPOSITE: Playing with a garden hose on a too-hot summer day.
MERIT AWARD ROSALIE M. STAIRE Mahomet IL USA
The News-Gazette KODAK EKTAR 25 Professional Film

Alex Thinking OPPOSITE, FAR RIGHT: My son had just finished swimming and was a little tired, and didn't care that he was unclothed.
MERIT AWARD DENISE E.S. PRELLER Congerville IL USA
The Pantagraph KODAK EKTAR 25 Professional Film

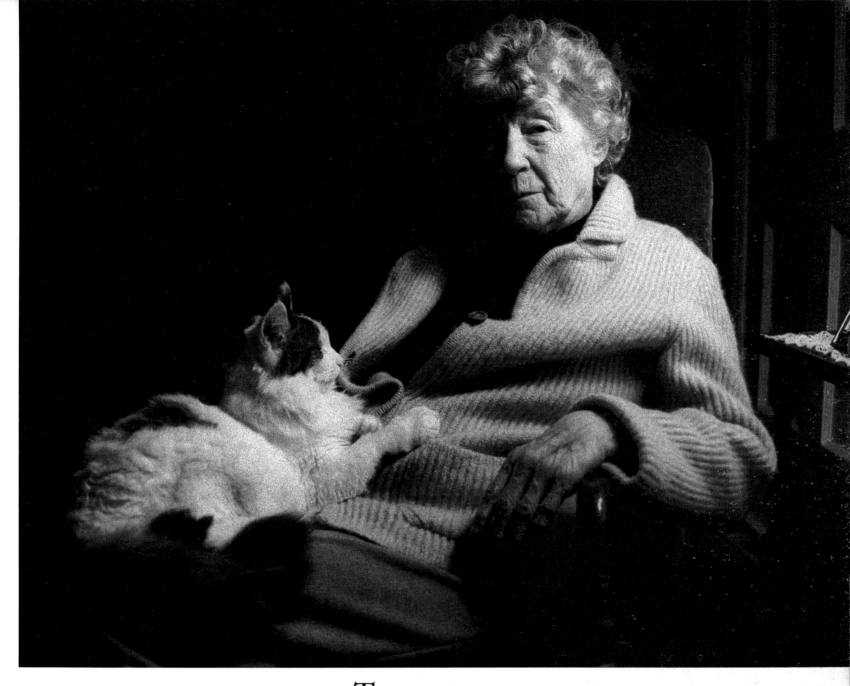

Mom and Marya ABOVE: My mother holding
our cat, Marya, in our living room.
MERIT AWARD JOAN E. BARRETT
Whitesboro NY USA *The Daily Sentinel*
KODAK TRI-X Pan Film

Pat and the Cat OPPOSITE: A self-portrait at
home.
HONOR AWARD PAT FORBELL Brookville FL USA
The Tribune KODAK T-MAX 400 Professional Film

Those of us who have friends and relatives over age 60 are
grateful for their wisdom and humor. We cherish our seniors who
bring their "young at heart and mind" attitude to every segment
of society. The photographs in this category capture the essence
of the lives and lifestyles of those who have journeyed past the
60-year milestone, whether with grace or by sheer tenacity.

About to Bloom This woman in St. Martin, sitting on a bench, with her arms crossed looks like she's about to bloom with her bright, flowered clothing and expression.
MERIT AWARD KAREN HILL Middletown NJ USA *The Times*
KODACOLOR VR-G 100 Film

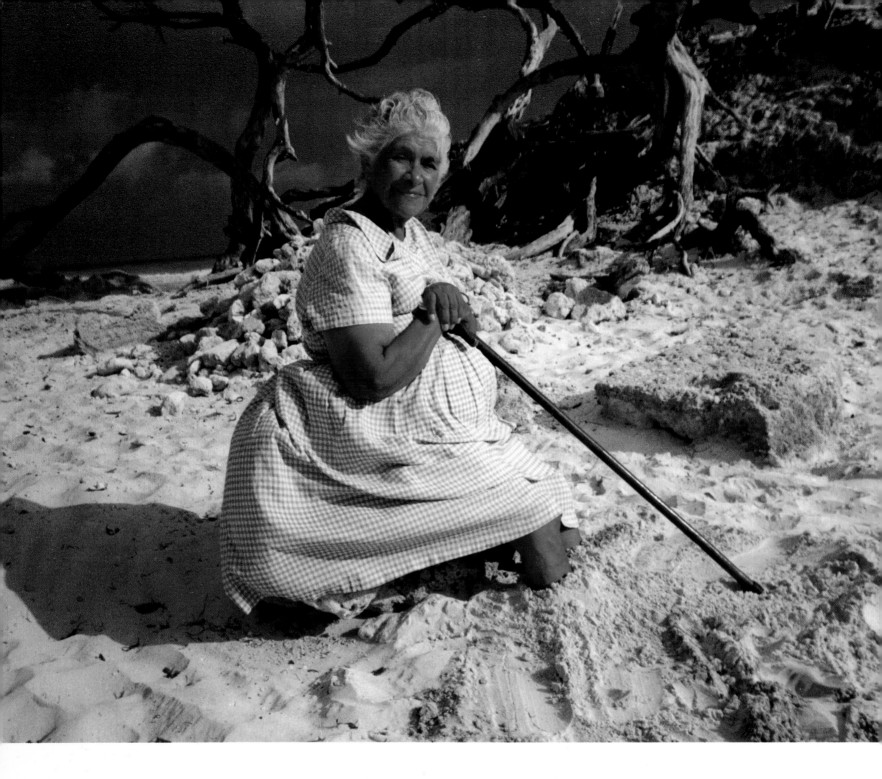

Cancun Cameo ABOVE: Woman on the beach at Cancun, Mexico.
HONOR AWARD HOWARD S. ALEXANDER
Lookout Mountain TN USA *The News-Free Press*
KODAK GOLD 100 Film

Hopeful Eyes on the Future OPPOSITE: Edith "Mae" Wilbur was 86 when she posed with her great-granddaughter, Rebecca. Edith died the following year.
HONOR AWARD SUSAN L. LAKE Hillsboro OR USA *The Argus*
KODAK GOLD 200 Film

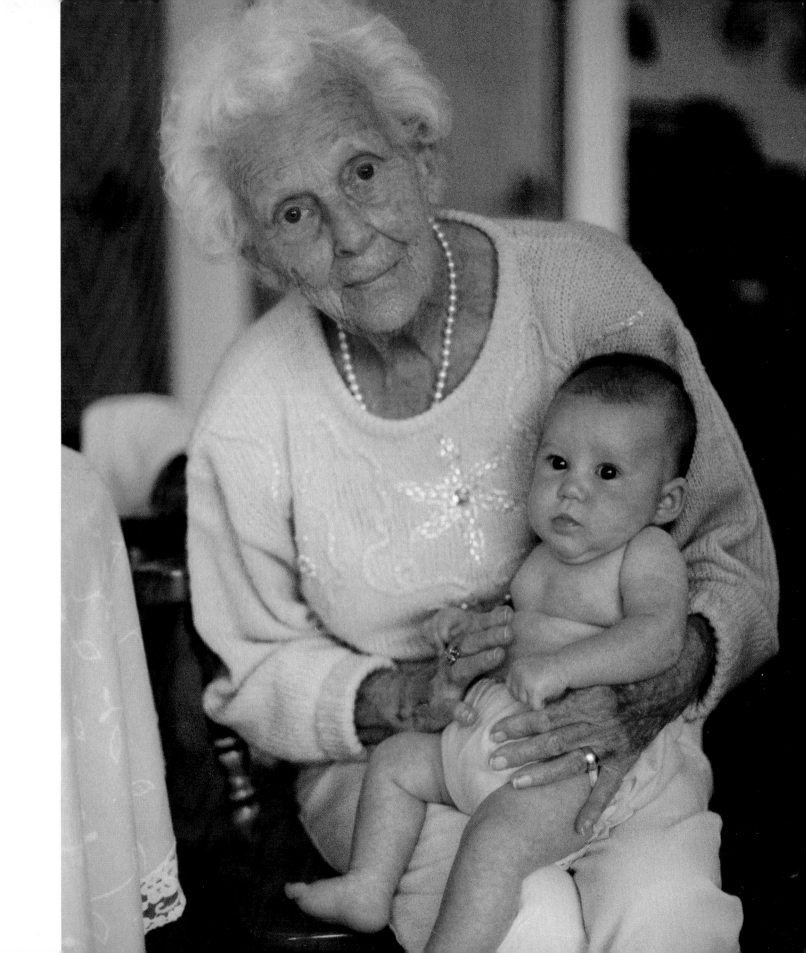

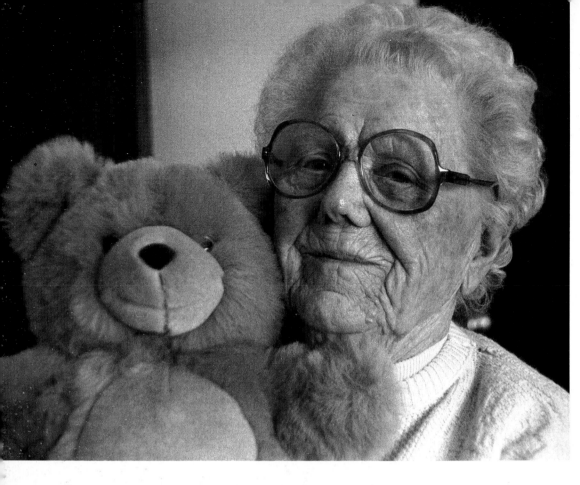

Mary Kostecki and a Friend LEFT: Portrait of Mary with her teddy bear.
MERIT AWARD TINA GAJEWSKI Mosinee WI USA
The Daily Herald KODAK T-MAX 400 Professional Film

I Love You, Grandpa! BELOW: An outgoing five-year-old, Nancy, and her elderly friend, Dr. Abner Overdeer.
MERIT AWARD EMILIE M. BOTTIGGI
Franklin TN USA *The Review-Appeal*
KODAK TRI-X Pan Film

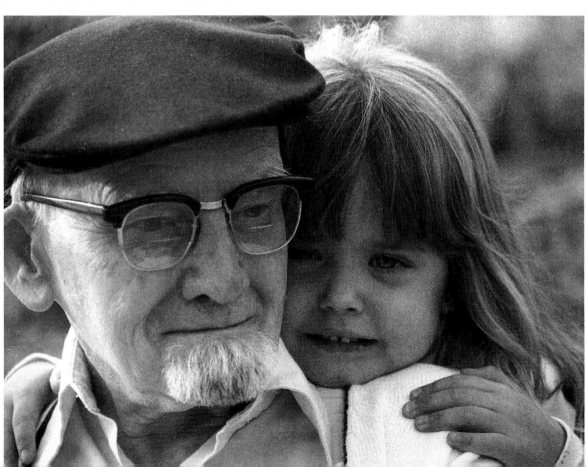

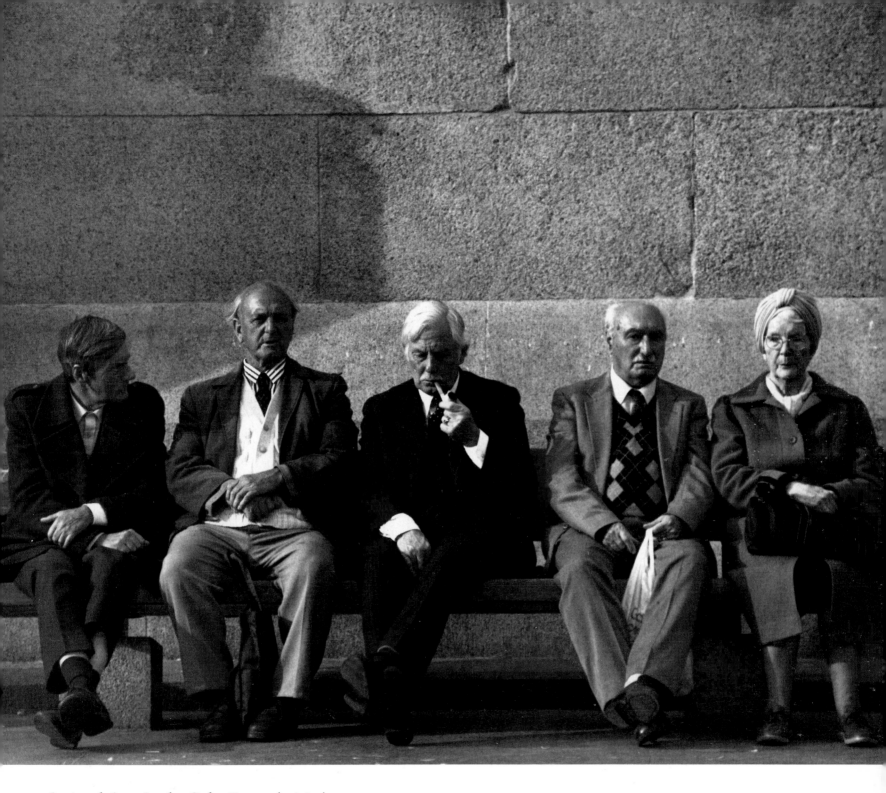

Contemplations, London Style Five people sit in the afternoon sun in Trafalgar Square, London.
HONOR AWARD DEBRA BLAHA Schenectady NY USA *The Gazette*
KODAK T-MAX 400 Professional Film

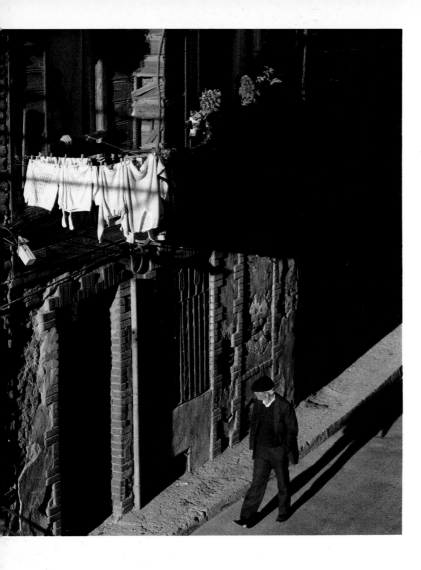

Constitutional Walk LEFT: Gentleman on a late afternoon walk in Istanbul, Turkey.
MERIT AWARD JIM CHAMBERS Greenville AL USA *The Advocate*
KODAK GOLD 200 Film

Old Traveler BELOW: This man on his cart is very old and travels the road between Encarnacion and Aguascalientes, Mexico.
MERIT AWARD JOAQUIN DUENAS NEGRETE
Col. San Marcos MEXICO *El Sol del Centro* KODAK GOLD 400 Film

Humble Kindness OPPOSITE: Feeding pigeons is an act repeated every day throughout the world.
MERIT AWARD RUBEN R. LOZANO Montarrey MEXICO *El Norte*
KODAK GOLD 100 Film

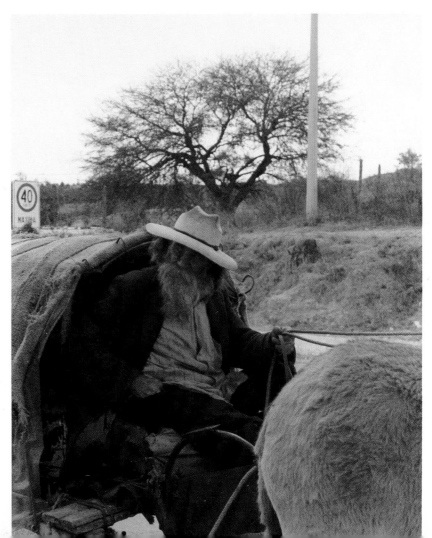

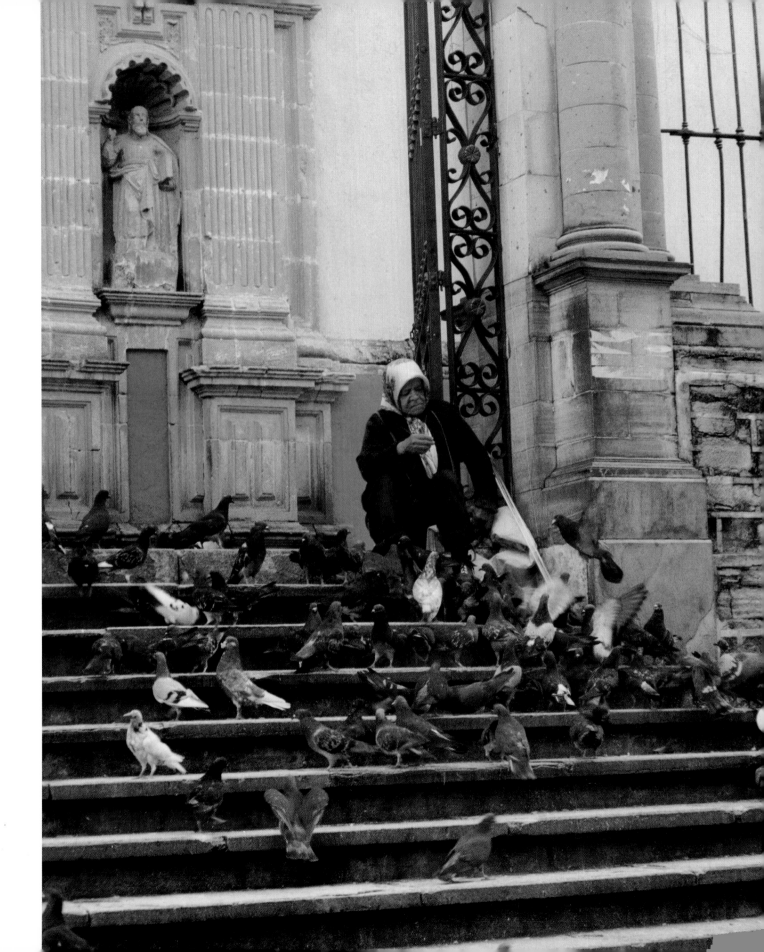

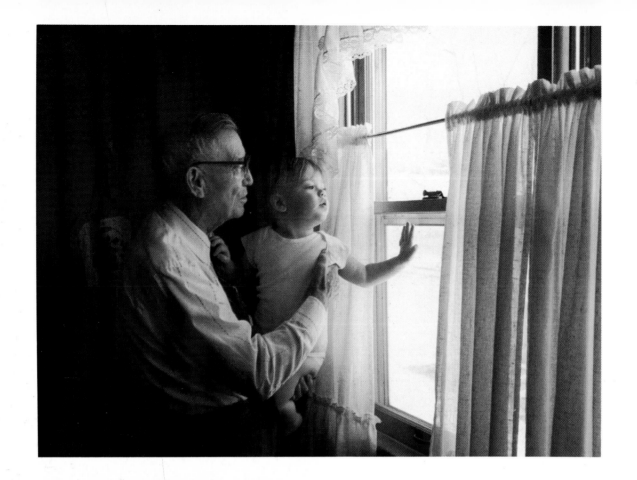

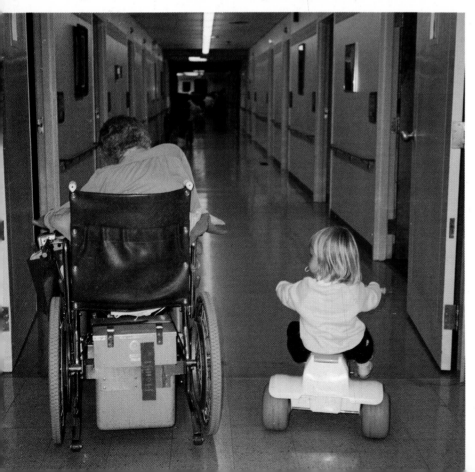

Generations of Love ABOVE: My grandfather holds his great-grandson to look out the window.
HONOR AWARD TAMARA S. HALE Atchison KS USA
The Daily Globe KODAK GOLD 400 Film

Generations LEFT: Great-grandmother and great-granddaugher cruise nursing-home halls together.
MERIT AWARD RUSS STODDARD Boise ID USA
The Idaho Statesman KODAK GOLD 100 Film

Forever Young ABOVE: Ninety-year-old Gramme with her granddaughter at a family barbeque.
MERIT AWARD MARY KATHLEEN MACISAAC
Calgary, Alberta CANADA *The Herald* KODAK GOLD 100 Film

A Little Walk and Talk RIGHT: Emma insists that her grandfather join her for a walk.
MERIT AWARD DAVID BANIGAN Toronto, Ontario CANADA
The Guardian KODAK GOLD 400 Film

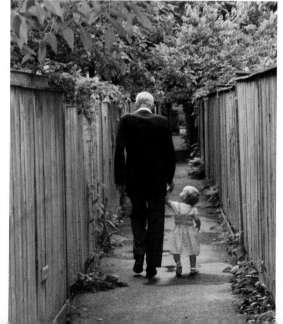

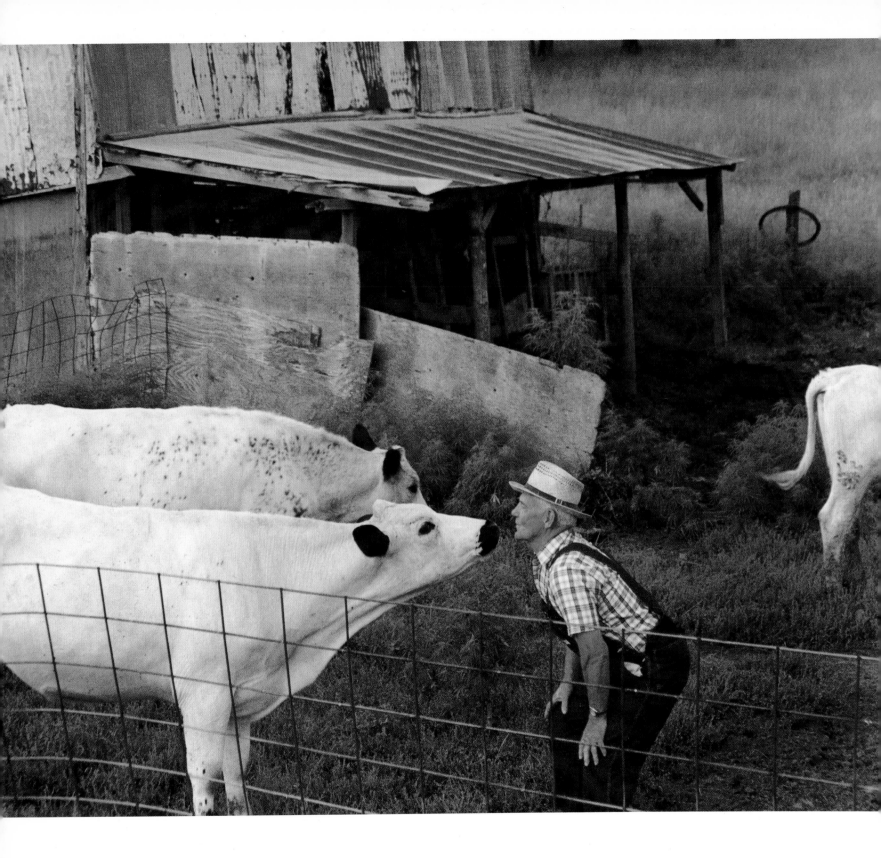

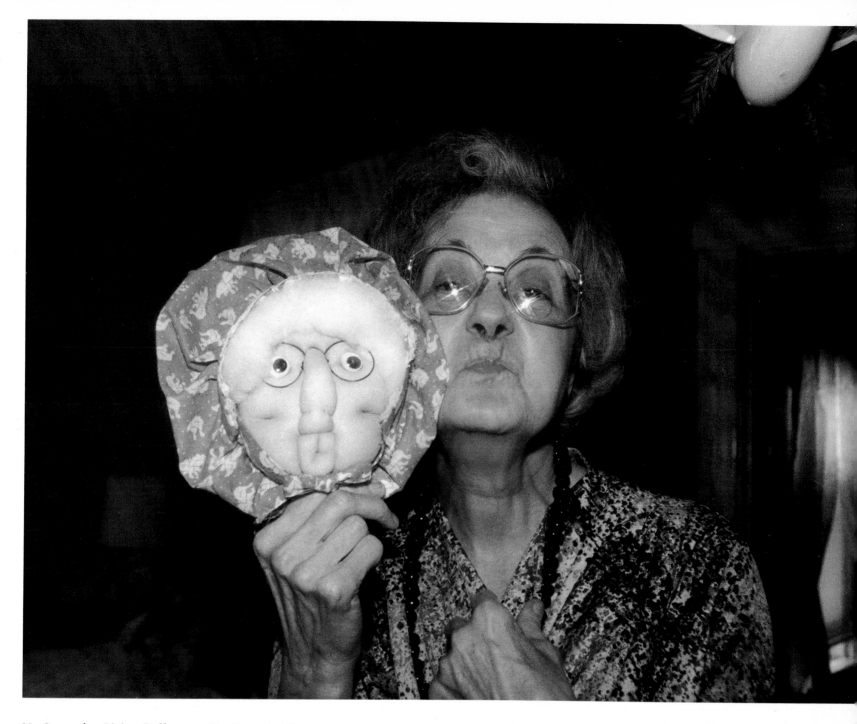

My Granny's a Living Doll ABOVE: My Granny holding a Granny doll to compare the likeness.
MERIT AWARD MELISSA LYNN HOWELL Dover TN USA
The Leaf-Chronicle KODAK GOLD 400 Film

Gimme a Smoooch! OPPOSITE: My father-in-law about to receive a kiss from one of his steers.
MERIT AWARD CAROL HAGER Atchison KS USA *The Daily Globe*
KODAK GOLD 200 Film

Stroke OVERLEAF: My husband at rowing school in West Palm Beach, from the chase boat.
MERIT AWARD MAY ELIZABETH BERRY Shreveport LA USA
The Times KODAK GOLD 100 Film

147

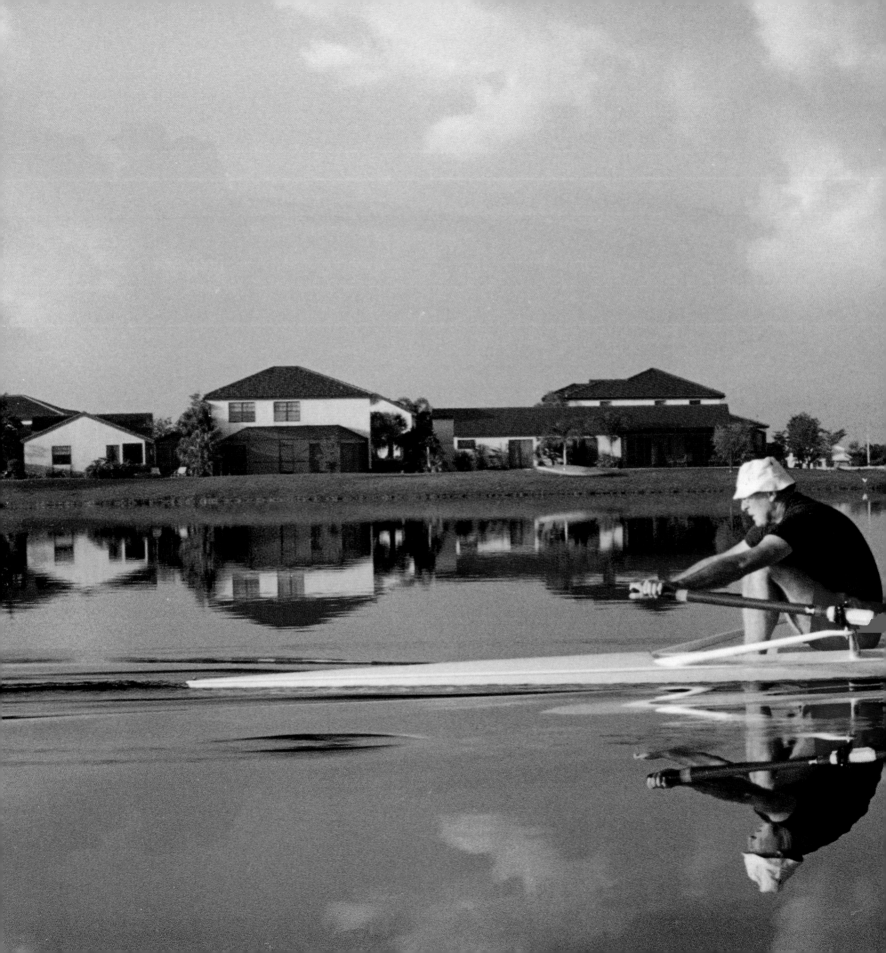

PRINTS FROM SLIDES
KODAK *TRANSPARENCY FILMS*

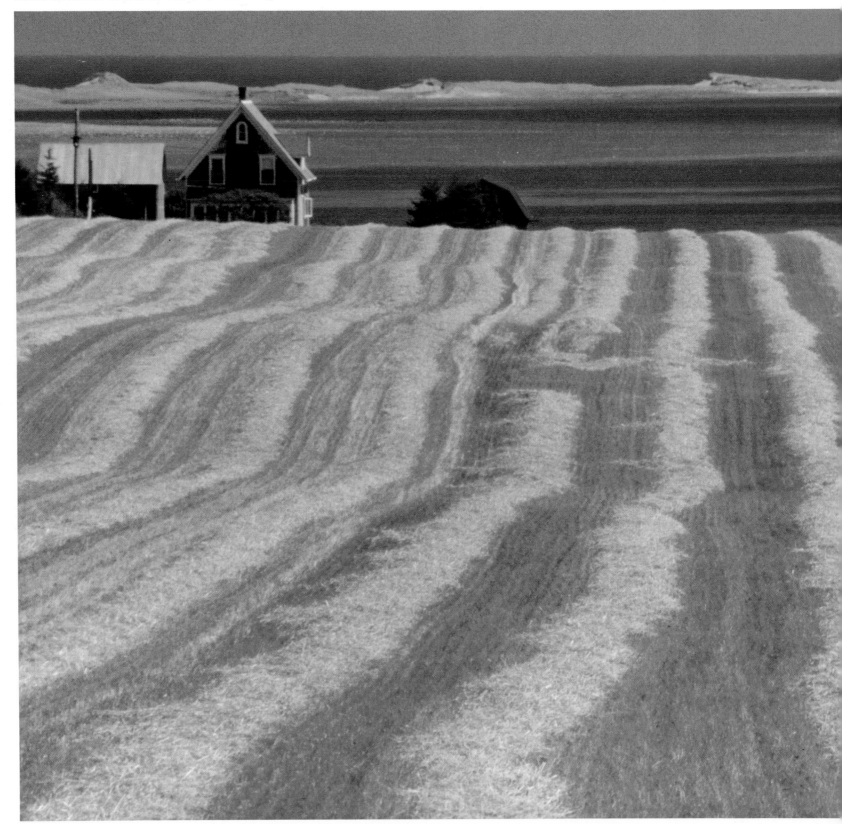

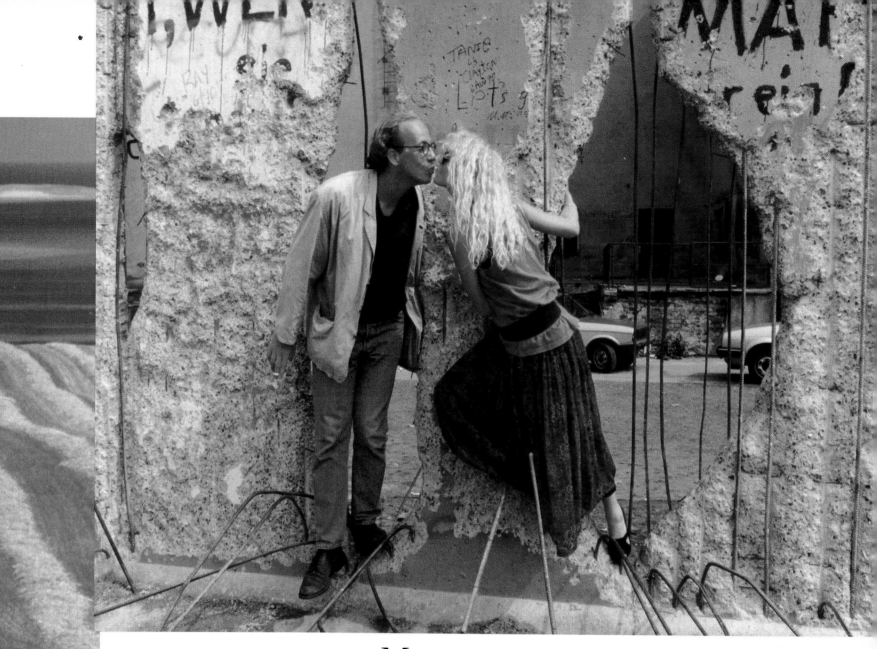

Reunification in Berlin
ABOVE: A couple kissing at the
demolished Berlin wall.
MERIT AWARD COLETTE F. JACOBS
Brooklyn NY USA
The Topeka Capital-Journal
KODAK EKTACHROME 100 Film

Grain Field OPPOSITE: Partially
harvested grainfield with a
farmhouse and New London Bay
in the background, Prince
Edward Island, Canada.
HONOR AWARD LOIS T. SCHUETZLER
Davidsonville MD USA *The Capital*
KODAK EKTACHROME 100 Film

Many amateur photographers prefer color slides because they
can easily be shared with friends. Good slides also make outstand-
ing enlargement prints. The photographs in this section, originally
taken with transparency film, display the same variety and special
quality that makes them award winners. Special consideration was
given to the way the photographs used color, composition, and
action to tell a story.

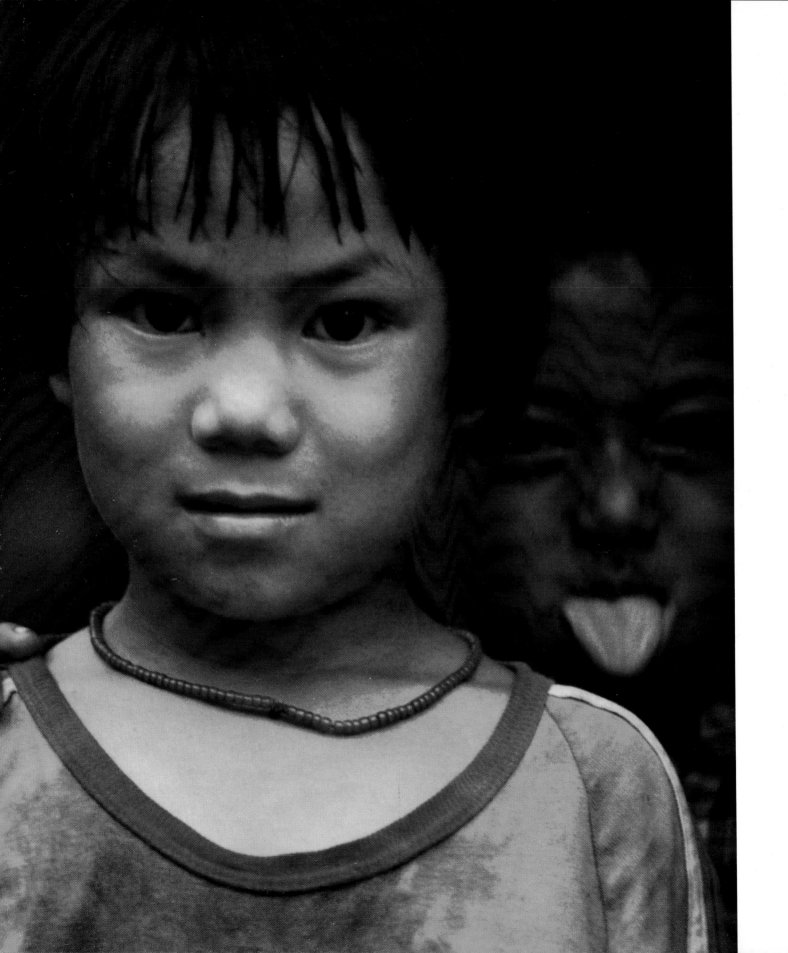

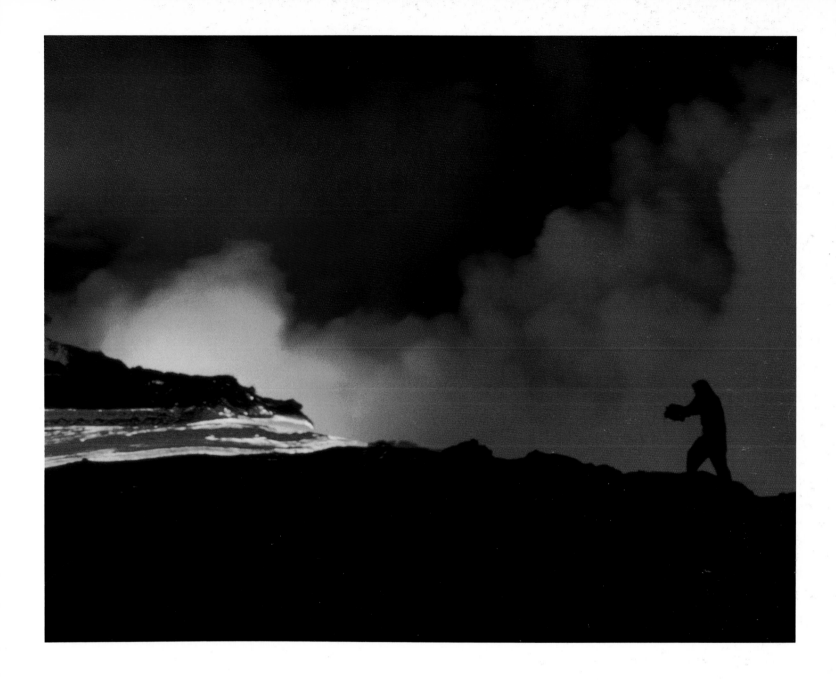

Edge of Fire ABOVE: Molten lava breaks out at the coastline
in Volcanoes National Park, Hawaii.
MERIT AWARD HAROLD G. SMITH Oak Ridge TN USA
The Oak Ridger KODAK EKTACHROME 64 Film

Innocence of Childhood OPPOSITE: Two Thai children in
Aku Village, Thailand.
HONOR AWARD DR. MICHAEL A. NEWMAN Yardley PA USA
The Times KODACHROME 64 Professional Film

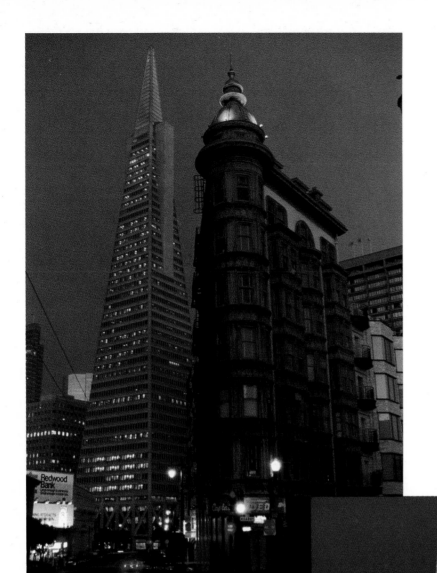

Sheep Drive, Monument Valley OPPOSITE: Navajos herd sheep down a steep ridge in Monument Valley, Utah.
MERIT AWARD CAROLE L. HAGAMAN Blackstone VA USA
The News Leader KODACHROME 64 Professional Film

San Francisco RIGHT: Victorian houses—"Painted Ladies"—with San Francisco in background.
MERIT AWARD DR. MARY LOU HOLLIS
Kalamazoo MI USA *The Gazette*
KODAK EKTACHROME 50 HC Film

The Old and the New ABOVE: Changing eras of architecture at dusk in San Francisco.
MERIT AWARD DR. MARY LOU HOLLIS
Kalamazoo MI USA *The Gazette*
KODAK EKTACHROME 100 Film

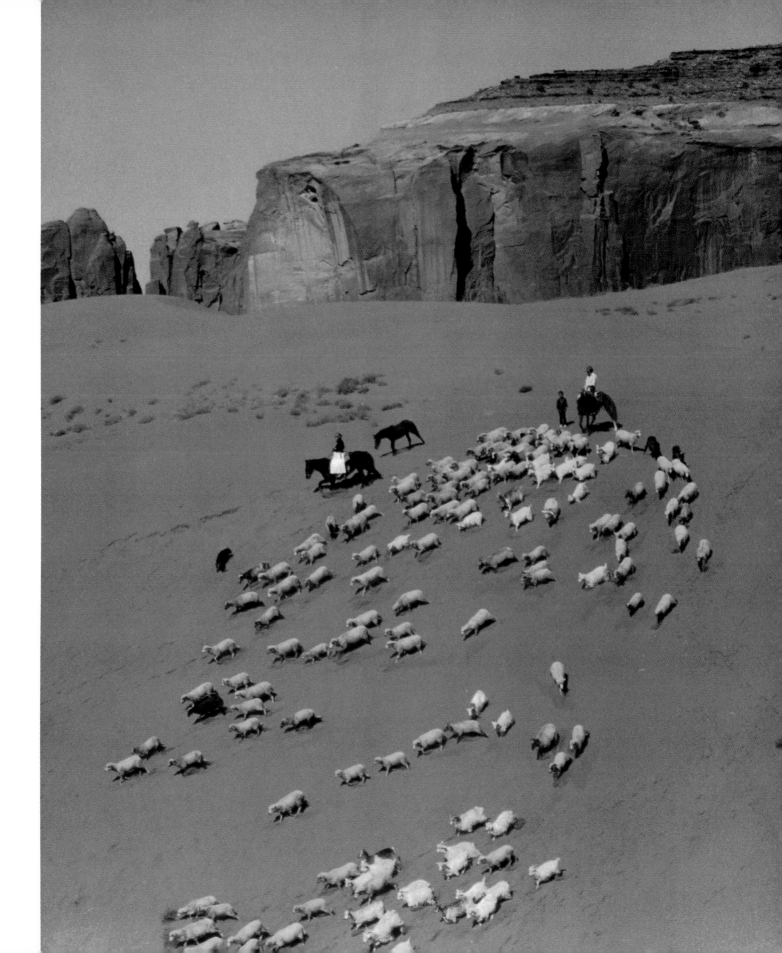

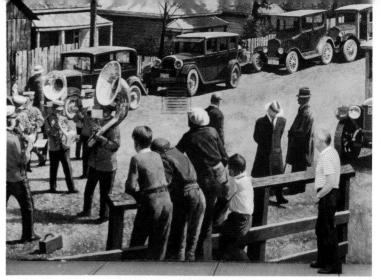

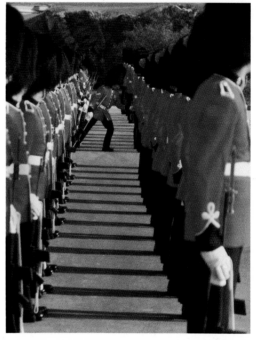

King of the Castle TOP LEFT: My children climbing on an ice castle.
MERIT AWARD WILLIAM R. FETTES Regina, Saskatchewan CANADA
The Leader-Post KODACHROME 64 Professional Film

Watching! ABOVE RIGHT: My husband, incorporated into one of the mural's "watchers."
MERIT AWARD VIVIANE M. FIOR
Saskatoon, Saskatchewan CANADA *The Star Phoenix*
KODACHROME 64 Professional Film

Royal Canadian Goose RIGHT: Canadian guards in—and out of—formation.
MERIT AWARD DAVID B. FINGERHUT Townsend MA USA
The Boston Globe KODACHROME 64 Professional Film

Companions BELOW: Street vendors in colorful clothing, Leon, Mexico.
HONOR AWARD FRANCISCO ARANDA SALAZAR
Sebastian Leon MEXICO *El Sol de Leon*
KODACHROME 64 Professional Film

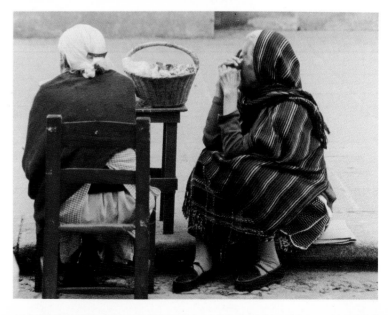

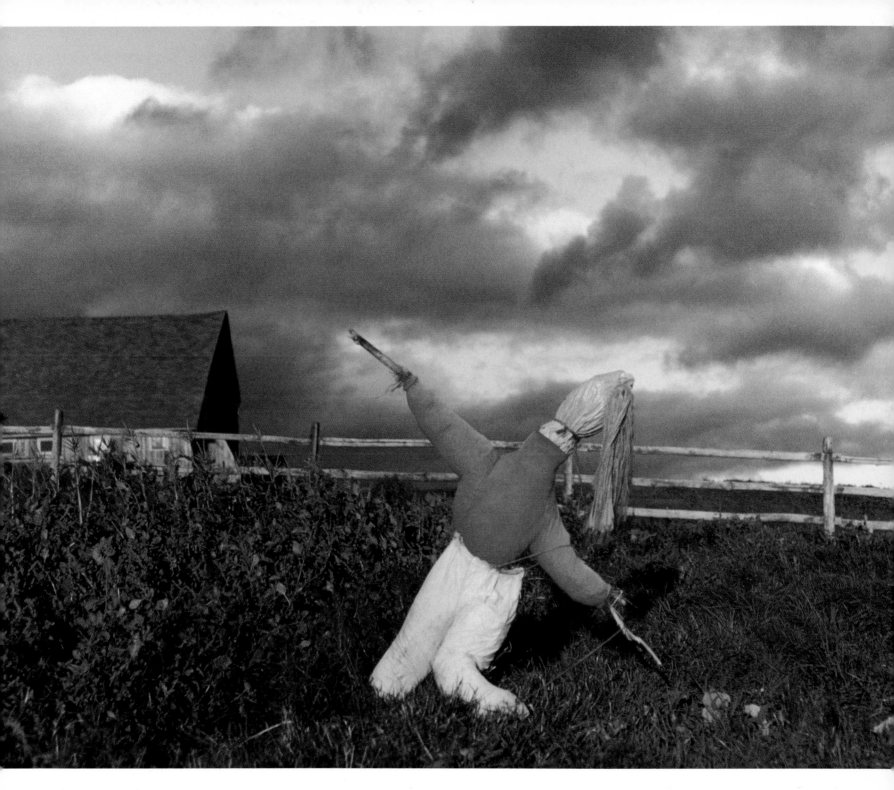

The Scarecrow's Dance A Ruppert, Vermont, scarecrow
dances before a dramatic cloud background.
MERIT AWARD DOUGLAS E. HERRMANN Scotia NY USA
The Gazette KODACHROME 64 Professional Film

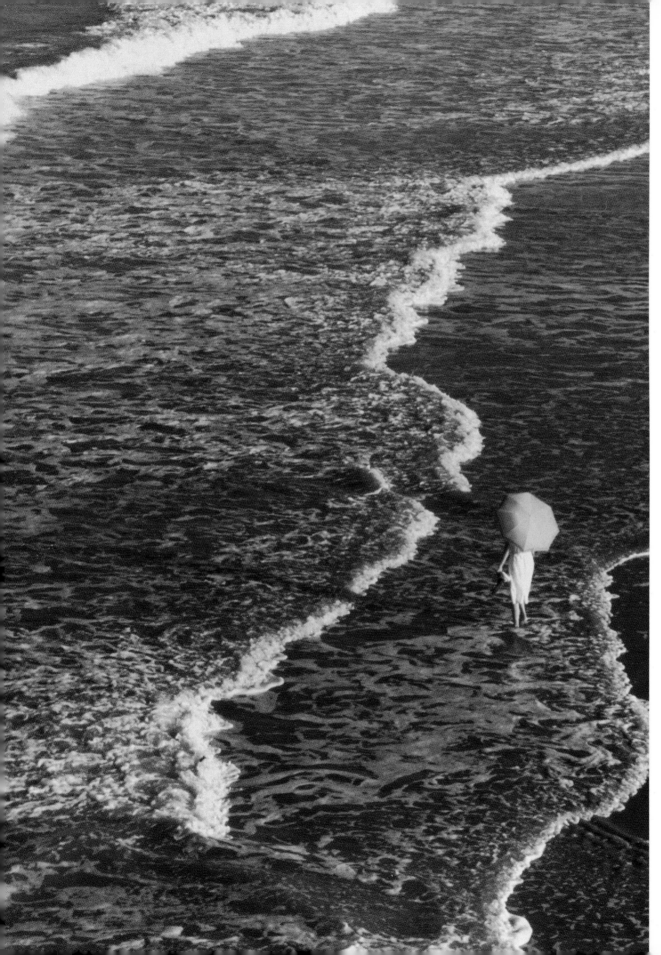

The Sea LEFT: Ocean, woman, and parasol.
MERIT AWARD CHARLES JING
Baltimore MD USA
The Baltimore Sun
KODAK EKTACHROME 64 Film

Early Morning at Peggy's Cove
OPPOSITE, TOP LEFT: Dinghy, lobster traps, and reflections in calm water.
MERIT AWARD DEAN PENNALA
Plainwell MI USA *The Gazette*
KODACHROME 25 Film

Fish Out of Water OPPOSITE, TOP RIGHT: Outdoor market in Tokyo, Japan.
MERIT AWARD LEON GOLDENBERG
Tampa FL USA *The Tribune*
KODACHROME 64 Professional Film

Four River Boats OPPOSITE, BOTTOM LEFT: Pattern of boats in Nova Scotia from a nearby bridge.
HONOR AWARD
DIANE FERBER COLLINS
Stamford CT USA *The Advocate*
KODAK EKTACHROME 200 Film

Abstract with Flower Petals
OPPOSITE, BOTTOM RIGHT: Rose petals and yellow lily petals through textured glass.
MERIT AWARD PARASTOO FARZAD
Vestavia AL USA *The News*
KODAK EKTACHROME 100 Film

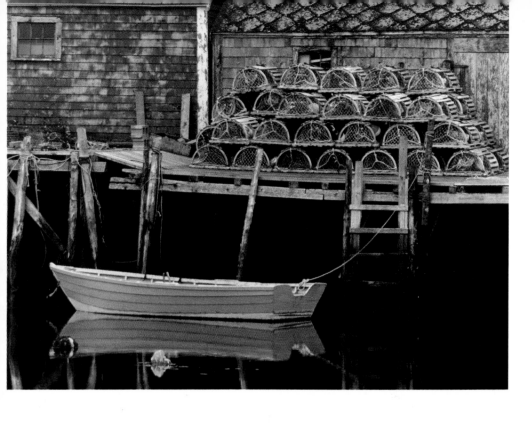

KODAK COLOR SLIDE FILMS

Color slide enthusiasts have a wide range of film choices. Transparency film is the best choice for viewing pictures with projectors or hand-held viewers. Yet slides can also be made into color prints and enlargements, or even transferred onto video tape.

Slow-speed films are sharp and very fine grained. Fast films help stop quick movement, provide greater depth of field, and make picture-taking easy in daylight.

If you want to photograph a child playing with a menagerie of stuffed animals, use a medium-speed film to bring out details and brightness. But if the goal is to capture the face of a spinning dancer in a crowded room with subdued lighting, use a fast film. Experiment. Try lots of different speeds. You may get some unexpectedly good photos.

Kodak offers two major types of color slide film—KODACHROME and EKTACHROME—each in a variety of film speeds to help ensure quality images.

KODACHROME Film is known for its rich colors, minimal grain, and exceptional sharpness. It comes in a range of speeds—or ISO ratings—25, 40, 64, and 200.

EKTACHROME Film also produces color slides. It comes in a variety of speeds—ISO 50, 100, 160, 200, and 400—that cover nearly all situations you might encounter.

Choosing the best film for different situations takes practice, but with the right speed, the proper lighting conditions, and a photogenic subject, anyone can shoot memorable photographs.

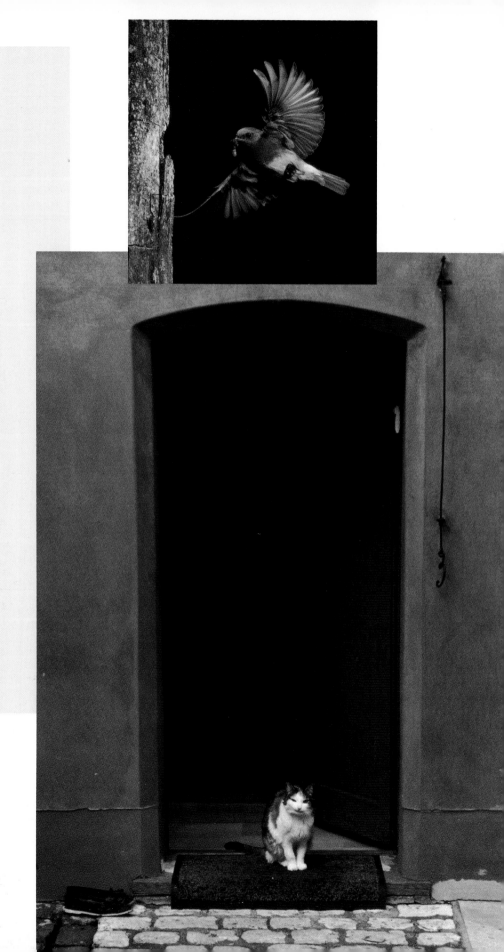

A Family to Feed TOP: An Eastern Bluebird brings food to its nest in a fence post.
MERIT AWARD HAROLD B. KEY Jackson TN USA
The Sun KODACHROME 64 Professional Film

Welcome—Remove Shoes Before Entering
RIGHT: German cat in an open doorway.
MERIT AWARD BILL MCIVER
Fort Lauderdale FL USA *The Sun-Sentinel*
KODACHROME 200 Film

Unexpected Trip RIGHT: A horse hits a jump and falls in the last race of the Gold Cup, Lexington, Kentucky.
MERIT AWARD Dr. James N. Sauer Tomahawk WI USA
The Milwaukee Journal KODAK EKTACHROME 400 Film

Say Cheese! BELOW: Squirrel photographing squirrel.
HONOR AWARD David S. Pugh Richmond VA USA
The News Leader KODAK EKTACHROME 100 Film

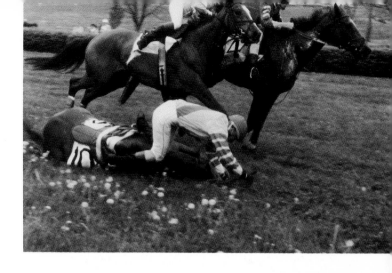

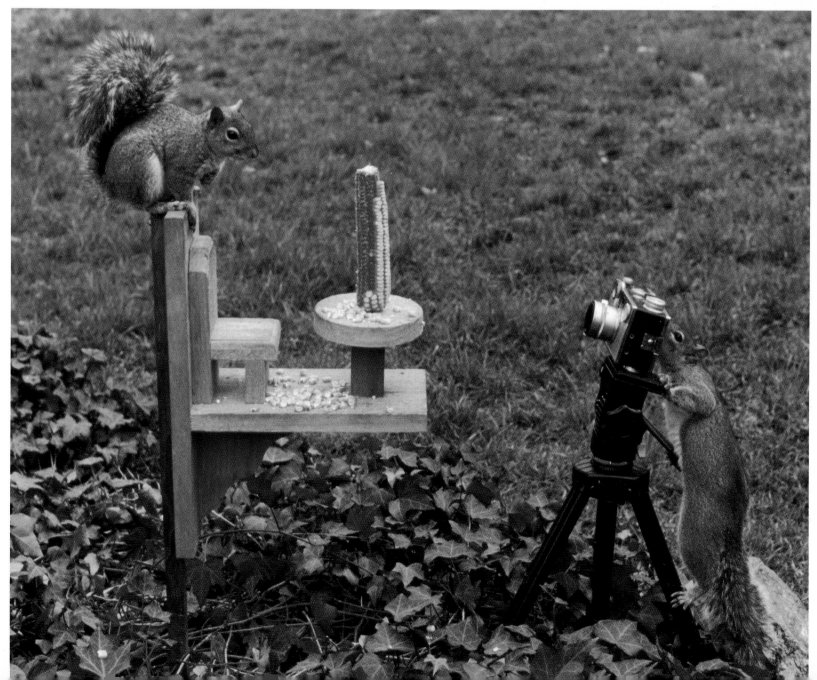

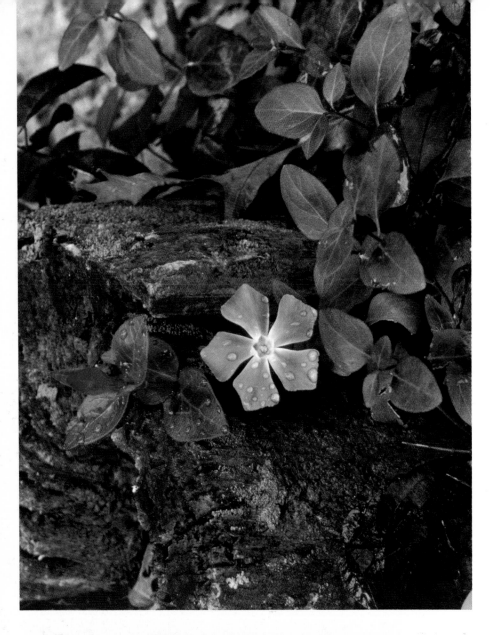

Wild Periwinkle LEFT: Wild periwinkle. I sprayed on the water drops.
MERIT AWARD C. P. GODDARD Natchez MS USA *The Democrat*
KODACHROME 64 Professional Film

Autumn BOTTOM LEFT: Oak leaf and grass laced with frost.
MERIT AWARD MAX GIDDINGS Kalamazoo MI USA *The Gazette*
KODACHROME 64 Professional Film

Bloom Where You Are Planted BELOW: Flowers among large green leaves.
MERIT AWARD DR. JAMES W. MUNSON Kalamazoo MI USA
The Gazette KODACHROME 64 Professional Film

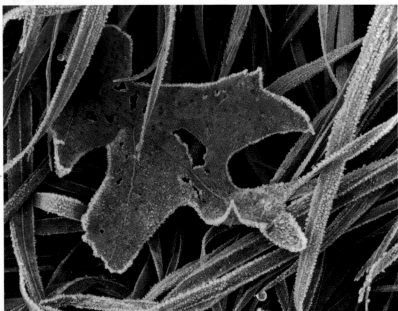

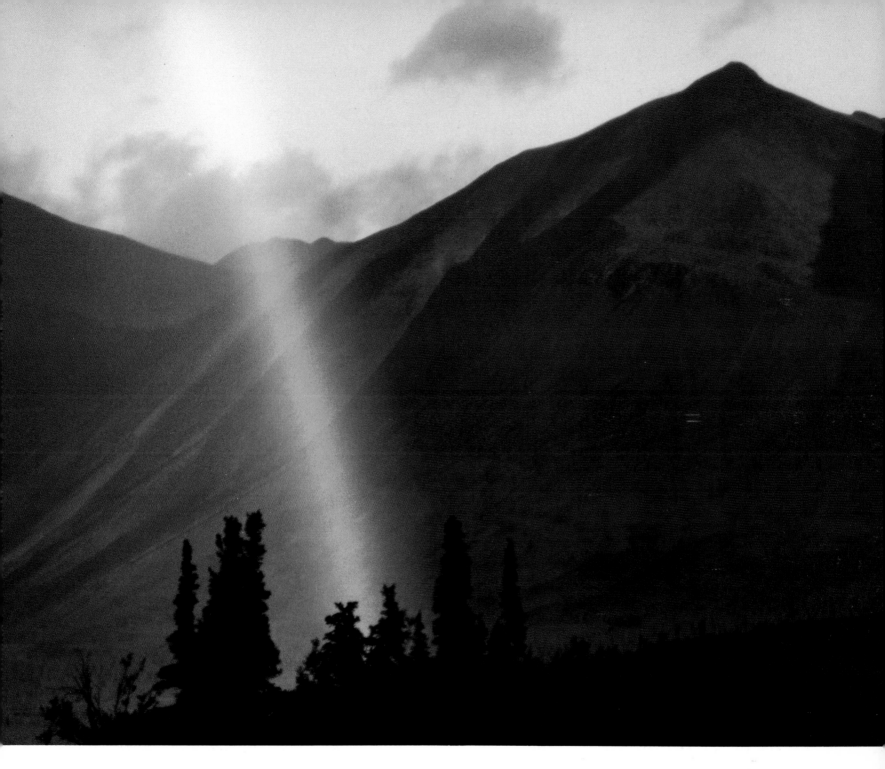

Treasures of Alaska Arched across our passage into the interior bush country of Alaska, this rainbow promises a safe journey.
MERIT AWARD Eva Moore Marion NY USA *The Times-News*
KODACHROME 64 Professional Film

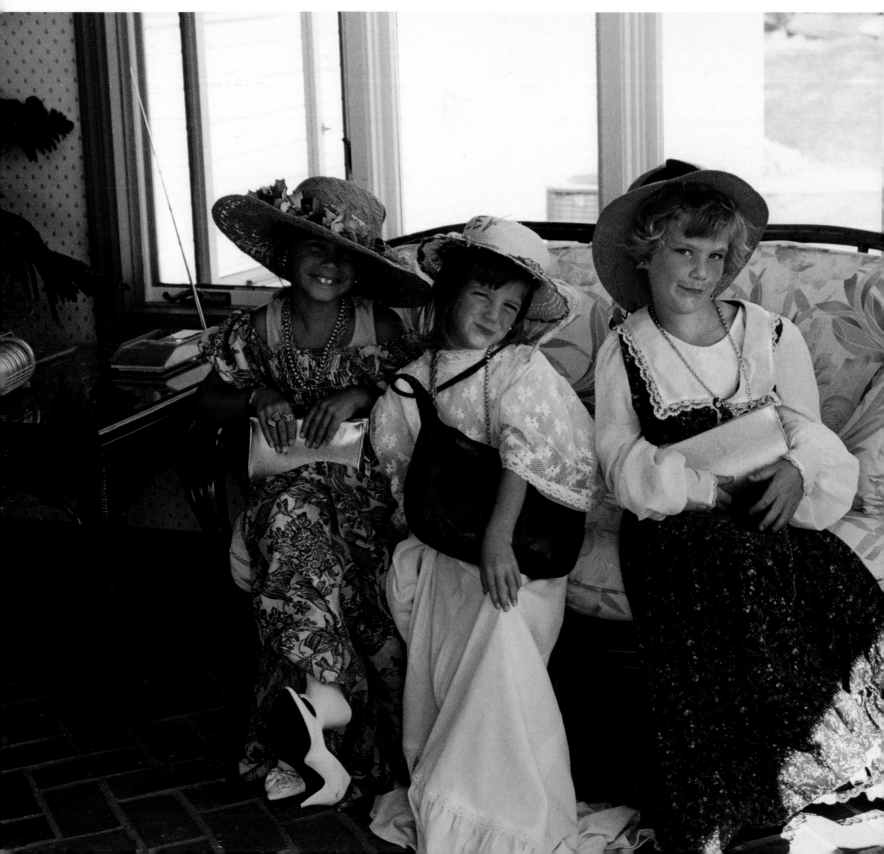

VISIONS OF THE HEART
SPECIAL MOMENTS

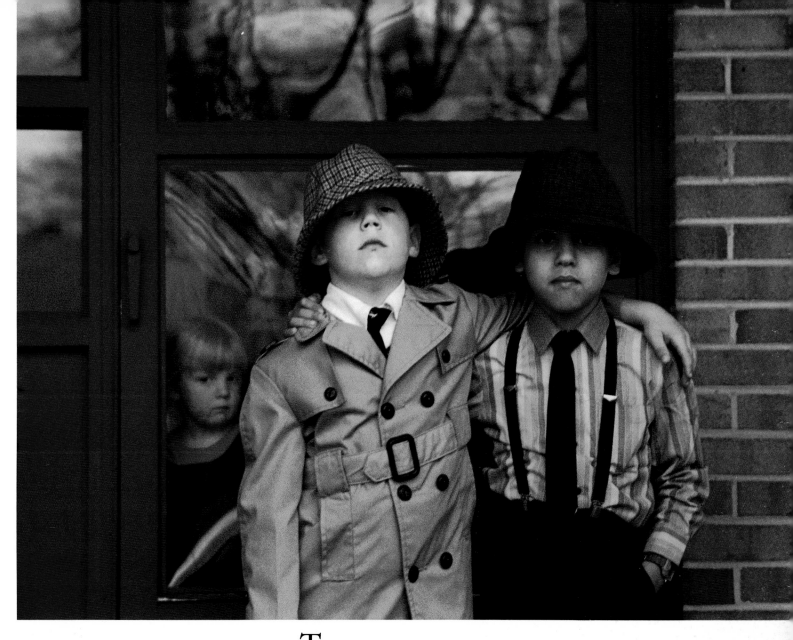

Tomorrow's Tycoons
ABOVE: Small boys playing
business tycoons.
MERIT AWARD JEAN JONES
Anchorage AK USA *The Times*
KODAK GOLD 200 Film

Sitting Pretty OPPOSITE: Girls
play dress-up on the sun porch.
HONOR AWARD NED ENSMINGER
Lancaster PA USA *The Sunday News*
KODAK GOLD 100 Film

The wonderful thing about these photographs is that they make the invisible visible. The bonds of friendship, the optimism of youth, the shock and delight of surprise, the joys of love—whether quiet or exuberant—are conveyed in the images presented here. Photographers who capture such moments feel a great satisfaction—as if the photo itself were a prize. And we viewers feel a connection to these familiar expressions of the human spirit.

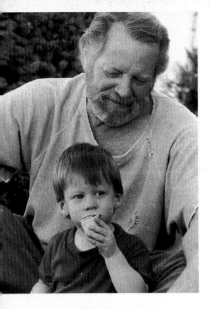

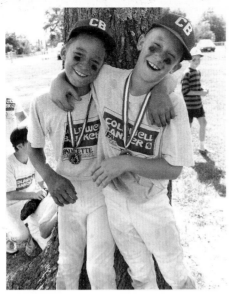

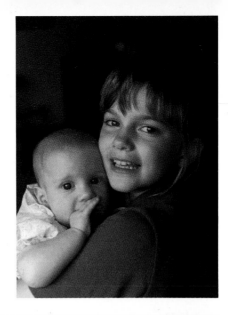

Life's Little Pleasures TOP LEFT: Grandfather, grandson, and ice cream.
MERIT AWARD JACI GRAFT Uniontown PA USA
The Herald-Standard
KODAK TRI-X Pan Film

After the Big Win TOP CENTER: A championship season.
MERIT AWARD ALBERT BUCHANAN SKILES Fayetteville AR USA
The Northwest Times
KODAK T-MAX 100 Professional Film

Sisters TOP RIGHT: Older sister holding baby.
MERIT AWARD ANN COVINGTON Fayetteville AR USA
The Northwest Times
KODAK GOLD 100 Film

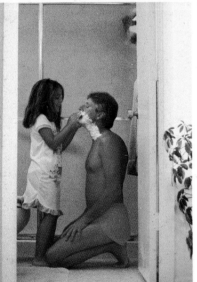

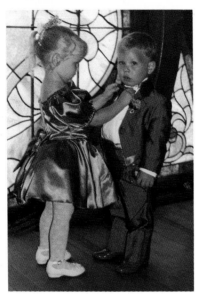

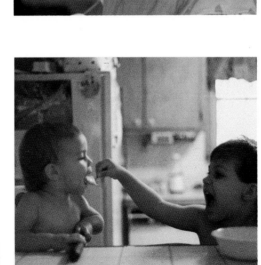

Daddy's Little Girl MIDDLE LEFT: Preparing Dad to shave.
MERIT AWARD DEBORAH ELLIS Palm City FL USA *The News*
KODAK GOLD 400 Film

Is This Necessary? CENTER: Straightening the ringbearer's tie.
MERIT AWARD JAN CORRIGAN Quincy IL USA *The Herald-Whig*
KODAK GOLD 200 Film

Do You Like My Hat? CENTER RIGHT: A hat for the sun.
MERIT AWARD ROSEMARY JOHNSON Ford City PA USA *The Leader-Times*
KODAK GOLD 200 Film

The Mother BOTTOM LEFT: My wife and son on our farm in southern Chile.
MERIT AWARD ENRIQUE REICHHARD Santiago, CHILE *El Mercurio*
KODAK GOLD 100 Film

Kelly's First Fish BOTTOM CENTER: Fishing derby—her first fish.
MERIT AWARD JOY A. SOHMER Hatboro PA USA
The Intelligencer-The Record
KODAK GOLD 200 Film

Open Wide BOTTOM RIGHT: Son feeding daughter ice cream.
MERIT AWARD BEVERLY PONDER Cairo GA USA *The Times-Enterprise*
KODAK GOLD 400 Film

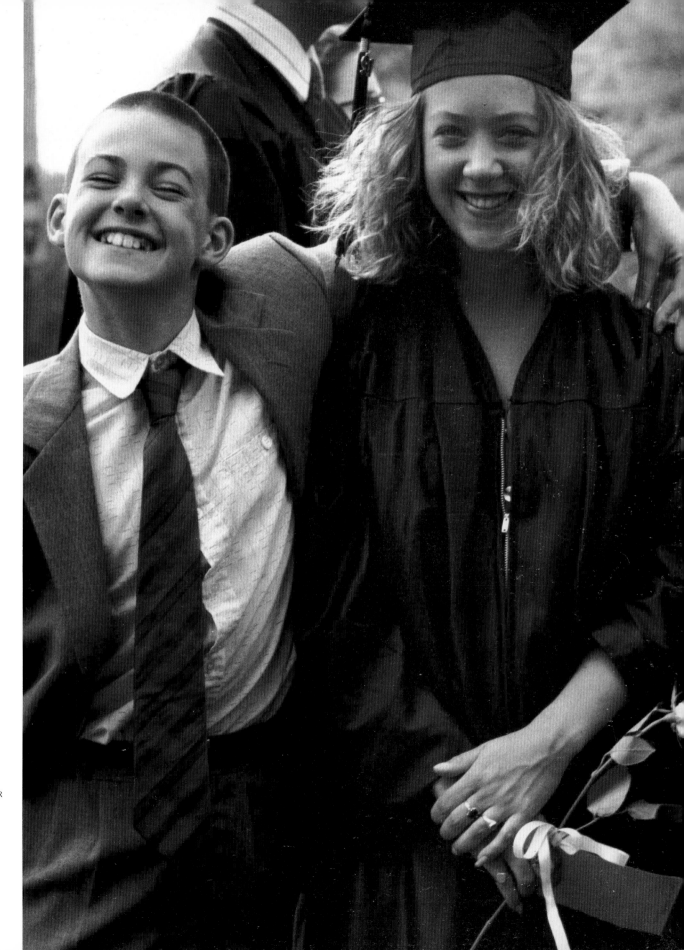

The Graduates
RIGHT: Graduation.
HONOR AWARD CONSTANCE FIEDLER
Stone Ridge NY USA
The Daily Freeman
KODAK T-MAX 100 Professional Film

Field of Dreams Ball players at a fastball game on a sunny day.
HONOR AWARD NICK LEUNG Saskatoon, Saskatchewan CANADA
The Star Phoenix KODAK High Speed Infrared Film 2481

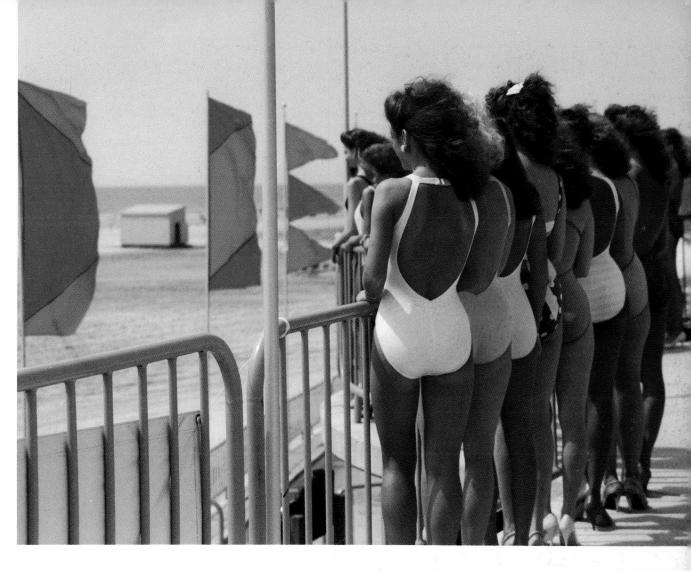

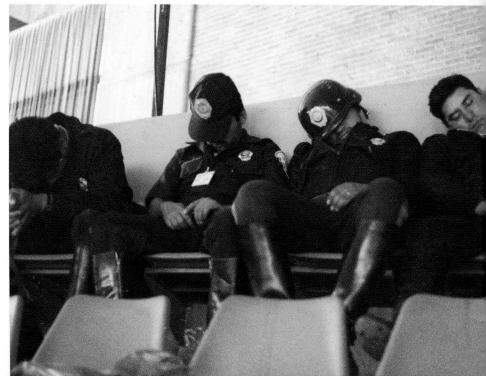

Beauty and the Beach ABOVE: New Jersey beauty contestants look longingly at the beach.
MERIT AWARD JOANNE J. HECKMAN Wildwood NJ USA *The Press*
KODAK GOLD 100 Film

Sleeping Police RIGHT: Four tired policemen on the last day of a karate tournament.
MERIT AWARD HORACIO GABRIEL RIVERA RANGEL
Col. Condesa MEXICO *El Universal* KODAK GOLD 200 Film

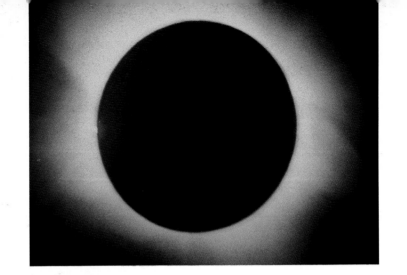

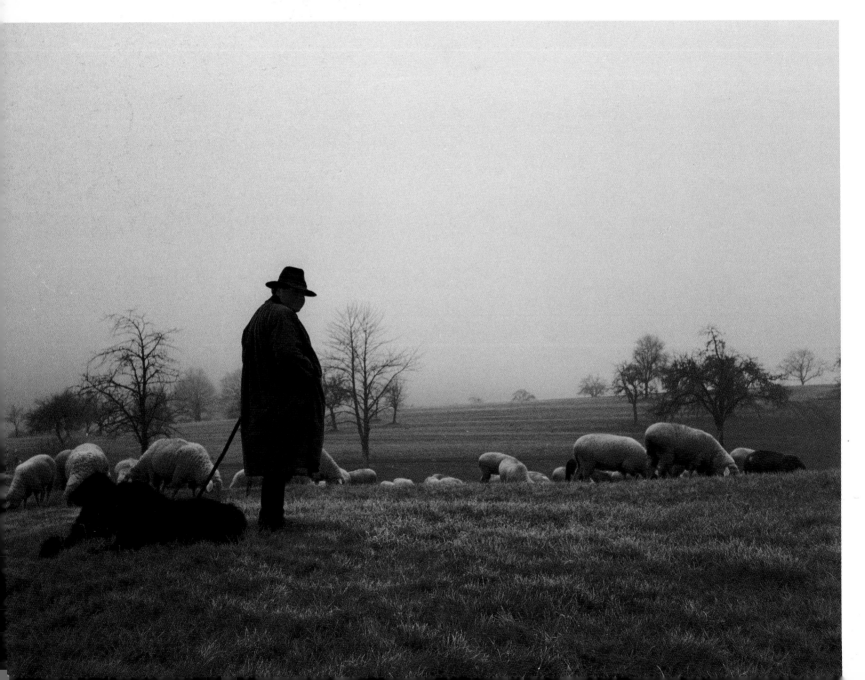

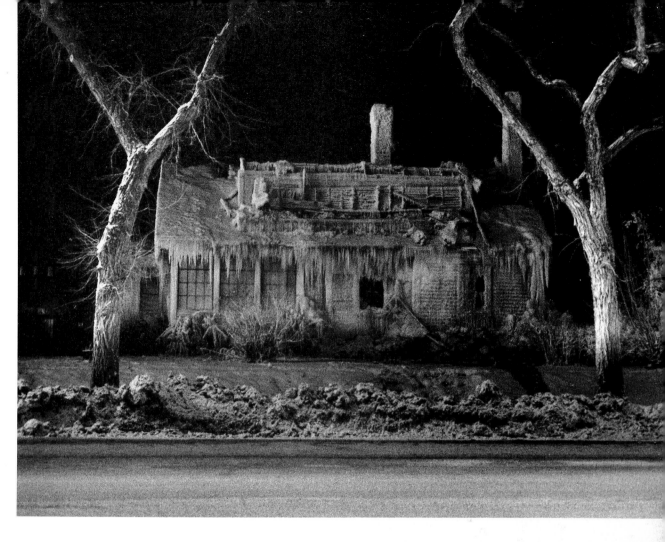

Second Dawn OPPOSITE, TOP: The exact moment that the sun began to reappear from behind the moon after an eclipse.
MERIT AWARD DR. JAMES T. STOCKARD
Clarkston WA USA *The Morning Tribune*
KODAK GOLD 100 Film

Shepherd in the Mist OPPOSITE: BOTTOM: Sheep herder with dogs near Heidelberg, West Germany.
HONOR AWARD KATHRYN AMOS
Alexander, Manitoba CANADA *The Sun*
KODAK GOLD 100 Film

Firehouse ABOVE: Picture of a house frozen in icicles after the fire's flames.
MERIT AWARD PAUL WHISHAW
Lethbridge, Alberta CANADA *The Globe and Mail*
KODAK T-MAX 400 Professional Film

Oregon's Prize RIGHT: Mt. Hood, Oregon, with an unusual, circular cloud formation.
MERIT AWARD ILENE BAILEY Hillsboro OR USA
The Argus KODAK GOLD 200 Film

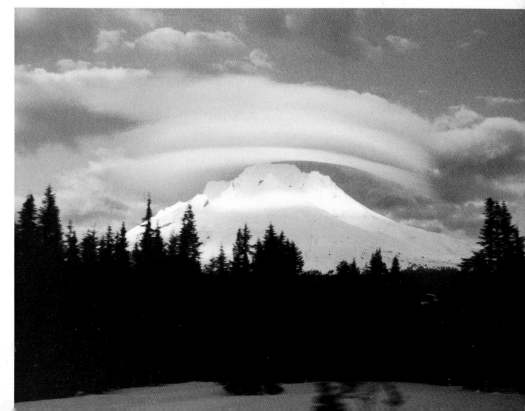

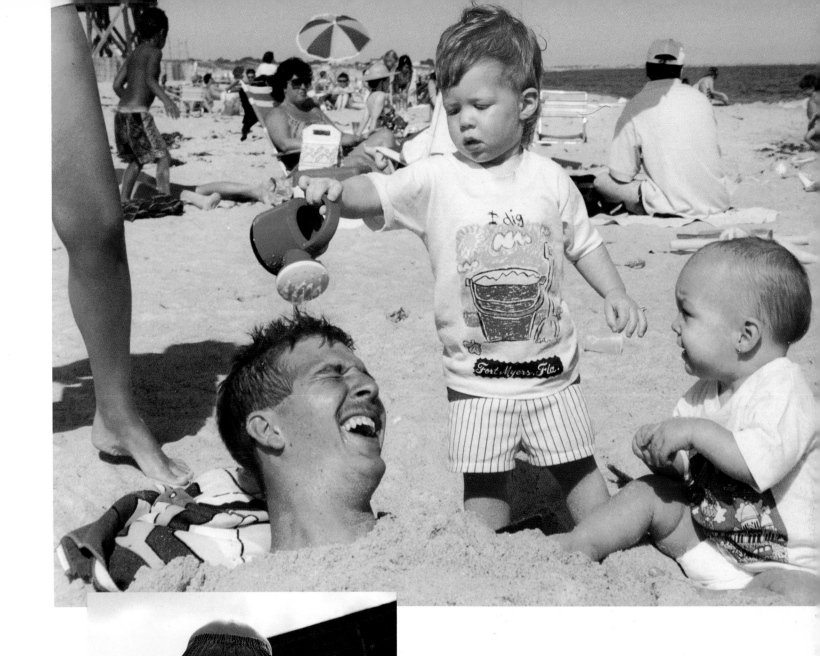

Three Boys with Goggles Three cousins wading with their goggles on.
MERIT AWARD J. Gregory Vowell Tallahasee FL USA
The Democrat KODAK GOLD 200 Film

July 4th Frolic ABOVE: A great July Fourth at the beach—then Drew gave dad a refreshing splash.
MERIT AWARD Diane Carlson Bristol CT USA *The Press*
KODAK GOLD 100 Film

My Head Fell Off Again LEFT: Six-year-olds in macabre play in the sand.
MERIT AWARD Sandra Coffee Tomlinson Sumter SC USA
The Times-Enterprise KODAK GOLD 100 Film

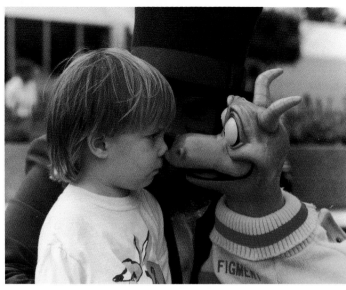

The Meeting of the Minds ABOVE: My son, Eddy, face to face with an unexpected character.
MERIT AWARD CHARLES EDWARD KNIGHT, JR.
Daytona Beach FL USA *The News-Journal*
KODAK EKTACHROME 64 Film

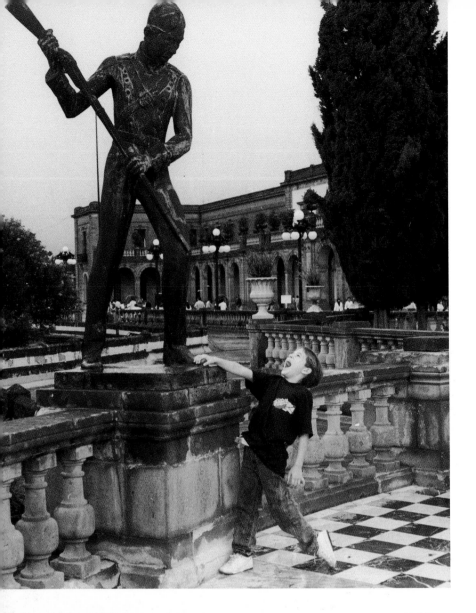

The Boy Hero LEFT: My son, the hero of Chapultepec.
MERIT AWARD SANDRA GO JON DE DELSOL Tampico MEXICO
El Sol de Tampico KODAK GOLD 100 Film

Dry Ice LEFT: Children's feet sitting in water with dry-ice fog.
MERIT AWARD JOHN A. CLARK Dekalb Junction NY USA
The Daily Times KODACHROME 64 Professional Film

Girl Watcher Daddy's little boy at the beach.
MERIT AWARD SRA. IGNACIO GONZALEZ ALVAREZ LEON MEXICO
El Sol de Leon KODAK GOLD 100 FILM

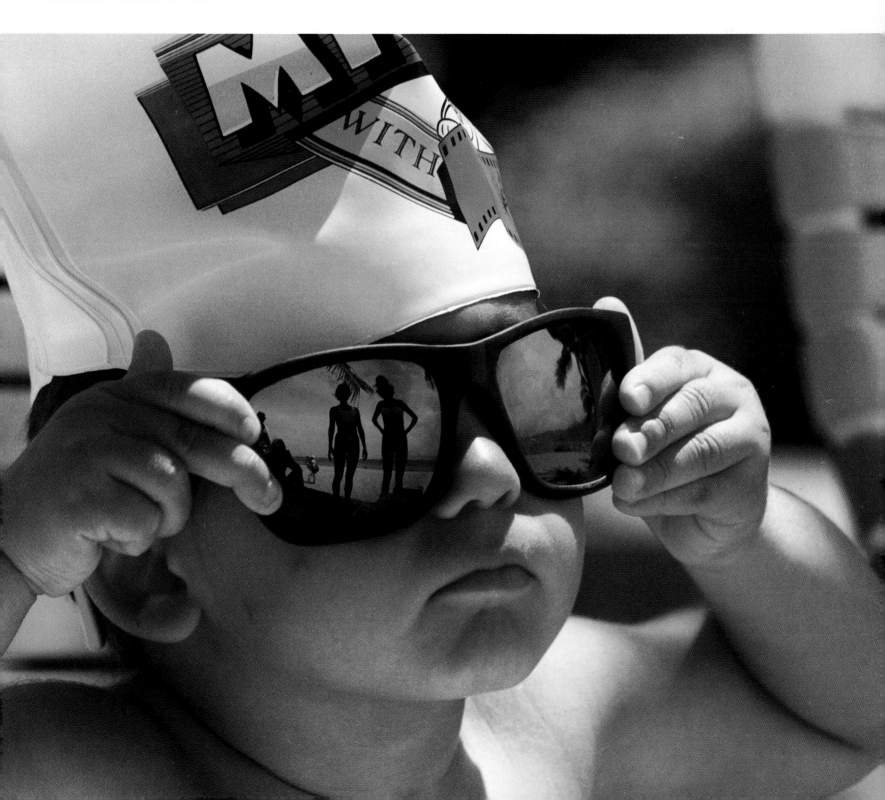

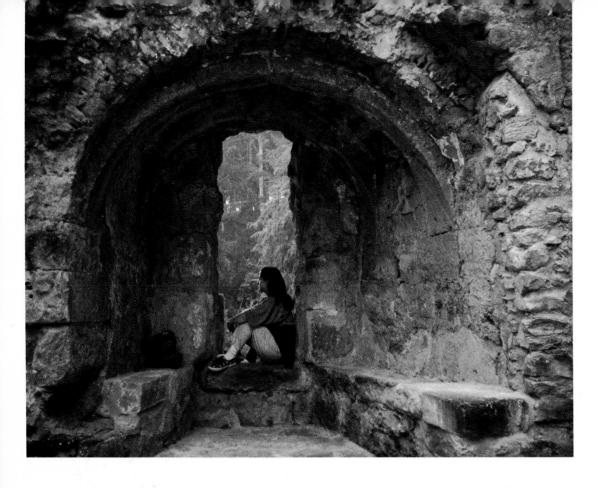

Meditating ABOVE: Seated in a stone arch, San Luis, Mexico.
MERIT AWARD SRITA. CECILIA ORTIZ MICHEL Guadalajara MEXICO
El Occidental KODAK GOLD 100 Film

Beach Vendor RIGHT: The hat seller.
MERIT AWARD SRA. FIDEL HERNANDEZ ROBLES Leon MEXICO
El Sol de Leon KODAK GOLD 100 Film

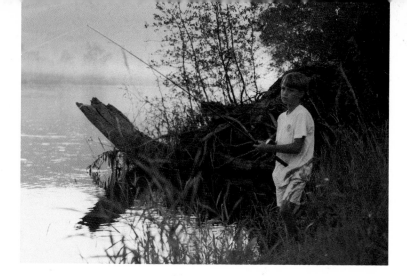

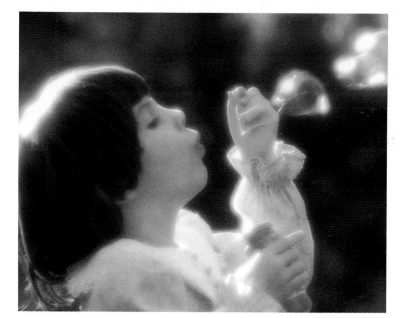

Sadie's Heavenly Tea ABOVE: Tea party with an angel at the arboretum in Newark, Ohio.
MERIT AWARD PAT WARTHEN Newark OH USA *The Advocate*
KODACOLOR VR-G 100 Film

Dusk at Clarke Fork TOP RIGHT: Hoping for a bite while fishing, but no luck. They just weren't biting.
MERIT AWARD WAYNE NELSON Calgary, Alberta CANADA
The Herald KODAK GOLD 100 Film

Bubbles B MIDDLE RIGHT: My daughter, Tess. I've called her Bubbles B for a couple of years.
MERIT AWARD RANDY S. WYMORE Omaha NE USA
The World-Herald KODAK VERICOLOR 400 Professional Film

Flight School BOTTOM RIGHT: Feeding sea gulls at Cape Hatteras, North Carolina.
MERIT AWARD JO W. EVANS Wooster OH USA *The Daily Record*
KODAK GOLD 400 Film

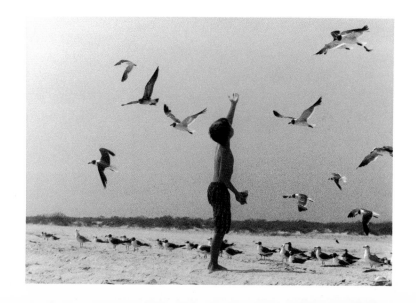

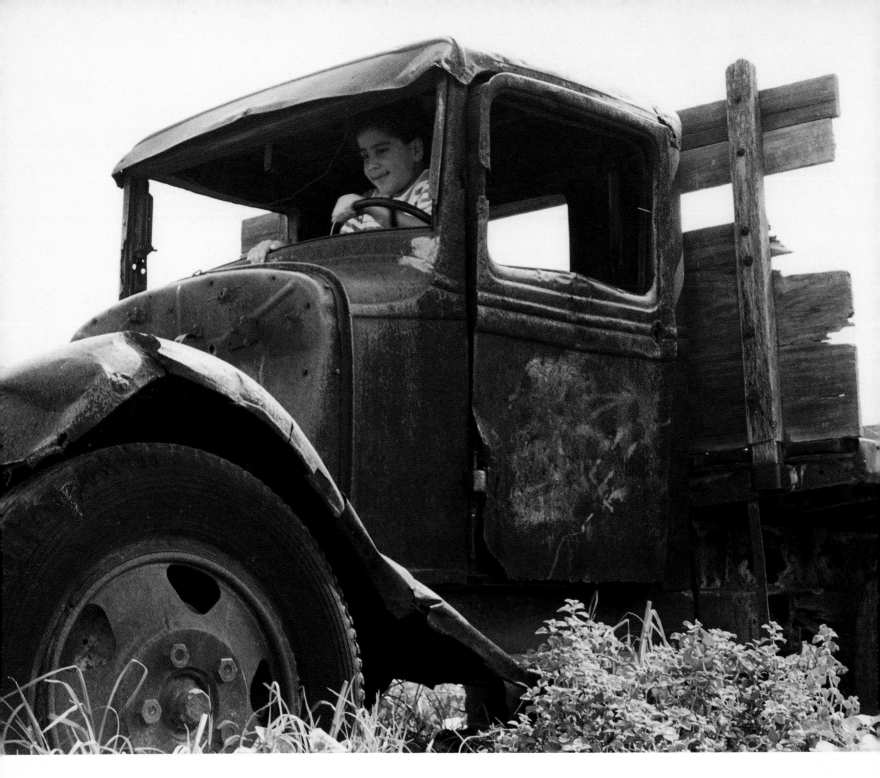

Up to Speed A child plays driver of an abandoned truck.
MERIT AWARD Dr. Miguel Carranza Lopez Tuhepel MEXICO
El Universal KODAK GOLD 100 Film

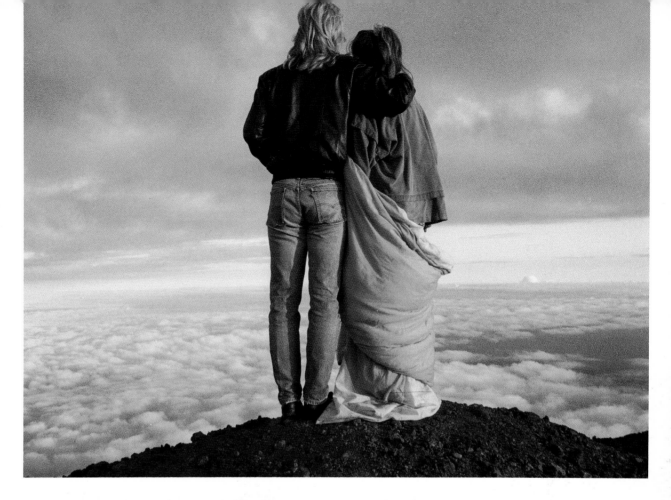

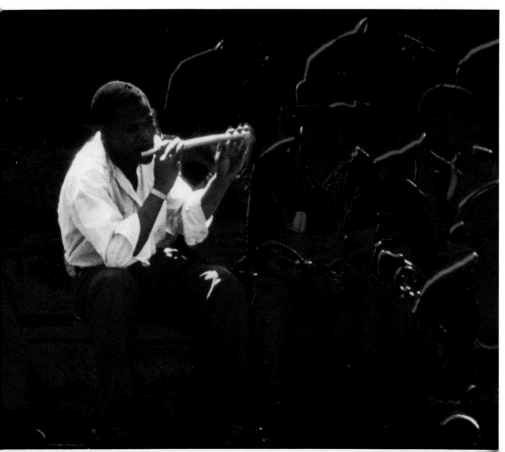

Serenity ABOVE: Haleakala, Maui, Hawaii. I placed the camera on some lava rock, set the automatic timer, and tried to look tranquil.
MERIT AWARD TODD RUCYNSKI New York NY USA
The Palladium-Times KODAK GOLD 200 Film

Musical Flute LEFT: Making music alone, despite the crowd.
MERIT AWARD GERALD A. ZUROWSKI
Oconoviowoc WI USA *The County Freeman*
KODACHROME 64 Professional Film

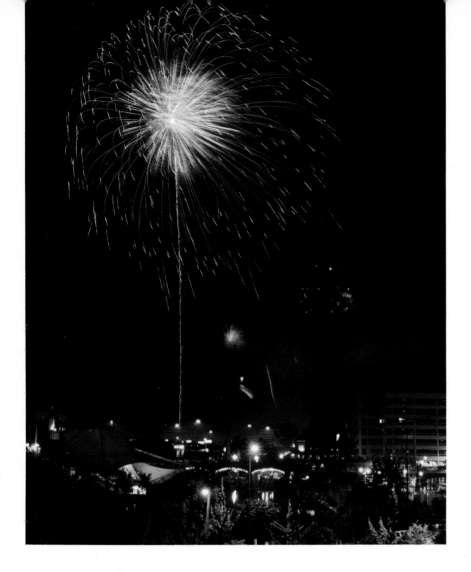

Independence Night ABOVE: Fourth of July fireworks in Knoxville, Tennessee.
MERIT AWARD KEITH L. WILLIAMS Knoxville TN USA
The News-Sentinel KODAK EKTAR 125 Film

Play Ball! OPPOSITE: The puppy was brand new. My niece enjoyed chasing it and being chased, in turn.
HONOR AWARD NANCY L. ROSS Toronto OH USA
The Herald-Star KODAK GOLD 200 Film

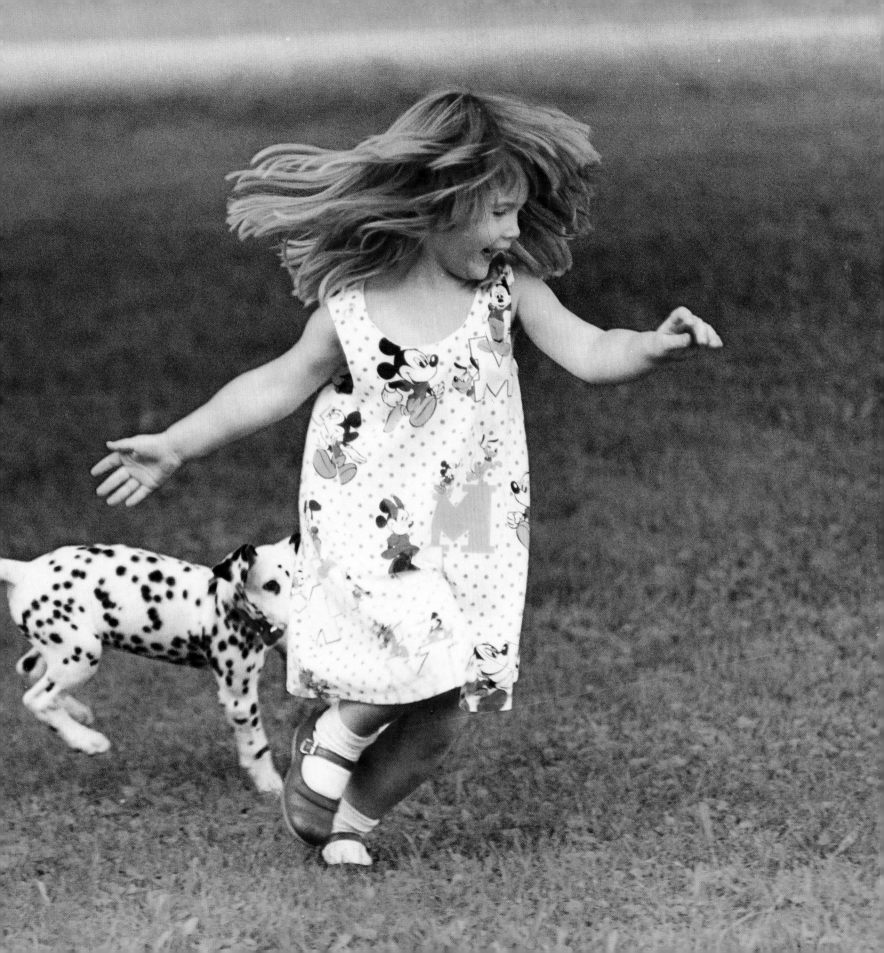

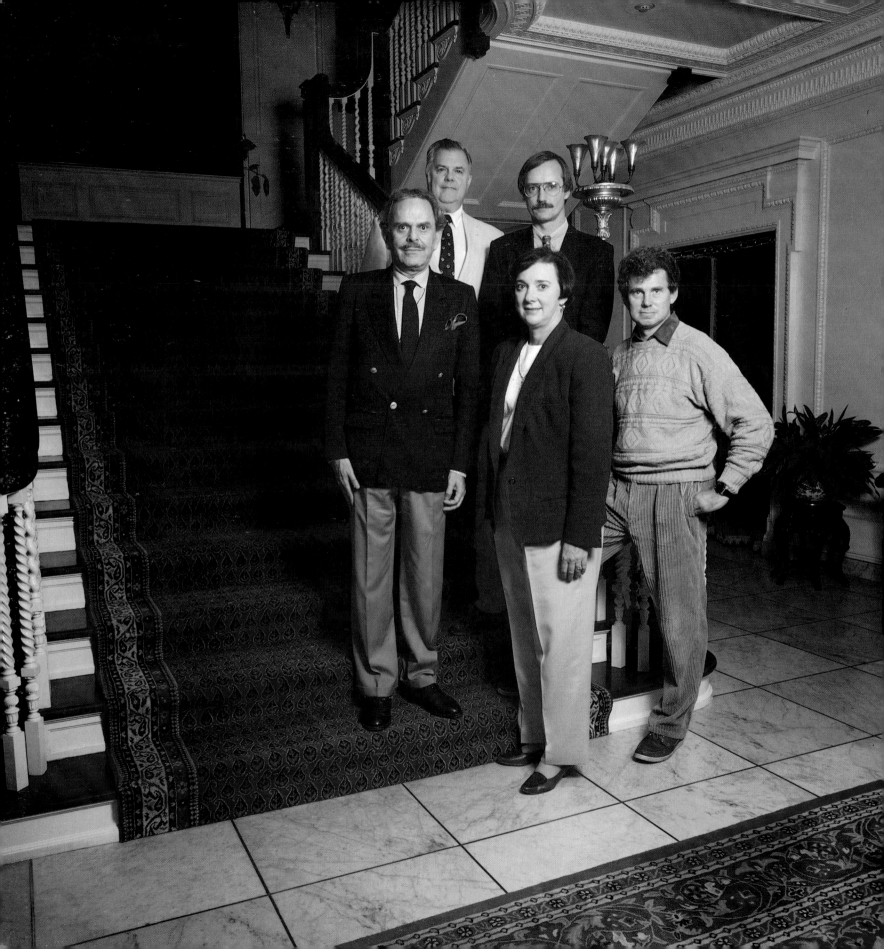

CHAPTER
III

THE JUDGES

An INDEPENDENT PANEL OF FIVE JUDGES GATHERED IN OCTOBER, 1991, AT KODAK'S HEADQUARTERS IN Rochester, New York, to evaluate the KINSA contest entries. As has been a tradition for 56 years, KINSA selected as judges men and women whose careers have immersed them in the world of photography. This year's judges hail from Canada, Mexico, and the United States.

Half a million snapshots arrived on the desks of newspaper editors around the world during the contest's submission period. From this flood, the editors selected more than 1,200 finalists.

The judges' first task was to make their personal choices for finalists in 10 subject categories. When finished, they compared results and began discussing the photographs' merits in earnest.

As a group, the judges then selected the 50 best photographs—the five best in each category. From this pool, they chose the top three award winners in color and in black-and-white. Then they cast their final votes for the grand-prize winner. By the end of the second day, the judges had earmarked seven photos for the major awards, 50 for honor awards, and 200 as special-merit winners.

During the selection, the judges' comments were recorded. Some comments are included in this book as a lasting record of words a judge might have said while contemplating the intangible qualities that made simple photographs somehow extraordinary.

CLOCKWISE FROM TOP LEFT: Fred Graham, Dennis Dimick, David Lewis, Ann Gallant, and Joffre de la Fontaine, photographed at the International Museum of Photography at George Eastman House.

DENNIS R. DIMICK
ILLUSTRATIONS EDITOR
National Geographic Magazine

DENNIS DIMICK has been a books and magazine editor for the National Geographic Society for more than 11 years. Since 1990, he has been illustrations editor of *National Geographic* Magazine and was formerly the illustrations editor for *National Geographic Traveler* Magazine.

Besides editing photographs and illustrations for the magazine, Dimick has also been responsible for illustrations for eight National Geographic Society books, including *Exploring Your World: The Adventure of Geography*; *The Desert Realm*; *Our Violent Earth*; *Wildlands for Wildlife—America's National Refuges*; *Nature's World of Wonders*; *Natural Wonders of North America*; *What Happens in the Autumn*; and *Pathways to Discovery: Exploring America's National Trails.*

Before joining the Society in 1980, Dimick was a newspaper photographer, writer, and editor for six years, including two years at *The Courier-Journal* in Louisville, Kentucky.

Dimick brings to his KINSA judging duties a strong awareness of photographic composition, color, and content derived from reviewing hundreds of photographs in his daily work.

Dimick's interest in photography spans nearly two decades. He was born in Portland, Oregon, and grew up in the Pacific Northwest, where his father was a fisheries biologist and his mother was a zoologist and librarian. He is an honors graduate of Oregon State University and the University of Wisconsin in Madison. In his career, Dimick has traveled extensively to most of the United States and throughout many parts of the world.

DR. JOFFRE DE LA FONTEINE Y FERNANDEZ
ADVERTISING AND
PUBLIC RELATIONS MANAGER
El Universal Newspaper

JOFFRE DE LA FONTEINE is a journalist and a prominent public figure in Mexico. His regular appearances on network television programs and as a lecturer have made him known through the country.

Born in Santo Domingo in the Dominican Republic, he is now a Mexican citizen. He received his Master's degree in International Relations from the University of the Americas, Puebla, Mexico, and his Doctorate in Political Science, Communications, and Institutional Administration from Southern Illinois University.

Fonteine has taught extensively in universities in Mexico, the United States, and Europe. He collaborates with associates at many newspapers, periodicals, and magazines throughout Mexico and the world.

Fonteine's responsibilities as the manager of advertising and public relations for Mexico City's principal newspaper requires him to have a regular and continuing involvement with illustration, art, and photography.

During the 1991 KINSA judging, Fonteine contributed a sensitive perception of the emotional nuances of the photographs being judged.

ANN T. GALLANT
PRESIDENT
Gallant Marketing, Inc.

ANN GALLANT is a management consultant, providing marketing services to media, service, and non-profit businesses. She was formerly the director of marketing and communications for *The Baltimore Sun*, a major metropolitan newspaper.

Gallant's consulting work regularly requires her to evaluate media publications for their presentation of graphics and illustrated matter.

During the past 10 years, Gallant has won over 100 national and regional creative, marketing, and research awards. She is frequently invited to speak on topics of strategic marketing, research, and promotion before such organizations as the International Newspaper Marketing Association, The American Press Institute, The Newspaper Research Council, and the American Marketing Association.

Gallant is the President of the International Newspaper Marketing Association. She holds a Bachelor of Arts from Agnes Scott College in Decatur, Georgia, where she was a National Merit Scholar. She has a Master's of Arts from the University of North Carolina at Chapel Hill and a Master's of International Management, Marketing from American Graduate School of International Management, Glendale, Arizona.

FRED GRAHAM
MANAGER OF PHOTOGRAPHY
Walt Disney World

FRED GRAHAM is a career photographer and the Manager of Photography for Walt Disney World in Orlando, Florida. Graham has been a judge for the KINSA contest since 1987.

Graham's photographic career spans nearly 25 years. First employed by RCA Corporation to provide photographic support for the Eastern Test Range at Cape Canaveral, he later worked for Trans World Airlines as a marketing representative. He was subsequently responsible for the visitor center at Kennedy Space Center, where he had roles in both photography and public relations.

Because of his Florida location, Graham also developed his skill at underwater photography and has taught underwater photography courses at Florida Institute of Technology.

After five years with American Broadcasting Company's attractions division, he joined Walt Disney in 1982 as a photography director. He is responsible for all staff-produced still photography throughout the 43-square mile Disney property, and supervises a staff of 21 photographers, lab technicians, photo librarians, and clerical personnel.

Graham is a native of Muscatine, Iowa. He attended State University of Iowa in Iowa City, Winona School of Photography in Indiana, and Florida Institute of Technology.

DAVID W. LEWIS
PHOTOGRAPHER AND
PHOTO HISTORIAN

DAVID LEWIS, a resident of Callander, Canada, in the province of Ontario, has devoted his life's work to mastering historic photographic processes. He is one of the last surviving craftsmen able to produce photographs by the bromoil, carbon and carbro, gelabrome, and cyanotype processes, all common to an earlier era.

Besides a strong dedication to his craft, Lewis is an active professional photographer. He is Senior Vice President for Gilbert Studios in Toronto, Canada, where he is responsible for all corporate photography. His professional work includes portraiture, public relations, and advertising photography.

Before joining Gilbert, Lewis was a freelance photographer whose work included a contract with The Ministry of Natural Resources. Previously, he had been a photographic supervisor for Creative Light and Sound, Ltd. of Toronto.

Gilbert has studied extensively in England and Wales with masters of historic photographic processes, including Georgia Procter-Gregg and Trevor Jones.

OPPOSITE: Judging the 1991 KINSA photography contest at Eastman Kodak Company headquarters in Rochester, New York.

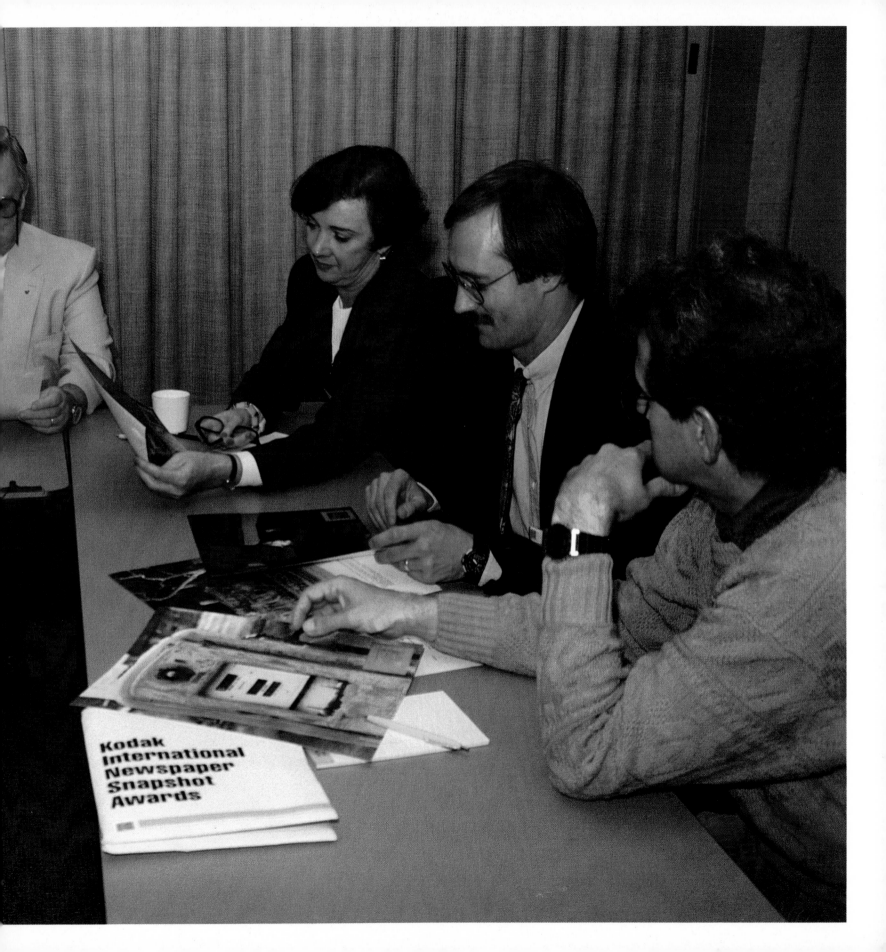

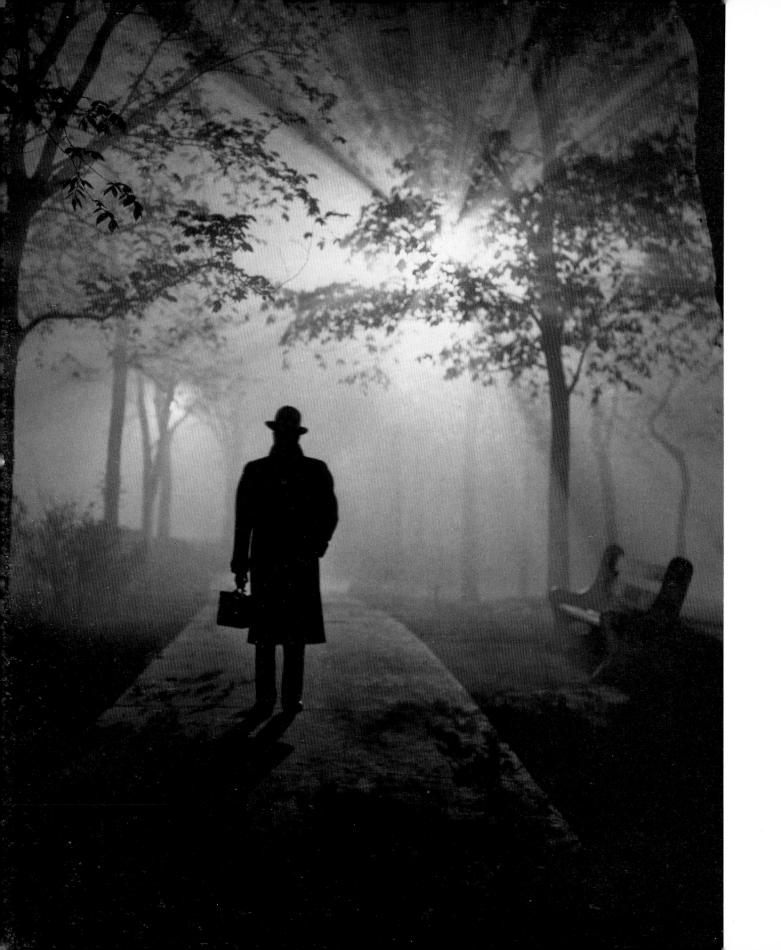

CHAPTER
IV

FIFTY-SIX YEARS
OF KINSA PHOTOGRAPHS

H<small>E STANDS IN THE SHADOWS OF THE NIGHT LIKE AN EVIL PHANTASM, A SYMBOL OF THE DARKNESS THAT WAS</small> sweeping over Europe in 1940 when Thomas Stanton entered his prizewinning picture in an early KINSA contest. The comments of the noted judges who selected his picture may be lost to history, but the image they honored provides a haunting memory of that era and its troubled mood.

Stanton's striking photograph graphically demonstrates that from its beginnings in 1935, and for each succeeding year, Kodak's photo contest has captured the spirit and mood of our world in pictures in a unique way. The source of KINSA's uncanny ability to reflect our time and place rests both in widely varied viewpoints of thousands of independent amateur photographers and in the informed and appreciative eyes of the 280 men and women who have acted as judges for the contest over the years.

The first contest, 56 years ago, drew together judges Sara Delano Roosevelt, the mother of President Franklin Roosevelt; Emily Post, the authority on manners and social customs; Lowell Thomas, the noted explorer and newsman; as well as Hiram Maxim of the Amateur Cinema League and Kenneth Williams of Eastman Kodak Company. In the years to follow, other respected public figures were to join their ranks. They include Amelia Earhart,

OPPOSITE: A shadowy figure in the night, 1940.

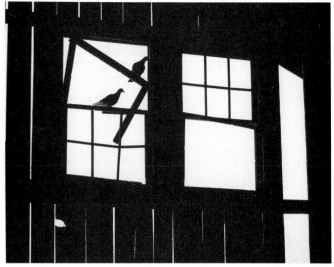

ABOVE: A moment of jealousy, 1947.

UPPER RIGHT: Abandoned barn and pigeons, 1954.

Mrs. Calvin Coolidge, Margaret Bourke-White, Norman Rockwell, Cornelia Otis Skinner, Walt Disney, Yousuf Karsh, and Ansel Adams.

From the beginning, these judges brought unique perspectives and insights to KINSA. Their selections reflected the world and times in which they lived. Early entries to the contest (called the Newspaper National Snapshot Awards for its first few years) quickly became known for their photographic beauty, charm, and irony in depicting everyday as well as personal slants on larger, global events.

After capturing family life in the closing days of the great depression, the world's eyes turned inward during the war years. As soldiers, sailors, and marines left home, their loved ones turned their minds to rationing, war-bond rallies, and the overriding tragedy of conflict. For many, the war ended on battlefields with unfamiliar names: Anzio, Omaha, Guadalcanal, and Midway. For many others, the war trudged on, punctuated with tense waits and long silences.

Throughout the conflict, wives and families anxiously sat at home. Letters came and went. Tears flowed frequently. Newspapers and radio broadcasts became focal points of daily lives, bringing the news of far-away battles, victories, and defeats. Then, one day, the guns fell silent and the war was over. Joyous homecomings, spanning more than three years, allowed millions of interrupted lives to begin anew.

World War II returned its fighters to the bosom of their country. For them, the postwar years were a time to catch up—to get a job, to get married, to find a home, and have a family. All over America, newly

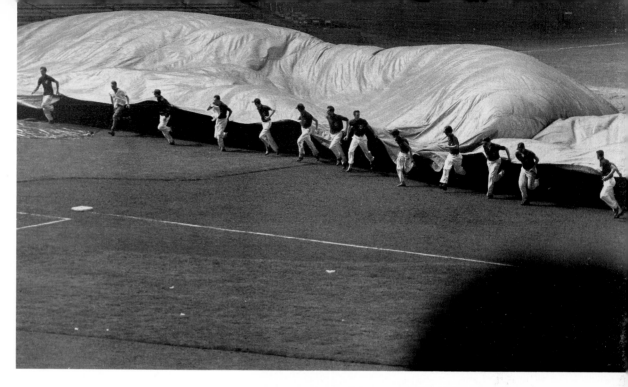

RIGHT: Ballplayers cover a baseball field, 1958.

BELOW: Soapbox racers, 1959.

built subdivisions echoed with the laughter of families rediscovering themselves and meeting new neighbors.

The KINSA contests of the late 1940s and early 1950s reflected an image of America focused on its core values. If there ever was a time of apple pie and motherhood, this was surely it. Proud parents, proud homeowners, proud workers marked an era of self-reliance, assurance, and stability. The KINSA winners of the early 1950s echoed a world on the move and able to laugh at itself.

But the war had ended with an uneasiness, too. Unemployment lines at home brought tension and stress. Factories geared to wartime footing struggled to provide new goods in the face of overwhelming demand. And abroad, the birth of a cold war rumbled restlessly in places like Berlin and Korea.

Millions of snapshots were taken during those years—many with folding Kodak cameras on rolls of black-and-white film. Every moment of life was documented, from births and christenings to the family pets. Past summer vacations returned to life in album photographs, with family members posed in front of Niagara Falls, Old Faithful, Yosemite, the Grand Canyon, the seashore. At home, television sets flickered into life, and children took their first steps, their first solid food, and their first communions, all before the watchful eye of the family camera.

Each year, KINSA judges sifted through thousands of photographs entered in the contest, seeking the best images to describe their world and its people. The mood and character of America was constantly changing. In 1957, satellites first roared aloft, touching off the race into space. The launch of astronauts a few years later forever widened America's

ABOVE: Memories of a loved one's departure, 1967.

viewpoint beyond its own, comfortable shores. At the same time, America was attracting unprecedented numbers of immigrants from Latin America, Europe, and Asia. Distant trends from abroad began to be felt at home, and the subjects in the KINSA photographs began to change their focus as well.

By the early 1960s, rock and roll was gaining an equal footing with swing, jazz, and folk. Hemlines were moving up, and shutters were snapping pictures of a world that had left the comfortable 1950s behind. The United States was beginning to stir to the words of a young, vibrant new president who promised each individual that they held the power within themselves to make a difference. It was a time of searching, of discovery, of promise.

It was also a time for the beginning of a fundamental rift between two cultures—one rooted in the great depression and World War II, the other in the stability and self-assurance of the postwar period. The country was moving forward, but not every citizen was pleased with the path it was taking.

The next few years were apocalyptic for America and the world. Places and events that had been recently unknown or unthinkable assaulted every American—both on nightly newscasts and in the streets. The Bay of Pigs, the Watts riots, the Kennedy and King assassinations, LSD, flower power, Vietnam, and Kent State overwhelmed the nation's senses. Again, young Americans marched into war—but this time it was a war without a clear purpose or plan. And, again, KINSA photographs captured the pain of farewells and the image of youthful men and women in uniforms.

192

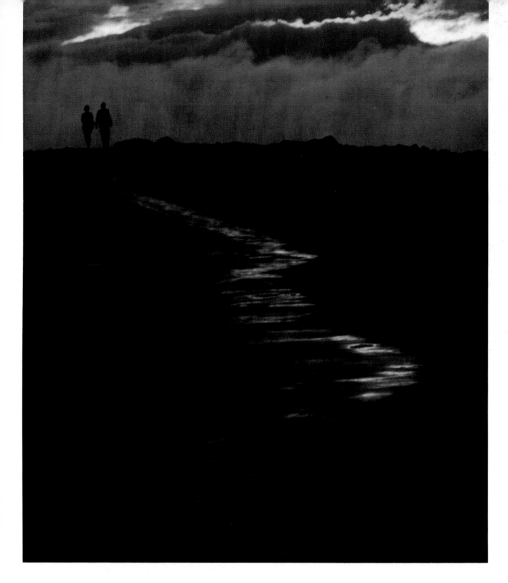

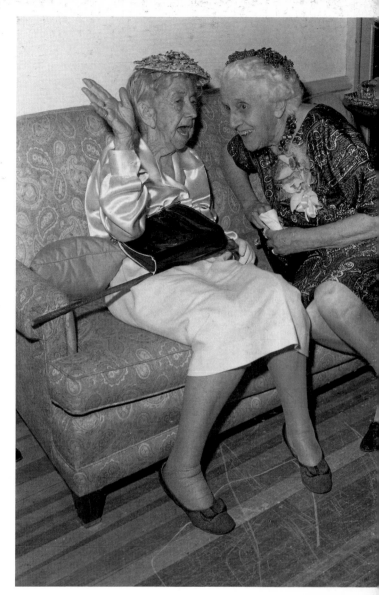

Throughout it all, life went on. Our national enchantment with taking pictures continued to document us as a people. Even as flickering household televisions revealed the horrors of war and its aftermath, shutters snapped and flash bulbs popped at birthday parties, family gatherings, and celebrations.

In the cities, many people were becoming preoccupied with their careers, the burgeoning women's movement, and the oil crisis. But in the broader land, no single fad could ever capture the enormous diversity of the American people.

One of the striking features of KINSA is the breadth of its scope. Rather than a single concept, we find every possible theme. The photos reflect hundreds of occupations, scores of religions, thousands of pastimes. Every culture and creed is seen and recorded. In this aspect alone, KINSA mirrors the American people and America as a land. With such diversity, surprising images have become a regular feature of the contest.

ABOVE: Telling a story animates two seniors, 1967.

UPPER LEFT: A couple approaching on a pathway, 1964.

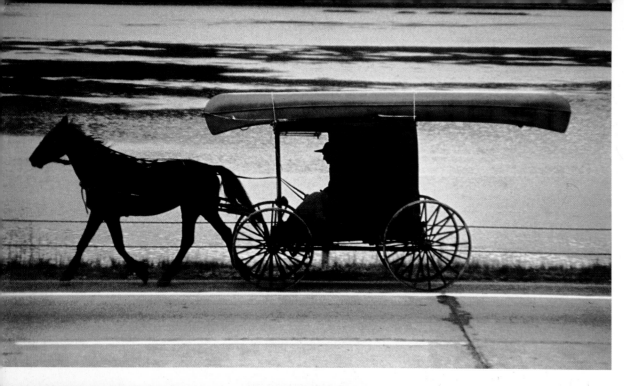

Surely the sight of a canoe traveling atop a horse-drawn Amish carriage was as startling to Eric Stewart in 1968 as it is to each viewer of his photograph. One imagines him coming upon the unlikely scene, doing a double take, then having the presence of mind to take his memorable snapshot. The KINSA contest judges recognized Stewart's spontaneity, his proficiency, and the whimsy of the situation with their top award.

In recent years, especially since Mexican newspapers joined the contest in 1977, KINSA has become an international contest, underscoring the oneness of individuals in today's global society. Despite this, as the contest has become more international, it has stayed more and more the same. Of the thousands of pictures entered each year, the three most popular themes remain babies, pets, and animals.

Against a background of ongoing strife in Asia, Africa, and the Middle East, a dramatically changing Eastern Europe and Soviet Union, and a warming planet beset with environmental concerns, KINSA photographs overwhelmingly reflect the optimism, beauty, and tenderness of our people and our world.

The contest has expanded to include photographs from Canada, Chile, and Mexico, as well as from the United States. People of many nations appear in suspended animation, as do their children, pets, homes, and modes of transportation. Through KINSA eyes and images, the world remains a beautiful place, filled with charm, humor, and irony.

Whatever the coming years may bring, KINSA will continue to reflect in its photographs our world, its people, and a fascinating glimpse into a thousand lives.

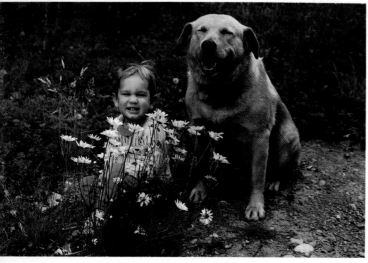

ABOVE: Two happy friends, 1990.

TOP: A surprising moment in Pennsylvania, 1968.

1935 SARA DELANO ROOSEVELT, Mother of President Franklin D. Roosevelt
EMILY POST, Authority on Modern Manners & Social Customs
LOWELL THOMAS, World Traveler, Author, Lecturer, News Commentator
HIRAM PERCY MAXIM, President of Amateur Cinema League
KENNETH W. WILLIAMS, Eastman Kodak Company

1936 AMELIA EARHART, Aviatrix
ALBERT W. STEVENS, Cdr/National Geographic Army Air Corps Stratosphere Balloon
GEORGE HENRY HIGH, FRPS of Great Britain
MRS. CALVIN COOLIDGE, Wife of President Calvin Coolidge
KENNETH W. WILLIAMS, Eastman Kodak Company

1937 RUTH ALEXANDER NICHOLS, Babies & Children Photographer
FRANKLIN L. FISHER, Chief of Illustrations, National Geographic
HOWARD CHANDLER CHRISTY, Portrait Photographer, Illustrator & Writer
MARGARET BOURKE-WHITE, Photographer of Industrial & News-Interest Subjects
KENNETH W. WILLIAMS, Eastman Kodak Company

1938 TONI FRISSELL, Society & Fashion Photographer
GEORGE HENRY HIGH, FRPS, Oval Table Society
NORMAN ROCKWELL, Artist & Illustrator of Human-Interest Subjects
CORNELIA OTIS SKINNER, Actress, Radio Star & Amateur Photographer
KENNETH W. WILLIAMS, Eastman Kodak Company

1939 NEYSA MCMEIN, Artist & Illustrator
JOHN OLIVER LAGORCE, Associate Editor, National Geographic
WALTER DORWIN TEAGUE, Industrial Designer & Photographic Critic
LOWELL THOMAS, World Traveler, Author, Lecturer, News Commentator
KENNETH W. WILLIAMS, Eastman Kodak Company

1940 SIR E. WYLY GRIER, Canadian Painter & Art Critic
FRANK LIUNI, Camera Pictorialist, President of Photographic Society of America
DR. ARTHUR D. OLMSTED, Photographic Authority, Smithsonian Institution
NORMAN BEL GEDDES, Designer & Expert Photographer
KENNETH W. WILLIAMS, Eastman Kodak Company

1941 IVAN DMITRI, Internationally Known Photographer
MRS. OSA JOHNSON, Famous Explorer & Photographer
MCCLELLAND BARCLAY, Noted Illustrator, Painter & Amateur Photographer
DR. GILBERT GROSVENOR, President & Editor, National Geographic Society
KENNETH W. WILLIAMS, Eastman Kodak Company

1942 WALT DISNEY, Artist, Creator of Disney Cartoons
ELEANOR PARKE CUSTIS, FRPS, Pictorialist & Salon Exhibitor
MAJOR GENERAL DAWSON OLMSTEAD, Chief Signal Officer, U.S. Army
JOHN S. ROWAN, Pictorialist & President of Photographic Society of America
KENNETH W. WILLIAMS, Eastman Kodak Company

1947 TONI FRISSELL, Photographic Illustrator
YOUSUF KARSH, Photographer of Celebrities
CHARLES B. PHELPS, JR., President of PSA & Prominent Salon Exhibitor
LOWELL THOMAS, World Traveler, Author, Lecturer, News Commentator
KENNETH W. WILLIAMS, Eastman Kodak Company

1948 VALENTINO SARRA, Photographic Illustrator
FRANKLIN L. FISHER, Chief of Illustration Division, National Geographic
TANA HOBAN, Photographer of Babies & Children
ANSEL ADAMS, Photographer of the West, Author & Lecturer
KENNETH W. WILLIAMS, Eastman Kodak Company

1949 HAROLD BLUMENFELD, Editor of Acme Newspictures
JULIEN BRYAN, Photographer & Lecturer
MELVILLE GROSVENOR, Assistant Editor, National Geographic
LEJAREN A. HILLER, Photographic Illustrator
KENNETH W. WILLIAMS, Eastman Kodak Company

1950 KIP ROSS, Staff Picture Editor, National Geographic
JOSEF SCHNEIDER, Photographer of Babies and Children
S. W. MAUTNER, Executive Editor, IN Photos
JOHN G. MULDER, President, Photographic Society of America
KENNETH W. WILLIAMS, Eastman Kodak Company

1951 EDWIN L. WISHERD, Chief of Photography Lab, National Geographic
YLLA, Photographer of Animals
OLLIE ATKINS, Photographic Illustrator
EVAN DMITRI, Photographic Illustrator
KENNETH W. WILLIAMS, Eastman Kodak Company

1952 STEVAN DOHANOS, Magazine Artist & Illustrator
HALLECK FINLEY, Photographic Illustrator
B. ANTHONY STEWART, Senior Staff Photographer, National Geographic
ROBERT BOYD, President, National Press Photographers' Association
KENNETH W. WILLIAMS, Eastman Kodak Company

1953 ROBERT KEENE, Photographic Illustrator
WILLIAM TAYLOR, Chairman, School of Journalism, Kent State University
THOMAS CRAVEN, President, White House News Photographers' Association
WALTER M. EDWARDS, Asst. Illustrator, Editor, National Geographic
KENNETH W. WILLIAMS, Eastman Kodak Company

1954 LOUISE DAHL-WOLFE, Staff Photographer, Harper's Bazaar
ANTON BRUEHL, Nationally Known Photographer
JOSEPH COSTA, Chairman, National Press Photographers' Association
LUIS MARDEN, Photographer/Member, Foreign Ed. Staff, National Geographic
KENNETH W. WILLIAMS, Eastman Kodak Company

1955 RICHARD BEATTIE, Eminent Photographic Illustrator
HAROLD BLUMENFELD, Executive Newspictures Editor, UP Association
RAY MACKLAND, Picture Editor, Life
ANDREW POGGENPOHL, Senior Illustrations Editor, National Geographic
KENNETH W. WILLIAMS, Eastman Kodak Company

1956 HENRY BURROUGHS, President, White House News Photographers' Association
HERBERT S. WILBURN, JR., Asst. Illustrations Editor, National Geographic
DON BENNETT, Editor, PSA Journal
SIR ELLSWORTH FLAVELLE, Canadian Photographer & Salonist
KENNETH W. WILLIAMS, Eastman Kodak Company

1957 PHOEBE DUNN, Camera Editor, Parents Magazine
NORMAN ROCKWELL, Illustrator & Painter
FRANC SHOR, Assistant Editor, National Geographic
MURRAY ALVEY, President, White House News Photographers' Association
PETER J. BRAAL, Eastman Kodak Company

1958 JOHN W. HUGHES, Chief, Still Pictures, National Film Board of Canada
EDWARD WERGELES, Cover Director, Chief of Photography, Newsweek
LEONARD J. GRANT, Asst. Illustrations Editor, National Geographic
HOWELL CONANT, Magazine Photographer & Illustrator
PETER J. BRAAL, Eastman Kodak Company

1959 JAMES M. GODBOLD, Director of Photography, National Geographic
MAX DESFOR, Supervising Editor, Wide World Features Pix, AP
LARRY KEIGHLEY, Special Assignment Photographer, Saturday Evening Post
GEORGE R. GAYLIN, Manager, Washington Bureau, UPI Newspictures
PETER J. BRAAL, Eastman Kodak Company

1960 ROBERT L. BREEDEN, Asst. Illustrations Editor, National Geographic
GORDON N. CONVERSE, Chief Photographer, The Christian Science Monitor
SUZANNE SZASZ, Magazine Photographer & Illustrator
CLIFF EDOM, Assoc. Professor & Director of Journalism, Univ. of Missouri
PETER J. BRAAL, Eastman Kodak Company

1961 GILBERT M. GROSVENOR, Editorial Staff, National Geographic
ARTHUR ROTHSTEIN, Technical Director, Photo Department, Look
IRVING DESFOR, Photo Columnist, AP
JON ABBOT, Photo Illustrator & Color Specialist
PETER J. BRAAL, Eastman Kodak Company

1962 CHRIS LUND, Photographer, National Film Board of Canada
ROBERT E. GILKA, National Geographic Society
YOICHI R. OKAMOTO, U.S. Information Agency
OTTO STORCH, Art Director, McCall's
PETER J. BRAAL, Eastman Kodak Company

1963 MARY S. GRISWOLD, Assistant Illustrations Editor, National Geographic
WALTER CHANDOHA, Noted Photographer of Animals
FRANK ZACHERY, Art Director, Holiday
WILLIAM A. BERNS, VP for PR, NY World's Fair Corporation
PETER J. BRAAL, Eastman Kodak Company

1964 WILLARD N. CLARK, Editor & Publisher, U.S. Camera
ORMOND GIGLI, NY Photographer & Color Specialist
THOMAS R. SMITH, Editorial Staff, National Geographic
CONRAD L. WIRTH, Retired Director, National Parks System
PETER J. BRAAL, Eastman Kodak Company

1965 Richard Beattie, Freelance Photographer
Allen Hurlburt, Art Director, Look
William E. Garrett, National Geographic Society
Julia S. Scully, Editor, CAMERA 35
Peter J. Braal, Eastman Kodak Company

1966 Ivan Dmitri, Director, Photography in the Fine Arts
John Durniak, Editor, Popular Photography
Joseph B. Roberts, Asst. Director of Photography, National Geographic
Lorraine Monk, Head of Still Photography, National Film Board of Canada
Peter J. Braal, Eastman Kodak Company

1967 Dean Conger, Writer-Photographer, National Geographic
Maurice Johnson, Staff Photographer, UPI
Myron Matzkin, Senior Editor, Modern Photography
Ozzie Sweet, Freelance Photographer
Peter J. Braal, Eastman Kodak Company

1968 Richard O. Pollard, Director of Photography, Life
William W. Carrier, Jr., President, PPofA
Winfield Parks, Photographer, National Geographic
Glen Fishback, Glen Fishback School of Photography
Peter J. Braal, Eastman Kodak Company

1969 Jack Deschin, New York Times
Chris Lund, National Film Board
Dick Leach, Scholastic
Bates Littlehales, National Geographic Society
Peter J. Braal, Eastman Kodak Company

1970 Brother Norman Provost, Photo Teacher, Mater Christi High School
O. Louis Mazzatenta, Asst. Illustrations Editor, National Geographic
Robert Bode, Freelance Photographer
John Jackson, VP & Director of Stage Operations, Radio City
Peter J. Braal, Eastman Kodak Company

1971 Irving (Doc) Desfor, AP, NYC
Gordon N. Converse, The Christian Science Monitor
Volkmar (Kurt) Wentz, Foreign Editorial Staff, National Geographic
Byron E. Schumaker, White House Photography Staff
Peter J. Braal, Eastman Kodak Company

1972 Ray Atkeson, Freelance Photographer
Brother Norman Provost, Photo Teacher, LaSalle Military Academy
Joseph Scherschel, Photographer, National Geographic
Prof. Arthur Terry, Illustrations & Photojournalism Dept., RIT
Peter J. Braal, Eastman Kodak Company

1973 Jon Abbot, Color Specialist & Photo Illustrator
Seth Fagerstrom, Senior VP, Art, Rumrill Hoyt
Alan Royce, Assistant Illustrations Editor, National Geographic
Julia Scully, Editor, Modern Photography
Peter J. Braal, Eastman Kodak Company

1974 Edward E. Betz, Owner & Professional Photographer, Marsh Studios
Dick Faust, Professional Commercial Photographer, Dick Faust Studio, Inc.
James L. Stanfield, Staff Photographer, National Geographic
Ozzie Sweet, Freelance Photographer
Lee Howick, Eastman Kodak Company

1975 Elie Rogers, Assistant Illustrations Editor, National Geographic
Margaret W. Peterson, Freelance Photographer
Charles Reynolds, Photo Editor, Popular Photography
Casey Allen, Professor, NY Univ. & Host of "In & Out of Focus" TV Show
Lee Howick, Eastman Kodak Company

1976 Patricia A. MacLaughlin, University of Illinois
Ben Kuwata, J. Walter Thompson Company
Robert S. Patton, National Geographic Society
James E. McMillion, Jr., RIT
Lee Howick, Eastman Kodak Company

1977 Charles E. Morris, APSA, Photographic Society of America
Declan Haun, National Geographic Society
Jose Rodriguez Estrada, PR Director, Novedades, Mexico
Robert W. Hagan, Ford Motor Company
Lee Howick, Eastman Kodak Company

1978 William L. Allen, Jr., National Geographic Society
William S. Shoemaker, Professor, Photographic Sciences, RIT
John Barras Walker, Contributing Editor, Canadian Photography
Jorge Fernandez, El Imparcial de Hermosillo, Mexico
Lee Howick, Eastman Kodak Company

1979 Anne Dirkes Kobor, Illustrations Editor, National Geographic
Tom Bochsler, Commercial & Industrial Photographer, Ontario, Canada
Hector Hernandez Aviles, PR Director, El Sol de Tampico, Mexico
Manfred H. Strobel, Corporate Photographer, Chrysler Corporation
Lee Howick, Eastman Kodak Company

1980 Monica Cipnic, Associate Picture Editor, Popular Photography & Camera Arts
Thomas Powell, Illustrations Editor, Spl. Publications, National Geographic
Professor William S. Shoemaker, RIT
Dora Luz Guerrero, General Manager, La Opinion, Mexico
Lee Howick, Eastman Kodak Company

1981 Dr. Richard Zakia, Chairman, Fine Arts, Photography Dept., RIT
Henry Greenhood, President, Photographic Society of America
Frank Grant, President, Professional Photographers of Ontario
James Amos, Photographer, National Geographic
Jorge Medina Mora, Creative Director, Ad Agency, Mexico
Norman Kerr, Eastman Kodak Company

1982 Mark Hobson, Freelance Photographer
David Johnson, Picture Editor, Special Publications, National Geographic
H. Warren King, Teacher of Photography, Reseda High School
Alejandro Segura, Novedades, Mexico
Lee Howick, Eastman Kodak Company

1983 Lenore Herson, VP, Imagebank
Bank Langmore, Freelance Photographer
Bill Buckett, Bill Buckett Associates
Susan A. Smith, Chief of Film Review, National Geographic
Lee Howick, Eastman Kodak Company

1984 Lucy H. Evankow, Picture Editor, Scholastic
Robert M. Hernandez, Illustrations Editor, National Geographic
Frank Pallo, President, Photographic Society of America
Arthur Rothstein, Associate Editor, Parade
Norm Kerr, Eastman Kodak Company

1985 DeWitt Bishop, Past-President, Photographic Society of America
Richard Clarkson, Assistant Director of Photography, National Geographic
Freeman Patterson, Professional Photographer, Author & Lecturer
Myron Sutton, Professional Photographer & Author
Keith Boas, Eastman Kodak Company

1986 Betty Dimond, Honorary Member, Photographic Society of America
Alva Dorn, Photo Columnist, Retired Picture Editor, The Kalamazoo Gazette
Kent Kobersteen, Illustrations Editor, National Geographic
Norm Rothschild, Senior Editor, Popular Photography
Carl Nielsen, Eastman Kodak Company

1987 Eddie Adams, Professional Photographer, Winner of Pulitzer Prize
Janet Charles, Professional Photographer
Fred Graham, Director of Photography, Walt Disney World
Thomas Kennedy, Director of Photography, National Geographic
Derek Doeffinger, Supervising Technical Editor, Eastman Kodak Company

1988 William T. Douthitt, Illustrations Editor, National Geographic
Fred Graham, Photography & Audio Visual Productions, Walt Disney World
Louis Psihoyos, Professional Photographer
Billie B. Shaddix, Director (retired), The White House Photographic Services
Susan Vermazen, Picture Editor, New York Magazine

1989 Joseph H. Bailey, Staff Photographer, National Geographic
Fred Graham, Manager of Photography, Walt Disney World
Douglas Kirkland, Professional Photographer & Author of Light Years
Eliane Laffont, President of SYGMA Photo Agency
Marianne Bump Lurie, Associate Film Producer & Rep of INMA

1990 Fred Graham, Manager of Photography, Walt Disney World
Gene Hattori, Professional Photographer, Saskatchewan, Canada
Gerardo Lara Gzz., El Norte, Mexico
Paula Markiewicz, International Newspaper Marketing Association
Kathy Moran, Picture Editor, National Geographic